Producing Games

From Business and Budgets to Creativity and Design

D.S. Cohen,
Sergio A. Bustamante II

Tech Editor: Tae Joon Park

Contributed by
Sheri Graner Ray and Michael McShaffry

ELSEVIER

AMSTERDAM • BOSTON • HEIDELBERG • LONDON • NEW YORK
OXFORD • PARIS • SAN DIEGO • SAN FRANCISCO
SINGAPORE • SYDNEY • TOKYO
Focal Press is an imprint of Elsevier

Focal Press is an imprint of Elsevier
30 Corporate Drive, Suite 400, Burlington, MA 01803, USA
Linacre House, Jordan Hill, Oxford OX2 8DP, UK

Library of Congress Cataloging-in-Publication Data
Application submitted

British Library Cataloguing-in-Publication Data
A catalogue record for this book is available from the British Library.

ISBN: 978-0-240-81070-6

For information on all Focal Press publications
visit our website at www.elsevierdirect.com

10 11 12 13 5 4 3 2 1

Printed in the United States of America

D.S.

To my sunshine Amanda, you make me everything that I am.
To my loving parents Steven and Carol Ann Cohen, for your belief in my dreams.
To Joan and Armando Reyes, you are forever eternal in the richness you granted our souls.

In the loving memory of Genevieve McLane and Dianna Rohler whoes lives have changed the world forever.

Please support the Fully Belly Project. (www.thefullbellyproject.org)

Sergio

With love to my beautiful wife Susie Sapardanis, and to our lovely daughters, Siara Anastacia Bustamante and Zoe Marie Bustamante. Each day I'm grateful to have you in my life.
To my parents Sergio A. Bustamante, Sr. and Maria Elena Bernal Garcia, and step-mom Kathy Coffman. Your support and love keeps me going.

TABLE OF CONTENTS

Section One What is a Video
Game Producer?....... 1

Section Nine Post-Production.... 267

ABOUT THE AUTHORS

D.S. Cohen

With close to 10 years experience as an industry pro, D.S. has been credited with over 50 current and Next-Gen console and handheld games published by the industry

giants. Most recently he was the Producer and Co-Writer of *SAW: The Video Game*, a project he conceived years before it went into production, then spearheaded into a reality. You can regularly find his writings about the retro history of video games on The New York Times' website About (classicgames.about.com). U.K. readers will find his contributing column, *Cyberdrams* in Fantastique magazine. He also lets loose his personal ramblings on pop-culture and the games industry at VideoGameSexy.com and his personal blog, WritingForTheTrade.com.

Photo by: Graham Millington

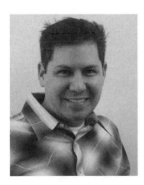

Serigo A. Bustamante II

Leading the charge and coming up with better, and innovative processes, has always been the goal of Serigo A. Bustamante II. A 16 year game industry veteran, Sergio has had a major influence and impact in developing and designing games for premier publishers. His career spans tenures at Activision/Treyarch, EA/Tiburon, and Brash Entertainment. His motto: "Just play!"

Companion Website

Visit http://www.ProducingGames.com for sample forms, bonus chapters, and more!

ACKNOWLEDGEMENTS

The authors would like to thank the following individuals without whom this book would not be possible…

Tae Joon Park – Our brilliant and supportive tech editor.
Chris Simpson – Our brilliant and patient editor.
Chris Soares (SequentialPixel.com) – For the incredible cover design.
Matthew Krause (MatthewKrause.com) – For the kick-ass robot model.
Troy Dunniway – For asking us to take this on.
Sarika Chawla and Aaron Rigby for the advice and sanity check.

For the insightful quotes we thank…

John E. Williamson – President – Zombie Studios
Andy Kipling – Producer – Zombie Studios
Peter Akemann – President, The Workshop (theworkshop.us.com)
Nate Birkholz – Producer – BottleRocket Entertainment
Ben Hoyt – Sr. Producer, Games at Paramount Pictures

For the marvelous images in this book we thank…

Mark Long and Zombie Studios (zombie.com)
Joe Minton and Digital Development Management, Inc.
Jen Chong and Fortyseven Communications
Warner Bros. Interactive Entertainment
Capcom Entertainment, Inc.
Electronic Arts, Inc.
Hudsonsoft, Inc.

Also a big thank you to the following for all of their support…

Patrick Sweeney, Jonathan E. Eubanks, Randy Culley, Kevin Brown, Edan Patinka, Maria Bustamante, Doug Patinka, Chris Sapardanis, Michelle Foote, Mike Foote, Tammy Sapardanis, Jim Sapardanis, William Guerrero, Lindsey Kuna, Larry Shapiro, Douglas Rappaport, Anais Wheeler, Doug Rukavina.

We would also like to thank The Calabasas Library without which we would have never found a quiet and comfortable place to work.

And thank you to all of our friends and family for their love and support on this epic journey.

Intro: So You Want to be a Video Game Producer

Building a Next-Gen console game requires numerous team members all working in harmony, each with the same specific goals. These various artists, programmers, designers, audio engineers, and others each have their own specialty that is essential to creating a quality video game; but a successful game doesn't simply hinge on these team members all doing their respective jobs. It is making sure that each moving part flows together in a smooth, even, and balanced process, with results championed, political torpedoes dodged, and a single creative vision maintained throughout. The one team member who is responsible for this; to keep the trains on the tracks, the energy up, and the creative juices flowing, is the video game producer.

FIGURE **1**

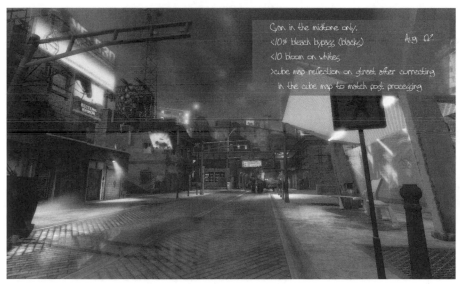

Producing a game can be a road filled with many hazards.
Image Courtesy of: "Tango Down" Zombie Studios

The constantly shifting balance of video game development is so mind-boggling that it's amazing any project makes it from concept to launch, and many don't. The most streamlined and organized game can seem like complete chaos to an outsider, but this is simply the nature of the beast. Games rarely get the time they need to properly develop and outside influences like publishers, licensors, talent, developers, game engines, and first parties[1] can shake up the most organized and streamlined process on a daily basis. At the eye of this hurricane it is the producer, the one upon whom everything is riding, to keep the swirling wind of chaos, red flags, and fires at bay with everyone and everything turning to them until that *Release to Manufacture Build (RTM)* disc is burned.

For as many different types of games, there are also just as many types of producers, so it is hard to give just a simple job description. While job titles such as artist, writer, and programmer are easy to define, the abstractness of what a producer does makes it difficult to pin down. Basically a producer does all of the duties in the process of a video game, but none of them all at once. A good producer needs to know how each duty and responsibility in the production process works, with enough technical know-how to assist with each if any problem that arises, and to understand the importance of its purpose, but not necessarily know how to do any of those precise duties themselves. The producer needs to give everyone what they need, as that is inevitably what the producer needs to get the mission accomplished.

What you hold in your hands is a tool kit, survival guide, and start-up all in one. You'll learn the skills of being an organized, detailed, and strong leader; you'll get the tools of the trade with examples, templates, and diagrams, and you'll also get tips on how to deal with complex projects, and even more complicated people. Everything a producer needs to get the job done.

There are numerous types of games out there. The most standard, lengthy, and intricate production cycles are Next-Gen console games developed for Nintendo, Sony, and Microsoft systems. Other types of games such as online causal, downloadable, mobile, MMOs, and those for hand-held devices may have differences in their structure and schedules, but the processes for a console game are adaptable and can be easily tweaked. With all game formats and platforms the process must be flexible for the expected and unexpected because just like fingerprints, no two game productions are exactly alike—but don't fret. With the help of this book, you'll recognize the pitfalls to avoid, and gain the knowledge you'll need for a successful production.

[1]Nintendo, Sony, and Microsoft

What is a Video Game Producer?

Producer Primer

What a Producer Manages

The role of a producer will always be at it's core, to schedule, budget, manage and oversee a game project. What those specific duties cover all depend on the company you are working for, the project you're on, and your own personal style. A company with good management will play to your strengths, placing you on projects and in roles that will leverage your specialties.

Often when a producer has a strong flair for design and creativity, they will also be in charge of directing those areas as well. While this is an important role for the producer, it is essential that they still allow the designers, artists, and writers to do their jobs, with the producer guiding the vision and not shutting out the voices of the other creative team members.

As many companies cut corners (and jobs), a growing responsibility that is slowly being added to the producer's plate is localization. While there was a time that localization was handled by a specialty localization producer, those roles are starting to phase out with the duties being tossed onto the producer's heap, which can be both a benefit and a burden. Even when the producer is not in charge of localization, they always need to be mindful of it, making sure the game code is structured to allow translated voiceover and on-screen text to be dropped in.

Why Become a Game Producer

This one's got a simple answer ... because you want to. After reading this book you'll have a clear idea of what a producer needs to know and do. If you still like the idea, then pursue it.

If you want to exclusively work on the creative of a game, then you're better off going into design. If you want to be in charge of just the character model creation, then off to the art department you go. If you want to touch all aspects of the game and are highly organized, then you're a cinch for the role of producer.

The most important things to consider when deciding to become a video game producer are: 1. Do you love video games? and 2. Do you play video games?

So often we see producers that just fall into their jobs with no desire, passion, or enthusiasm for games. If you don't play games, keep up with the latest trends, innovations, and gameplay styles, your game will reflect it and suffer.

FIGURE
1.1

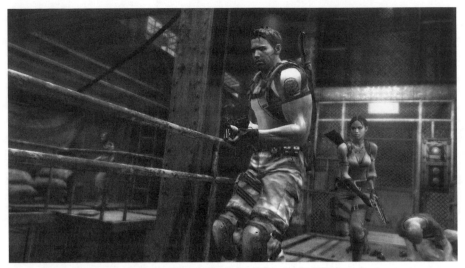

The Resident Evil series spawned innovations and game trends in horror.
Image Courtesy of: "Resident Evil 5" Capcom.

How to Become a Producer

Becoming a producer is as complicated as it is simple. The short version is simply work in the video game industry any way you can, and make it clear that your career path is to become a producer.

The typical entry into production is to start as a tester. Although the tester position is the lowest paid position in game development, paying an average of $10 to $12 per hour, it is also one of the key positions. Testers are the ones who play the game builds and find all the bugs. Without them there would be no way or time for the development team to find every little issue or problem with the game and still have time to fix them. A tester is often young and just breaking into the business, but has the chance to get thrown right into the mix of development and learn all the different aspects of it. Because of this, testers get a taste for which elements of the gaming business they want to work in, and if they pursue it, can go in any number of directions.

If attempting to get a position in production directly out of college, you're going to run into some serious competition from testers who already have a few years ahead of you in the working world, plus a qualified tester has already proven strong communication, reporting, and organizational skills, something a recent grad has

not had the opportunity to experience just yet. Simply having a degree doesn't mean you've paid your dues, and many production teams don't have the time to sit and train an inexperienced newbie. Because of this it's recommended that a recent graduate start out in a position outside of production in another group such as operations or administration, and volunteer to help production as often as possible.

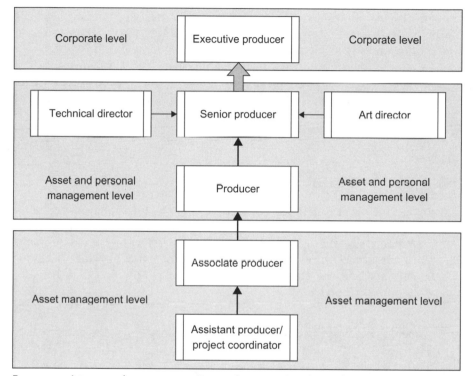

FIGURE
1.2

From an assistant producer to executive producer, getting there takes a lot of hard work and dedication.

Now if you can't survive on a $10 an hour job but still want to become a producer, don't despair. There are countless avenues for breaking into the biz. Heck, the writers of this book started out in game audio and marketing.

Break into games any way you can, in any position you're skilled at, from finance to office assistant, you're nearly always going to start near the bottom. Once you're in, get involved with the projects going on at your company, volunteer to help the production team out (they seem to always need extra help), and learn everything you can. Soon you'll find that the team and company have become dependent on you, placing you in the perfect position to transition to the path of a producer.

Publishers and Developers

If you're into video games at all you've undoubtedly heard the names Activision/Blizzard, Capcom, and Electronic Arts (EA). These are publishers. The publisher finances the game, manages the franchise, licenses the rights to release on first party systems, and oversees the progress of the games development, but they don't actually make the game itself, that's the role of the developer. While some developers are owned by the publisher, many are independent, making games with several different publishers, sometimes simultaneously. The team at the developer consists of artists, programmers, and specialists all working on building out the game for the publisher to release. Developers come in numerous sizes and specialties; they can consist of a single small team or as a large company with numerous offices, each with several development teams. Both the publisher and developer hold extremely important roles in the creation of a game, neither of which could function properly without their respective producers.

Internal and External Producer Roles

The producer on the development side is referred to as the internal producer, while the producer on the publishing side is called the external producer. This is because the development producer is working with the internal team in day-to-day development, and the publishing producer is external of the day-to-day, but is working with other groups such as marketing, PR, sales, legal and first parties to ensure that the game is getting what it needs for release.

FIGURE
1.3

Concepts like these go between developer and publisher.
Image Courtesy of: "Terminator Salvation: The Videogame" WBIE.

While the external producer ensures the game is published and coordinates with outside vendors, it's still up to both the internal and external developer to make the game a success on financial and creative levels. Both need to work in harmony and make sure that they adhere to a commitment to quality that each relies on the other for their success.

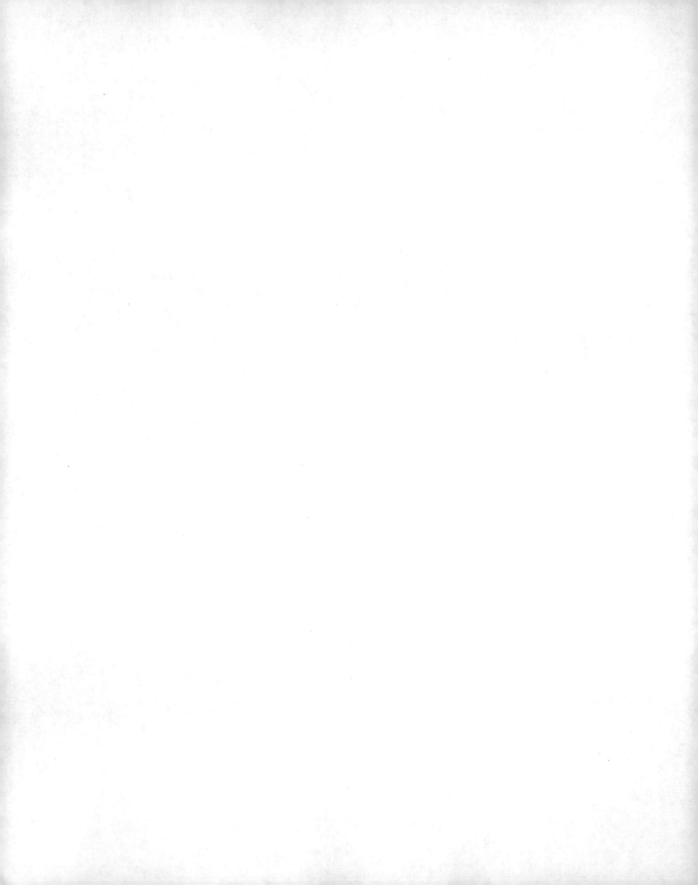

CHAPTER TWO

Producing at a Developer

FIGURE
2.1

Producers understand the consequences of what can go wrong.
Image Courtesy of: "Tango Down" Zombie Studios.

On the development side, the producer is charged with managing the team building out the game on a day-to-day basis. Of all the different types of producers, this is the one who needs not only strong project management skills, but should be well versed in the technical side of the process. Without knowing what different disciplines are needed, the number of team members and a basic understanding of the duties of each role, the project could easily fall apart.

Producers on a development team are looked towards to provide direction and leadership, and to keep things on course at the same time. Doing so is not easy when you have a range of people with different personalities, skill sets, and agendas.

9

A producer is mindful of all of these and looks to steer the ship in a path of least resistance and in the direction with the fewest number of bumps and bruises. Sometimes this means having to crack the whip if a team member is not living up to their responsibilities, but it also means being the team's cheerleader and strongest champion, praising their hard work, ensuring that they know it is appreciated and not going unnoticed.

FIGURE
2.2

It takes a certain precision to get through a development cycle.
Image Courtesy of: "Tango Down" Zombie Studios.

The producer on a development side is also the main point person with their counterpart at the publisher. With the publishing producer they will work out the full milestone schedule, manage the milestone submissions, give input to the budget needs, and champion the team's ideas.

The Schedule

One of the most important items you control that will avoid any derailments along your journey through game development is the schedule. Like a captain of a ship, the schedule will be your map in order to make it to your destination in one piece. Schedules are never perfect, but they do allow the producer to guide their team and present something concrete for others to see and follow.

The schedule is also the first to be modified during the course of a project. A reality of game development is that things change and evolve without notice, so the producer must be just as flexible, ready to move things around to maintain top efficiencies. It's easy for a project to overturn if you don't know where to place all the moving parts. In order to avoid some of the pitfalls it's always a good thing

to have the schedule done early, with a reasonable amount of padding for key milestones. Although it might look like you have plenty of time to work with at the beginning, you'll soon learn there is no avoiding crunch mode.

The schedule starts with the publisher dictating the length of the overall production. At that point it's time for the dev producer to build out a milestone schedule which outlines each item that will be delivered to the publisher, when it will be submitted and how it represents the work that the publisher is paying for.

Dev Budget

Budgeting a game typically starts with a blanket, ideal numbers thrown out by the developer or producer, but it will inevitably end up modified into a final calculation through a cooperative effort between the publisher and developer. The dev producer's role here is to provide information on how many team members will be needed, the equipment, tools, and other resources required and provide a breakdown of how much these will cost to the publisher. These are considered the below-the-line costs, the resources needed to actually build a game. The bells and whistles such as voice-over talent, composers, and other specialists are the above the line costs, which are typically handled by the publisher.

Pitching Ideas and Representing the Team

As the development producer you are the main communication conduit between the dev team and the publisher. While there are lots of ideas thrown around as a game is in development, all creative ideas need to be cleared and approved by the publisher.

While you will likely have quite a few creative ideas yourself, it is extremely important to listen to all of your team's ideas. Work with the creative director to organize brainstorming sessions and require that the entire team attend. This will not only give your team members an investment in the project, but will often bring up some really terrific ideas.

Once you have all the ideas in place, you must represent them to the publisher, and allow for a few variations for them to choose from. You can also not discount the creative input of the publisher. Not only do they hold the purse strings, but they may also have quite a few good ideas to contribute, plus in cases where you're working with a license, the publisher will be the pipeline to the stakeholders, all of which have their own unique vision for the game.

While you'll constantly receive conflicting ideas, stories, and designs from all different sides, as the developer producer, your part is to defend and represent the ideas of your team above all else, yet walk the political tightrope to have all the other outside entities feel they have played an important part as well.

FIGURE
2.3

Game development is like a complex machine with all the parts working together.
Image Courtesy of: "Bionic Commando" Capcom.

Manage Milestone Submissions

One of the more grueling tasks for the internal producer is managing milestone submissions, which must be delivered on target and on time. You are responsible for making sure your work is ready, as well as every other team member meeting their deadline. Each line item in the milestone delivery must be accounted for, and at an acceptable quality. Anything less falls on your shoulders as a missed, incomplete, or failed milestone and results in no payment from the publisher, something your team depends on for getting payroll and the developer depends on to stay in business.

As milestone submissions include a spectrum of files, from docs and images to video files and game builds, so it's best to have a strong file transfer system to get the submission delivered to the publisher. The most often used are FTP sites and digital delivery services, however there are more efficient and time saving (but more costly) services that are constantly changing and upgrading.

Once the publisher receives the milestone submission from the internal producer the clock begins to tick and things like submissions reviews, approvals, invoices, and payments get processed. Each of these take time, and the longer the submission is delayed, the longer the internal development team might have to wait for the publisher to deliver payment.

FIGURE

2.4

Number	Description	Date	Payment
TEMPLATE MILESTONE BREAKDOWN v.01 - PS3 & 360			
MS#1 Concepting 1		5/25/2009	$500,000
DOC	• First Pass High Concept Doc. - Initial Vision & Direction, Game Type		
ART	• Concept Art of Three Prime Characters		
MS#2 Pre-Production 1 - Project Kickoff		6/24/2009	$370,900
DOC	• GDD (1st Draft) - Characters, Environments, Player Controls, Combat & Skills		
DOC	• ADD Art design doc (1st draft) - Continued Concept Art of Characters & Environments		
MS#3 Pre-Production 2 - Interim Milestone		7/24/2009	$439,400
DOC	• GDD (2nd Draft) - Characters, Environments, Player Controls, Combat, Skills, AI Behaviors, UI Concepts, & Game Levels		
DOC	• TDD (1st Draft) - Engine, Physics and Core Systems Overview		
DOC	• ADD Art design doc (2nd draft) - Preliminary 3D Models		
MS#4 Pre-Production 3 - Interim Milestone		8/23/2009	$530,700
DOC	• GDD (3rd Draft) - Characters, Environments, Player Controls, Combat, Skills, AI Behaviors, UI Concepts, Audio, Cinematics, Animations, & Game Levels		
DOC	• TDD (2nd draft) - Gameplay System (AI, Mechanics)		
DOC	• ADD Art design doc (3rd draft) - Preliminary 3D Models and Textures		
MS#5 Pre-Production 4 - Interim Milestone		9/22/2009	$564,900
PS3/360 BUILD	• First Pass on character models (Main Character and Core Enemies)		
DOC	• GDD (4th Draft) - Beta Draft (prelim before finalization)		
DOC	• TDD (3rd Draft) - Beta Draft (prelim before finalization)		
DOC	• ADD Art design doc (4th Draft) - Continuation of preliminary 3D Models and Textures		
MS #6 Pre-Production 5 - Final Design Documents Before Proof of Concept (POC)		10/22/2009	$564,900
PS3/360 BUILD	• First Pass on main character animations, representative of future direction and developed from the list of animations in the Game Design Document. First initial pass of environment(s).		
PS3/360 BUILD	• Begin prototype progress of core character control/mechanics. Memory map included.		
DOC	• PRODUCTION MILESTONE SCHEDULE: Definition of assets and builds to be delivered over the course of full production demonstrating material progress of game development.		
DOC	• GAME DESIGN DOCUMENT: (Final Before POC) Full game design document featuring detailed descriptions of all game features and game content (including, but not limited to, game levels, environments, characters, AI behaviors, UI, controls, cinematic, etc.). - Game Design Document must include all necessary descriptions, charts, tables, concept art, and support materials to provide a fully complete and detailed description of the game at this early phase of development. - PURPOSE: Game design must be fully complete in order to provide an accurate description of all aspects of the game. - Additionally, it must be documented in enough detail to provide the basis to begin the process of identifying all game assets, content, features, and functionality; in other words, it should be feasible to begin a full asset and functionality revelation once the Game Design Document is complete.		
DOC	• TECHNICAL DESIGN DOCUMENT: (Final Before POC) Full Technical Design Document featuring a comprehensive assessment of existing technologies to be utilized in the development of the game; along with any new technologies to be developed for completing the game. - The TDD must include complete overviews for: game engine architecture, asset creation pipelines (to include data export schemes), dependencies, and technical risks. - A full risk assessment must be provided along with viable strategies for addressing them. - PURPOSE: The TDD should serve as the blueprint for creating the game engine and all relevant technologies. - Additional emphasis is placed on a risk assessment document identifying all risks—technical and otherwise—associated with creation of the game, along with viable strategies for resolving them.		
DOC	• ART DESIGN DOCUMENT: (Final Before POC) The art design document must have a detailed analysis of the visual elements in the game, such as characters, levels, weapons, lighting, animation, etc.. - This analysis must include (as appropriate) color charts, animatics, comps, character bibles, level designs, schedules, staffing plans, dependencies and risks. - The ADD must also include a comparison to existing titles if a sequel, and/or a comparison to existing assets if based on a licensed property, such as a movie. - The ADD must include a list of milestones, a description of the approval process (including who has approval) and a description of the design revision process. - The ADD must also include a priority list that identifies which elements (no more than 3 or 4) are absolutely essential to the identity of the game. - PURPOSE: The main focus of the ADD is to identify the key visual elements needed to achieve the desired design goals and document all decisions regarding style and quality. This ensures that everyone (development team, marketing group, licensor, etc.) has the same expectations and also sets a clear design target to reference throughout development.		
MS#7 Pre-Production - Proof-of-Concept (Target Render)		12/21/2009	$553,500
MOVIE	• Movie showing key characters, combat, skills, enemies, game mechanics, and general direction and tone the game is going to take.		
PS3/360 BUILD	• Second Pass on main character animations, representative of future direction and developed from the list of animations in the Game Design Document. Second initial pass of environment(s).		
PS3/360 BUILD	• Second Pass of interim PS3/360 build showing in-engine progress of core character control/mechanics. Memory map included.		
MS#8 Pre-Production - Prototype 1 - First Playable Build		12/21/2009	$553,500
PS3/360 BUILD	• Early look at how VFX and particle systems will look like in the game. Memory map included.		
PS3/360 BUILD	• Initial Technical Prototype: Preliminary - "look and feel" gameplay/visual target build running on PS3/360 hardware. Memory map included. The gameplay portion of the delivery should demonstrate control of the character and game mechanics (running in an environment) using the main character model.		

Milestone schedule example.

FIGURE

2.4

MS#9	Pre-Production - Prototype 2 - Second Playable Build	1/20/2010	$525,000
DOC	• Fully updated Game Design, Art concepts, and Technical Design documents		
DOC	• Marketing Demo specification (based on first playable/vertical slice milestone).		
PS3/360 BUILD	• **Technical Prototype:** "look and feel" gameplay/visual target build running on PS3/360 hardware. Memory map included. The gameplay portion of the delivery should demonstrate control of the character and game mechanics (running in an environment) using the Main character model.		

MS#10	Pre-Production - Prototype 3 - Interim Build	2/19/2010	$519,300
APPROVAL	• First Party Concept Approval/Feedback from Sony & Microsoft		
PS3/360 BUILD	• Interim Build - All PS3/360 character models textured and lit (in an in-engine viewer/test room). Models do not have to be complete, but all models should be represented to an early stage of development.		

MS#11	Pre-Production - Prototype 4 - Interim Build	3/21/2010	$519,300
DOC	• Updated GDD, ADD and TDD Docs.		
PS3/360 BUILD	• In-game events demonstration.		

MS#12	Pre-Production - Prototype 5 - Interim Build	4/20/2010	$496,400
PS3/360 BUILD	• Environment #1		
PS3/360 BUILD	• Combat Prototype		

MS#13	Pre-Production - Prototype 6 - Interim Build	5/20/2010	$450,800
PS3/360 BUILD	• Environment #2		
PS3/360 BUILD	• Skills Prototype		

MS#14	Pre-Production - Prototype 7 - Final Prototype: The Vertical Slice	6/19/2010	$382,300
PS3/360 BUILD	• **PS3/360 FIRST PLAYABLE/VERTICAL SLICE:** Fully playable level with full functionality of requisite features and elements running on PS3 and 360 hardware. - All art may not be considered final, but fully representative of final art assets. - All additional elements pertaining to the First Playable must be in a functional state, this would include any AI, character animations, combat, camera control, U.I., etc. - Both of Main Character's core gameplay mechanics are implemented and working. - PURPOSE: The First Playable is intended to be representation of typical game play, including look-and-feel for art, sound, and controls. - Additionally, the First Playable should answer the majority of technical unknowns pertaining to the creation of the game as well as illuminate & define content creation pipelines and processes. - The First Playable will also be reviewed by the Publisher and potential Licensors as an early representation of the game. - Memory map included.		

MS #15	Production - Full Game Production Begins	7/19/2010	$365,200
ASSETS	• Localization Kit: Delivery to Publisher of all assets necessary to translate, record and otherwise prepare the game for localization (screenshots of all screens containing text, text files of all on-screen and in-game text, final "as implemented" dialog script and final dialog media files).		
ASSETS	• Marketing Materials: Images of all collectables, environments and characters delivered to Publisher on media and in a manner to be determined at a later date.		
PS3/360 BUILD	• First Pass Cinematics Implemented.		
DOC	• **GAME DESIGN DOCUMENT:** - **Includes latest updates, changes, and revisions to the game** - Full game design document featuring detailed descriptions of all game features and game content (including, but not limited to, game levels, environments, characters, AI behaviors, UI, controls, cinematic, etc.). - Game Design Document must include all necessary descriptions, charts, tables, concept art, and support materials to provide a fully complete and detailed description of the game at this early phase of development. - PURPOSE: Game design must be fully complete in order to provide an accurate description of all aspects of the game. - Additionally, it must be documented in enough detail to provide the basis to begin the process of identifying all game assets, content, features, and functionality; in other words, it should be feasible to begin a full asset and functionality revelation once the Game Design Document is complete.		
DOC	• **TECHNICAL DESIGN DOCUMENT FINAL UPDATE:** - **Includes latest updates, changes, and revisions to the game** - Full Technical Design Document featuring a comprehensive assessment of existing technologies to be utilized in the development of the game; along with any new technologies to be developed for completing the game. - The TDD must include complete overviews for: game engine architecture, asset creation pipelines (to include data export schemes), dependencies, and technical risks. - A full risk assessment must be provided along with viable strategies for addressing them. - PURPOSE: The TDD should serve as the blueprint for creating the game engine and all relevant technologies. - Additional emphasis is placed on a risk assessment document identifying all risks—technical and otherwise—associated with creation of the game, along with viable strategies for resolving them.		

MS #16	Production - Production Build 1	8/18/2010	$291,000
PS3/360 BUILD	• First production pass build: Whitebox environments of level 1-2, character iteration, Environment #3. Continued Iterations.		

MS#17	Production - Production Build 2	9/17/2010	$262,500
PS3/360 BUILD	• Whitebox environments of level 3-4, character iteration, Environment #4, combat, continued Iterations.		

MS#18	Production - Production Build 3	10/17/2010	$262,500
APPROVAL	• Whitebox environments of level 5-6, 2 final, character models, continued character iterations, Environment #5-6, combat iteration, hud implementation first pass, online co-op first pass, game saves successful.		
PS3/360 BUILD	• Second Pass Cinematics Implemented.		
PS3/360 BUILD	• Music and sound effect tests.		

MS#19	Production - Production Build 4	11/16/2010	$262,500
	• Whitebox environments of level 7-8, completion of levels 1-4, continued iteration on art, mechanics and audio.		
MS#20	Production - Production Build 5	12/16/2010	$262,500

Continued

FIGURE
2.4

	• Completion of levels 5-8, final character models completed, environments completed, features locked.			
MS#21	**Production - PRE-ALPHA**		1/15/2011	$262,500
PS3/360 BUILD	• **Pre-Alpha:** The majority of TRCs have been addressed and half of the game could be considered at Alpha state, including code and assets.			
DOC	• Alpha Manual Documentation: Description of "how to play" controls and general functionality of the game.			
MS#22	**Production - ALPHA**		2/12/2011	$262,500
PS3/360 BUILD	• Game build 75% complete: Design, Art, Environments, Levels, Mechanics, Audio, etc.			
PS3/360 BUILD	• Final Cinematics Implemented. Memory map included.			
ASSETS	• Localization Kit: Delivery to Publisher of all assets necessary to translate, record and otherwise prepare the game for localization (screenshots of all screens containing text, text files of all on-screen and in-game text, final "as implemented" dialog script and final dialog media files).			
ASSETS	• Marketing Materials: Images of all collectables, environments and characters delivered to Publisher on media and in a manner to be determined at a later date.			
MS#23	**Production - BETA 1**		3/26/2011	$262,500
PS3/360 BUILD	• All features and functionality implemented and working as they will in the final commercial release on a representation of final delivery media and free from any software defects that prevent verification. - The Game is complete in terms of assets, functionality, and game flow and can be verified as such. - The Game is ready for delivery to Publisher's quality assurance department for verification and the complete Final testing cycle. - Remaining tasks include debugging, performance and memory optimizations, continued enhancement of assets and game balancing and tuning. - Stable, content complete build of game, some assets may be placeholder, but they must be meaningful (i.e., meaningful placeholder assets must be near-final). - Critical path progression is robust, all features and functionality are fully implemented and robust. Game tuning and balancing is mostly complete. - Memory map included.			
PS3/360 BUILD	• All known issues or bugs have been addressed; potentially shippable code. Bug testing continues on First Release Candidate.			
MS#24	**Production - BETA 2**		4/15/2011	$262,500
PS3/360 BUILD	• The game is submitted to Final Test and/or First Party Standards for final verification.			
MS#25	**GOLD MASTER CANDIDATE & ASSET ARCHIVE DELIVERY**		5/7/2011	$261,500
ASSETS	• Final asset delivery, including source code and all game data.			

Continued

In most cases, the length between milestone deliverables is about a month. Milestone submissions are delivered by the internal (dev) producer and handed off to the external (pub) producer, which is when the diligence and review process takes place and approvals are made; ultimately after the publisher producer, senior producer, management, legal, and accounting departments have all given their stamp of approval, the milestone is officially approved and payment is then processed for the development team.

Working With Your Publishing Counterpart

The dev producer and publishing producer have a symbiotic relationship that takes patience, understanding, and commitment to champion what both feel is best for the game. If not carefully managed and nurtured, this relationship easily breaks down, which will only make the process more painful for everyone involved. It's important for each producer to put him or herself in the other's shoes. As a development producer, you may see a new and risky feature as innovation fundamental to the gameplay. The publisher may see it as an unproven and unfounded risk whose cost could balloon out of control.

FIGURE
2.5

Disagreements like these should be kept to the TV screen.
Image Courtesy of: "Batman Arkham Asylum" WBIE.

Debates will be had, but a mutual respect must be maintained as it will be up to both producers to come to a conclusion that is best for the game. Far too often the dev producer sees the publishing producer as an obstacle rather than an asset, after all, they are not in the trenches with you sloshing through the day-to-day development of the game, yet they stand in judgment of your team's hard work. This may be how it feels, but only for those who do not truly understand what a publishing producer brings to the table and must deal with on their end.

The most common place for things to go awry between the dev producer and publishing producer is the budget. The dev producer can feel as though the publishing producer is asking for the stars and the moon, but only willing to pay with the tightest of budgets. "We want innovation! Competitive features! More levels! More models! More! More! More!" yet they aren't willing to flip any extra coin to pay for it.

This is of course just how it feels, but if you're on the publisher's side it sounds more like the developer is saying "Well sure we said we could do this ambitious of a game, but that was just to get you to sign on the dotted line. Now that we're pregnant with the game we're gonna throw some hidden costs at you. Oh, you want co-op? Yeah, sure it's in the contract, but it'll cost ya another $35,000 if you want it to actually work."

For your publishing counterpart to go ask for extra funds, especially for something that was agreed upon before a budget was set, is one of the most dangerous and damaging circumstances for both of you. Some serious justification, a change in the technology, or something unforeseen is the only acceptable explanation and these still require extreme justification as the change can severely affect the P&L. Long-term dev–pub relationships have been permanently damaged due to this and it should be avoided at all costs.

FIGURE
2.6

Producers have often been called to heroic tasks.
Image Courtesy of: "Batman Arkham Asylum" WBIE.

Unfortunately some things can't be foreseen and—whether it's a change in the scope, new features, or one of those unforeseen circumstances popping up—development and publishing producers must figure out the best and most efficient solutions when it comes to asking for a change in the budget. Sometimes it has the publisher seeking additional budget for the game, something he must believe in and prove the justification for. Other times it requires that the internal producer relocate resources to accommodate the extra costs, or even worse, bite the bullet and ask the developer to pay for the costs out of pocket. The latter typically only happens when the developer is not living up to their prearranged agreement.

CHAPTER THREE

Producing at a Publisher

Just as a developer needs a producer, so does the publisher. The publishing producer is someone who not only knows the development process, but the business, politics, branding, and trend side of the industry as well. This producer must be thorough and attentive to not just the developer's needs, but those of operations, business development, legal, marketing, PR, sales, licensors, legal, and corporate investors. External producers aren't simply shepherds of the project to see it onto store shelves; they are an important part of the gameplay, creative, and branding sides. They need to be a strong partner, shielding the internal producer from the political storm that can damage the game and the team.

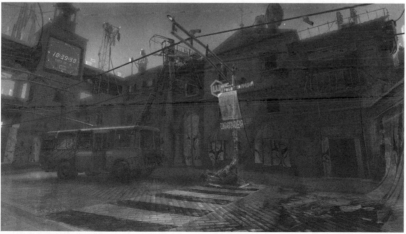

FIGURE
3.1

The countdown begins when the producer gets the thumbs up to proceed from corporate.
Image Courtesy of: "Tango Down" Zombie Studios.

When working on a game it is best for both the development producer (internal) and publishing producer (external) to be passionate about their project, or at least about their jobs. This passion gets everyone to put their heart, soul, and time into the game, which can create just as much friction as it does camaraderie. To maintain a good balance there should always be constant communication between the two. Almost daily e-mails and weekly calls are a must for both sides to stay informed and alert to the game's progress and needs.

Managing Schedules

Just as the developer needs to make sure that production stays on track, the publishing producer is charged with managing the overall schedule of the entire project. The overall scheduling typically starts with the external producer, who is responsible for evaluating the length of a project and determining how long it should take to develop. This of course is an ideal situation, as much of the time is dictated by the production slate, and in cases of games based on film licenses, how much time you have before the release date. To do this the external producer must balance the release date, devise what scope and size of the game is realistically achievable, and determine the budget needed based on both time and ambition. This is never an exact science, but with experience and foresight, a detailed schedule that reflects what it will take to develop a game emerges, drawing a map to the ship date.

Not only does the external producer strategize the length of the production cycle, but they must balance all of the other timelines that make up the master schedule. This includes operations schedule, localization, QA, marketing, PR, and sales.

Managing the Budgets

In addition to ensuring that the game stays on schedule and is of high quality, one of the more important aspects of producing a game from the external perspective is the accountability of the game's budget. The external producer is responsible for making sure that the budget adheres to and reflects the profit and loss (P&L), a figure that is determined with sales and finance, based on how many units of the game will have to sell before it becomes profitable. The P&L becomes the budgetary bible of the project. It's up to the producer to make sure that enough is allotted to allow for game quality, while still making it a viable investment for the publisher.

Although the final P&L calculation comes from other departments, the producer needs to be as active as possible so the game gets what it needs. Remember, if they come back with a number so low it would be impossible to make a proper game, the responsibility to try and make it a success lies squarely on your shoulders, so be realistic, but shoot for as high as you can get. The base number for the P&L calculation should be one you've supplied that takes into account the complete costs of production, which includes more than just the game's development.

Reviewing Milestones

When a milestone submission comes in from the developer, it's the external producer who receives and reviews it, taking an analytical view of what's been presented to check that things are moving in the right direction, checking for quality content, and making sure it represents the shared vision all parties have agreed upon.

The very first step you should take as publishing producer is to make sure everything that was defined in the milestone deliverables is present. The deliverables are a sort of checklist of items representing the work that has been accomplished by the team. Although the milestone is flexible up to a certain point in production, it is part of the contractual agreement with the developer, so the entirety of the deliverables must be present to ensure the developer's payment is approved and processed.

In cases where the publisher is driving the creative or brand, the external producer will most likely be the one providing the creative input and direction, which will also be included as part of their review of the milestone. When reviewing a milestone, you will not only depend upon your knowledge of production, the schedule, budget, and business, but your knowledge of what makes for an engaging and enjoyable video game, visually and in gameplay.

Managing Approvals

Once you've ensured all of the deliverables were submitted and you've completed your review of the milestone submission, you will usher it through the internal approval process. For the majority of publishers it is required that key team members, executives, and stakeholders review specific portions of and/or all of the milestone submission and provide approvals, for which the developers' payment is based. These team members will rely heavily on the opinions, feedback, and direction you provide in your initial review, as you are closest to the game than any other member of the publishing team.

The process varies from publisher to publisher, but the review should start with the producer, who provides the visual portions to the art director and the technical aspects to the tech director, who review in tandem. From there depending on the publisher's established process it goes through the pecking order from the senior and executive producers, legal, finance, and if over a certain dollar amount, sometimes the president, VP, and/or CEO of the company, all of whom must review and approve the milestone before payment can be processed.

Managing Testing

Once a game has been through about two-thirds of production, it's time for the publisher to start having builds tested. While the developer should already have one or two testers on staff, it's important for the publisher to start getting into the habit

FIGURE
3.2

Precise aim is required if you want to hit your target.
Image Courtesy of: "Wanted Weapons of Fate" WBIE/Universal.

of testing as well. The testers are part of the QA group, who scour the builds for bugs and issues that could negatively impact the player's experience, bring down review scores and prevent the game from getting approved by first parties.

While the producer doesn't necessarily manage the testing of the game itself, they will work with the QA leads in reviewing the progress of the testing, making sure all of the issues that would prevent first party approval have been taken care of and sometimes using them as a gage for the gameplay balance and quality, as the QA team will be playing the game more than just about anyone else by the end of production.

In crunch mode, the producer should be working right alongside the QA team, not only helping them to check for bugs, but clearing out the bug database of issues that are no longer pertinent, and ensuring QA gets the latest builds as they come in.

Support: Sales, Marketing, and PR

A game cannot be sold on quality alone, as a matter of fact, there are several innovative and critically acclaimed games that are simply overlooked for lack of solid marketing, PR, and sales teams behind them. The video game marketplace is extremely competitive, with publishers fighting for shelf space and the attention of consumers. If these groups do their jobs right, the worst game ever made can stand out as in-demand. The bigger the hype, the more awareness, more curiosity, and if the campaign is impressive enough, it can even increase review scores as everyone gets caught up in the excitement, even if the product itself is not worth it.

FIGURE
3.3

The Facilitator.
Image Courtesy of: "Wanted Weapons of Fate" WBIE/Universal.

A game without a strong sales, marketing, and PR plan behind it is rarely successful. If no one knows about your game, then there's a good chance no one's going to buy it. Marketing handles everything from online, print, and television advertising to the games' websites, packaging, cross-promotions, and sometimes trade shows. PR is primarily in charge of press, news bites, viral campaigns, and simply getting the word of mouth out there on the game. Sales takes what all the teams have put together and pitches the game to major retailers, convincing them that, among all the competition, your game is one they want on their very limited shelf space. As there is quite a bit of overlap of responsibilities in these three divisions, the groups must work closely together to create and execute their plans, and all of them should be working closely with the producer.

Regardless of how strong and knowledgeable these teams may be, they aren't the ones actually building the game, and are often promoting numerous titles at once; it's unrealistic to expect them to be as knowledgeable on the game as you are, so it's the publishing producer's job to provide the necessary information that these teams need to devise the best plans and strategies. Throughout the production of the game, you're required to provide marketing, PR, and sales with the status of the game with regular information updates. You'll also be expected to provide a steady stream of screenshots, info for press releases and fact sheets, supply website content, record playthroughs of the latest builds for sizzle and sales videos, and sometimes demo those builds for both press and potential retailers. Although marketing and PR often organize and run the publisher's booth at tradeshows and events, you'll need to work with the developers in preparing demos, videos, and screenshots, with both

yourself and members of the dev team on the floor demonstrating the game for the folks passing by or those curious to play the demo themselves.

Working with Stakeholders

If your game is based on a movie, TV show, comic book, or other established story, then you'll need to work closely with the group that owns the property, called the licensor. While for you the game's success is of the utmost importance, for the licensor, protecting the integrity and quality of their brand is more important than all else, including your game. Even if you're a big fan of the property, the licensor will always know it better than you, or at least how they want it perceived at the time, so to maintain control over their property, it's baked into the licensing agreement that they must review major aspects of the game.

FIGURE
3.4

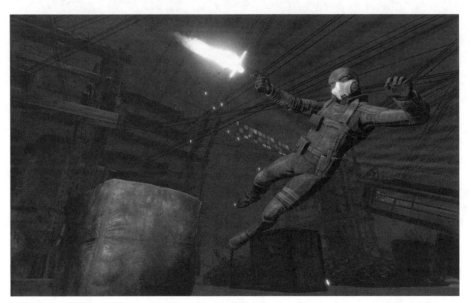

This game "Wanted: Weapons of Fate" is based on both a film and comic book which was licensed to make a video game. This means that there are stakeholders on both the film and comic book side that are involved in making sure the game is in alignment with their brand. Image Courtesy of: "Wanted Weapons of Fate" WBIE/Universal.

The best way to handle licensors is to make them as comfortable as possible with you as the producer right up front. The goal is to calm any and all concerns over having you oversee their interests as well as the game and trust that they have placed it in good hands.

In addition to the licensors, you may also be working with the creative forces behind the property, such as filmmakers, writers, producers, actors, and creators. This can be both a help and a hindrance as the license often requires their approvals on the game content. Because these creative professionals often have insight into

what is happening with the property outside of the game, collaboration with them can lead to access to film and television assets, animations, models, and narratives, all of which will only benefit your game.

Although they can be very helpful in getting you information that you need, it is rare to find a creative stakeholder who is helpful to the actual content of the game. We promise, they do exist and have provided some terrific input into games, however, often you'll find that a filmmaker who is excited and wants lots of input in the game can be just as damaging to the product as one who has no interest at all.

Overall, if the relationship is managed well and you've proven to them that you're the best to handle the game, these stakeholders can be a valuable resource and should be utilized for the strengths they can provide.

Supervising Audio Production

There are three main elements that go into audio production of a game.
They are:

- music
- sound effects
- voice-over

Music in a game sets the tone for the entire experience. The first few bars in a piece will instantly evoke an emotional reaction to what is happening in an area in the game. It's important to find a composer for your game whose work and mindset are in alignment with the direction you want to take the game. Once the composer's

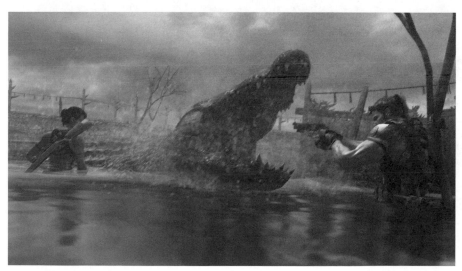

FIGURE
3.5

A scene like this is a ripe opportunity for sound design.
Image Courtesy of: "Resident Evil 5" Capcom.

25

been secured, the producer needs to work with them on the feeling, mood, and tone that should be impressed upon the player throughout the game.

It's a good idea to gather existing music you feel has the right sound and tone, then edit it together and provide it to the composer as direction, not in regard to the actual notes they'll be writing, but to show the impact you want the music to provide. Often this is already done by the developer, who may use placeholder music in the milestone builds.

Sound effects are also vital to a successful title. As audio capabilities in consoles and sound systems at home advance, sound design in games now rivals that of big-budget Hollywood features, and great care is given to make sure the sound landscape equals and enhances the visuals and emotional impact of the game.

Voice-Over

Voice-over (VO) is the audio recording of the game dialogue, which includes characters and narration. This gives the characters a "voice," the human element that brings the game to life, and the most effective way of communicating information to the player. Although the VO itself is written and recorded by other team members, mostly independent contractors, it is the producer's job to ensure that the quality of the written dialogue and recordings are of the highest quality possible.

FIGURE
3.6

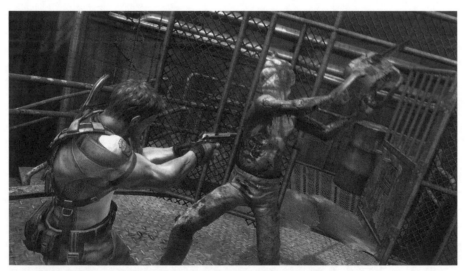

Sometimes even a vocal hit reaction can communicate intensity.
Image Courtesy of: "Resident Evil 5" Capcom.

The best VO recordings are ones the player doesn't notice when playing the game. It's only when VO is executed poorly that it stands out and can actually ruin a perfectly good game experience, or worse, make a dramatic game sound

unintentionally comical. Some of the absolute highest quality games with terrific, groundbreaking gameplay have been severely damaged by bad VO. Not only does this need to be managed by the producer during the actual VO session, but also at the writing stage. Make sure you have a wide variety of one-liners and alternate dialogue; otherwise your characters will be repeating the same lines over and over ad nauseam. Although it is important to manage all of these stages, you still need to allow a balance where the director, audio engineers, and writers have breathing room to do their jobs comfortably, otherwise you're not likely to get their best work.

In addition to quality writing and recording, it's important to select actors that can pull the human element of the characters off. Actors that are good in a movie or on TV might not be the best when recording dialogue. The producer should be involved in the casting of all primary characters, and unless it is a name actor you're specifically going after for notoriety, you should be listening to auditions or demo reels in selecting the best talent possible.

Contractors

Often games require talent that comes outside of the development team and publishing. Whether working with an actor, a composer, or a writer, the producer is going to need help in finding the talent they need and securing them for the duration of the project.

There are numerous talent agencies and management companies with game talent as their clients. Working with these agencies, the producer can arrange introductions and meetings with outside talent. The agencies will match you up with

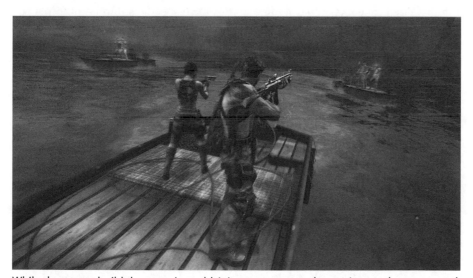

FIGURE
3.7

While dev teams build the game's world. It is contractors such as writers and composers that make sense of it all for the player and deepen the experience.
Image Courtesy of: "Resident Evil 5" Capcom.

a selection of clients that align with what you are looking for in both content and cost. Even if the task of hiring talent is delegated to another team member such as the creative director, it's important that the producer remain involved as much as they can because they know the game better than anyone.

When working with licenses, especially with film and television, there is often pressure to hire the film or show writer(s) for the game. This is typically a bad idea. Game writers hold a very specific skill set that film and television writers usually lack experience with. Game writing cannot be approached the same way as screenwriting; games require not only 10 times more content, but are compiled in a completely different format than a screenplay. No matter how hard you try to prepare screenwriters for what is to come, they rarely comprehend the monumental task of writing a game. If you're in a position where you are required to use the film or television writer, be prepared to have another writer on hand to complete all of the work the primary writer isn't able to do and to reformat their work for what production, VO recording, and the localization team needs. Although the film and television writers might not be the ideal choice for actually writing the game itself, they can be a valuable asset when it comes to characters and narratives, so you may consider contracting them instead as creative consultants and hire a separate writer who specializes in games.

Prep for First Party Submissions

As it's the publisher who has the license with first parties to release the games on their respective consoles, it is also the publisher who must submit the build to those first parties for approval. This starts as early as the pre-production stage, when you submit fully vetted concepts. Typically first parties have specific submission forms you must fill out that focus on items they deem important. Remember, a console is only as good as the games released for it, so first parties police the content closely. Everything from age range, story, gameplay, and genre are examined and commented on.

FIGURE
3.8

Stay on top of your submissions. You don't want to miss the boat.
Image Courtesy of: "Resident Evil 5" Capcom.

Often you'll be required to resubmit your concept with either changes and/or feedback in response to the first party comments. The biggest pitfall in reviewing the feedback from first parties is fully understanding and differentiating between mandatory changes and opinions, and there is nothing wrong with asking for clarification when providing your notes back to them.

After the pre-pro stage of development, it is highly recommended to submit your Game Design Doc, concept art, and a recording of any prototypes built to first parties so you can gain early feedback and approvals on the game's direction. This type of communication can prevent issues down the road such as having to make dramatic changes after the point of no return.

Some first parties require a temperature check submission of the game code approximately six months into production. This is to give them an idea of how your concept is being executed, what has changed since the early concept stage, and if it's going in the appropriate direction for the platform and their business model.

At the final stages of production, your biggest challenge is the submission of the Game Master Candidate (GMC). This is what can make or break your game and ship date. It's a huge undertaking that requires months of planning and lots of process. You'll be provided a checklist of items to ensure that your submission is compliant with first party standards. Along with the list you'll be providing to first parties code with as many bugs fixed as possible, a bug report outlining the issues that are still present, the game rating (ESRB) certification and put it all in a neatly organized package that is designed to make it as easy as possible for the first party's review. Always be prepared and scheduled for a resubmission or two in case of a rejection, even with the highest of quality games.

Once you've received an approval on your GMC you will be "going gold" and supply your final approved code to first parties for manufacturing, referred to as the Release Candidate build. To prevent piracy and unauthorized game releases, all first parties mandate that they manufacture the retail version of the game. The final code will be delivered from the developer to the publisher and it's the producer's responsibility to ensure the code is an absolutely perfect and clean version of the game as this will be what hits store shelves. Once the Release Candidate has been thoroughly checked, it becomes the Release to Manufacture (RTM) build, which can be delivered either physically on disk or electronically to first parties for manufacturing.

CHAPTER FOUR

Producer Roles

Producing a Next-Gen console game is a monumental task, so it is ideal for a fully structured production team to be in place, with the executive producer as the senior most member, followed by the senior producer, then the producer, with the associate producer and production coordinator or assistant producer as the junior most members of the team. The actual duties for each of these production roles vary across companies.

FIGURE
4.1

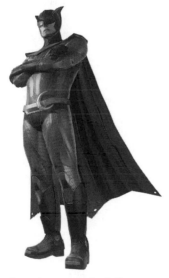

A good producer stands vigilant.
Image Courtesy of: "Watchmen" WBIE.

As we discussed in the first chapter, the basic job description of a video game producer is that of managing and overseeing the production of the game. On the development side, producers supervise the day-to-day aspects of the development, and on the publishing side they handle everything else that is necessary to get the game approved, promoted, and on shelves. Regardless of their level and title, producers must have ownership of scheduling, budgeting, team management, troubleshooting,

liaisons with stakeholders, and of course, quality. While the duties of each level of producer in the team are not identical between different publishers and developers, what's key in differentiating between the levels is experience and how hands-on they will be with the production of the game. Regardless of which member of the production team owns these various tasks, the one thing that can't be assigned is experience.

The primary responsibilities of the producing team are ...

Budgets: Determining a clear dollar amount the game will cost to produce. This includes not only the development amount to create the game, but the above-the-line items such as cinematics, music, voice-over, etc.

Schedules: A timeline of the production cycle broken down into tasks and their delivery dates, structured so that each discipline can be achieved. The production schedule should also reflect the timeline of non-production teams such as operations, marketing, PR, and sales to ensure that all initiatives are being accounted for.

Staffing: A staffing "man-month" plan that breaks down each discipline needed for the game. This affects both the budget and the schedule, so it is important for the senior and executive producers to be involved and approve. Often a producer evaluates existing team members and potential additions to ensure their skill sets match the end goals of the product.

Managing: Overseeing everything from the big picture to the day-to-day aspects and progress of the game. The producing team needs to manage each individual aspect of the game's production to ensure all facets are working correctly, the quality of the product is at the highest possible, and to guarantee everything is running smoothly, and if not, have the knowledge to troubleshoot and resolve issues as they arise.

Creative: While the responsibility of the game creative varies amongst teams and companies, it is always the producer's responsibility to uphold a single creative vision across the entire team to ensure all aspects are in alignment with the same style, direction, and quality. In addition the producer must have a strong sense of what has the makings of a good game, which is often more important than having a good grasp of narrative and visual style. After all, what's a game without good gameplay?

Executive Producer

At the top of the production chain, the executive producer (EP) is the final voice in decision making, as inevitably they are responsible for the team reaching their goals and shipping the game on time and on budget. The EP is the one who communicates directly with corporate and provides them with status updates, including if the game is tracking properly and to justify an increase or change in budget or scope.

A proper EP serves as both leader and mentor, providing the support and guidance needed to enable the team to work at their best capacity. As EPs have the most production experience, it is their knowledge which will catch errors, oversights, and clear the path to avoid pitfalls down the road. To do this they must

FIGURE
4.2

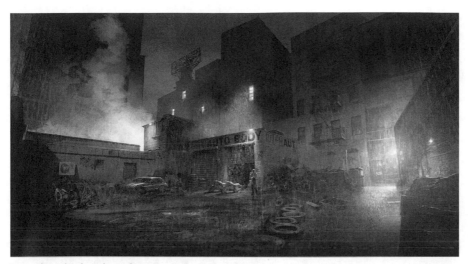

It can be a bit lonely at the top.
Image Courtesy of: "Watchmen" WBIE.

examine, provide input, and approve all aspects of the game including budgets, schedules, assets, and deliverables.

Typically an EP oversees multiple titles and teams, planning and executing an overall production strategy based on the slate and goals of the company. They work with the other departmental executives to craft an overall vision and slate that will leverage their placement in the market. This dictates what projects they take on, the release date of each, and the genre, style, and approach for every project.

Senior Producer

The senior producer (SP) is the captain of the ship, providing the guidance to steer the production team in the right direction, and is responsible for the day-to-day happenings on an individual project. They are the highest level of the production staff working in the trenches, backing up their producing team and making the tough decisions when problems arise. The SP should always be involved in the decision-making process to confirm that all bases are being covered, and be able to step in when high-level issues arise beyond the control of the primary producer.

The information conduit for marketing, PR, and sales regarding the game should be through the SP. Although these other groups need to have up-to-date information on the game, too much can create just as many problems as too little, so the SP should be able to control and properly explain the updates and assets they are seeing. To do this effectively, the SP also needs to communicate regularly and effectively with the production team, requiring weekly updates, status reports, and daily discussions with the producers they are overseeing.

FIGURE
4.3

It's sometimes a thankless job.
Image Courtesy of: "Watchmen" WBIE.

Producer

If the senior producer is the captain of the ship, then the producer is the first lieu-
tenant that is in the field working with other leads on the project on a day-to-day
basis, making sure that the game development process runs smooth and efficiently.
The producer works the closest with all aspects of the production team and, along
with the creative director, should be the one to have the most knowledge of the
game. The producer is just as much a resource to the team as they are a manager,
keeping the production organized and the information flowing, and providing the
team with any support or materials they need to properly perform their duties.

As each element of the game is completed, the producer must review and
approve the deliverables making sure they are at an acceptable level based on the
goals of the project do not contain any feature leaks and will be an engaging expe-
rience for the end user. The producer is also the gatekeeper of these assets and
should only allow materials that they deem acceptable through to the next stage of
the approval process. If the producer is not satisfied with a deliverable and deems
it unapproved, they need to document their feedback clearly with solutions to any
issues. Never come to the table with a problem unless you also have a resolution to
recommend.

Aside from management and support, the producer is a troubleshooter, know-
ing the warning signs that might spin into a problem down the road and heading
them off at the pass. A producer needs to be able to identify red flag items as well
as check for content that could negatively impact legal, stakeholders, or approvals
from outside entities such as first parties and the ESRB.

This doesn't necessarily mean the red flagged item shouldn't be approved, but when moving on to the next stage of the process, the item of concern should be called out, along with a determination of the best strategy to resolve it.

FIGURE
4.4

Often the producer must fight alone to get with the game needs.
Image Courtesy of: "Watchmen" WBIE.

Although the majority of game production sits with the development team, there arc several aspects outside this realm such as vendors, writers, composers, voice-over talent, consultants, and license holders. The producer is tasked with working both internally with the dev team and externally with these outside groups to harmonize their contributions to the production efforts. It's important for these contractors to have a single point of contact to avoid confusion, to share the same vision, and for their work to compliment the product.

When the QA stage of the production begins, it is the producer who orchestrates the plans with the QA leads and provides the most accurate builds along with test plans and a walkthrough of the builds contents. As the build is being tested, the bugs are logged into a bug report program; the producer reviews the bugs and prioritizes which fixes take precedence. QA can easily fall apart and create serious delays and inaccurate bug reports if too many cooks are in the kitchen communicating with contradictory information. For example, if builds are coming in from multiple sources, they can easily get mixed up and the QA department might end up reviewing the wrong build, which can cause severe repercussions, losing a day of work or more at a critical time in finalizing the game.

Associate Producer

Think of the associate producer (AP) as an apprentice. They work closer with the producer than any other team member and support them in all efforts. As there

are far too many tasks for a producer to handle alone (though many often have no choice), the AP takes on responsibilities delegated to them that the producer either doesn't have time for or assigned so that the AP can learn and eventually take over a particular duty.

Often the AP isn't just the support mechanism for the producer, but for the whole production team. While the producer is dealing with the individual team members and leads on bigger issues and needs, the AP works with them for the smaller, less weighty items such as acquiring tools and providing resources, research, documentation, and reference materials. On matters of higher urgency and cost, the producer may go to upper management seeking an increase in budget, but going through the exercise of finding, researching, and acquiring the item needed will fall into the AP's responsibilities.

FIGURE
4.5

Being resourceful with technology can get you ahead.
Image Courtesy of: "Watchmen" WBIE.

The producer and AP should be in constant communication, with the AP having enough skills and knowledge to take over if the producer is not available or out of the office. This often requires stepping up to the plate and instilling confidence in the team members. A well organized and dependable AP will eventually be able to cut their teeth on a smaller project, or portion of a project.

Production Coordinator/Assistant Producer

The most junior member of the production team is referred to as the production coordinator or assistant producer. Many PCs are former testers, just out of school and/or are new to the industry and looking to start a career in game production, but if you're the latter, it's advised to gain some real-world working experience before

trying to take on a PC position, as you'll need the professional experience. Yes, this is the lowest producer tier, but it is also a role that requires extremely high organizational, reporting, and communication skills.

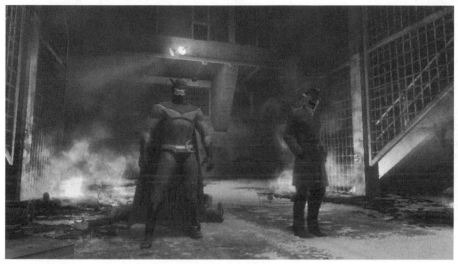

FIGURE
4.6

Working together, there's nothing that can stand in the way.
Image Courtesy of: "Watchmen" WBIE.

The PC role serves as an introduction to the world of producing video games and with it comes many of the tasks of keeping elements of the project organized. Regardless of the level of this position, the PC has many important responsibilities.

In addition to supporting the AP and producer for tasks, reporting, status updates, and research, the PC wrangles game assets and secures reference materials, then organizes it all in a structured system to track each asset and element. Although asset gathering and organizing might not seem like the most glamorous job in the business, it's extremely important for the production process to move in a steady and continual flow, without any delays caused by trying to find a misplaced item or track down reference materials.

While the role of a PC is important, they often have to take on the busy work that the AP and producer don't have the time or bandwidth to deal with. These feel like small tasks, and many are, but they are all important to the creation, development, and organization of a game. For example, during team meetings the producer and project leads will already have their hands full running the session, so the PC will be responsible for taking notes and providing a summary report to all pertinent parties, which loops everyone in and creates a record of what was discussed to prevent information from getting lost down the road.

The PC also works as a second pair of eyes when reviewing some of the larger portions of the game, such as playable builds. As many PCs come out of testing, they are typically gameplay experts and can provide valuable input to the AP and

FIGURE
4.7

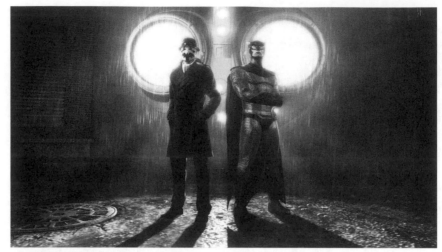

It's always a team effort.
Image Courtesy of: "Watchmen" WBIE.

producer on the quality of the gameplay and where it might be lacking. If a former tester has trouble completing a level, the end user certainly won't be able to either.

Other Producer Roles

At the larger publishers and developers, you may run into situations where the projects are simply too big for a single producer to manage. In these cases the producing duties are broken out by discipline, with unique producers who manage specific areas of experience.

FIGURE
4.8

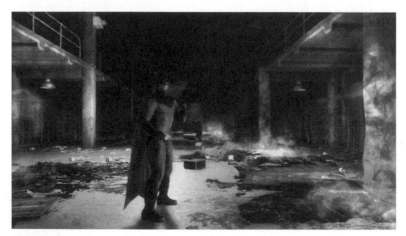

There's no producer role that is too small.
Image Courtesy of: "Watchmen" WBIE.

Localization Producer

For the game to release in non-English-speaking territories, all of the dialogue and on-screen text needs to be translated into a separate language and implemented into the game code. There are so many facets and parties involved in localization that it is very much like managing an entirely separate product, pulling the producer's attention away from the lead SKU. Because of this, some larger publishers secure a localization producer.

Localization is managed on the publisher end with the localization producer working with both the pub and dev teams in order to ensure that the game code is structured to allow both the translated VO and text to be switched out without major difficulties or negatively impacting other parts of the code. This takes a lot of planning for both the developer and localization producer, who has to create a localization schedule within the existing development schedule, making sure the dev schedule has all dialogue and text locked early enough for it to be translated, recorded, and implemented before submitting to first parties for approval.

FIGURE
4.9

You never know where your game might get localized next.
Image Courtesy of: "Tango Down" Zombie Studios.

The localization producer manages the translation of the in-game dialogue and copy, the process of supervising localized VO recordings, and reviewing its implementation for accuracy. They also need to be familiar with the laws of each territory and all first-party guidelines to make sure the game doesn't unintentionally violate any local regulations or first-party restrictions.

FIGURE
4.10

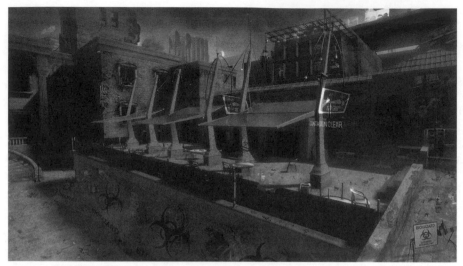

You never know where your game might get localized next.
Image Courtesy of: "Tango Down" Zombie Studios.

Cinematics Producer

Depending on the style and budget of the game, cinematics can play an important role in conveying story and emotions. Often the cinematics are on a grander scale in visual quality and motion than the in-game elements themselves, with cinematics now reaching the scale of big-budget animated films. As with animated features, these cinematics need a producer to manage their development. While large publishers sometimes have a full department dedicated to cinematics, many companies outsourced the task, but on either side a producer is necessary. With full teams of artists, animators, and engineers all striving towards building highly polished work, the cinematic producer oversees tasks within production similar to those the game producer handles, including budget, schedule, scope, and management of the production process itself.

Licensor Producer

A good licensor producer holds a multitude of tasks, just like any other producer. They should be as knowledgeable about the development process as a publishing producer is, as well as a conduit to key materials, and should uphold the branding guidelines that the publishing and dev teams must adhere to. The licensor provides brand assets such as film footage, images, designs, logos, stats, performing talent, likeness, voice-over, and everything you need to make the game look and feel just like the brand on which it is based.

FIGURE
4.11

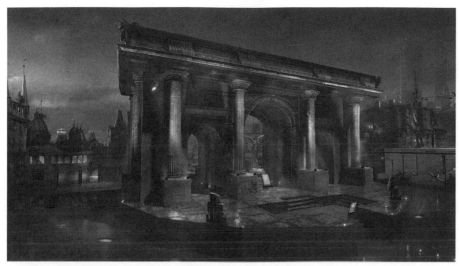

Locations like this are an excellent backdrop for cinematics.
Image Courtesy of: "Tango Down" Zombie Studios.

The licensing producer reviews all materials related to the game and brand to guarantee it is in alignment with how the stakeholder wants their property to be interpreted in terms of both quality and content. Because they must loop in all business and creative parties involved, a review that is both lengthy and intense, it's imperative to keep the licensing producer up-to-date on the product and production, to make sure all submissions are clear and organized, and ensure that all previous feedback is spoken to or adjusted for the next submission. Otherwise, resulting problems can cause delays and frustration on all sides.

CHAPTER FIVE

Size and Scope: Large vs. Small, Licensed vs. Original

FIGURE
5.1

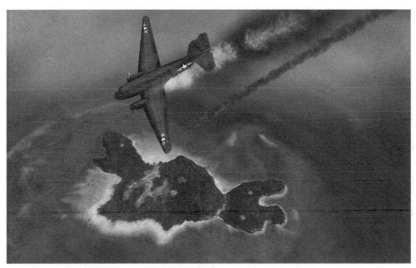

Size and scope affect both the schedule and the budget.
Image Courtesy of: "Battlestations pacific" WBIE.

As Next-Gen systems drive up the required technology for scope and visual resolution for console games, larger teams, higher budgets, and longer, more intense production schedules are becoming a requirement to properly compete in the marketplace. Every game has different budgets, schedules, and team sizes that affect not just the ambition of the project, but the overall quality of the game. If the original plan is to have a small title, then a modest-sized development team should be

approached with an appropriately sized budget in tow. If you're seeking to make a larger, more elaborate title, then you should be prepared to spend tens of millions of dollars and have a larger developer on deck. In cases where the developer is already attached, the size, type, and costs are based on the resources at hand.

While there are high-end games with big budgets and long production cycles in development, they don't guarantee that the outcome will be a AAA-quality title. The quality of good gameplay is based mainly on talent and time. Smaller dev teams and leaner budgets are often forced to take a more creative approach to the project and design, finding unique ways to engage the player without draining the financial pool.

Large, or small, it's how you leverage the resources at hand, utilizing the team to its fullest potential, but even the most efficient use of resources cannot save a game from the one thing that, without fail, causes unavoidable damage to a project: too short of a production cycle.

Team Sizes

Depending on the type of game being produced, the development team sizes can vary from a handful of members to an enormous staff stretching into the triple digits. Obviously, as the team size gets larger the producer will have a tougher time managing such a massive number of individuals and become more dependent on their team leads. The more people you have on the team, the more you'll have to juggle personalities, task sheets, schedules, and performance, as making sure everything is orchestrated correctly is the task of the producer. In some cases, multiple producers are assigned to a single title, each owning a different portion of the production.

Larger vs. Smaller

Having a large team on an ambitious project allows every discipline to be covered with 100% attention, as team members don't have to be concerned with multiple duties and are free to craft their work as close to perfection as the tools at hand and their skills allow.

So, do you want to go large when you're trying to develop those AAA titles that every industry pro dreams of making? Not necessarily. When it comes to creativity in gameplay, strong communication, and close teamwork, bigger isn't always better. It wasn't until the recent advancement of console technology that team sizes have grown into the large numbers that they are today. One of the big misnomers about video game production is that adding more bodies to a project can solve any problem, including a short production cycle. Games take time to make, no matter how many folks are added. Although it's preferred to have a reasonably sized team, an overstaffed project causes communication breakdowns and a lack of unity across the team.

The biggest challenge of a small team is bandwidth. Team members have to take on many more duties than they would on a large team, and work much harder with longer hours. The small team, however, does have some advantages over the large. There is more familiarity among team members, and a sense of camaraderie can be established through their shared experiences. Communication is much easier with a small team because there aren't so many entities to loop in, plus direct individual communication with fellow team members is easier when they are just down the hall instead of on a separate floor or in a different building entirely.

Nate Birkholz, Producer

"A smaller team is more reactive and flexible than a larger team.

Smaller teams allow the team members to have a better idea of the big picture and feel more invested in the project, as well, and can foster a greater sense of camaraderie than on a big team."

Big Budgets

While a large budget solves a lot of problems for producers and the team, it can also create just as many headaches that prove money doesn't solve everything. Large budgets allow you and your team more flexibility to get what you need and then some. There are less shared resources and equipment, plus you can leverage better technology and afford middleware solutions that can cut down on the time it would take to create the tech in house, and allow your game to look slicker and feel grander.

Big budgets also bring big names that will add value to your title. Famous writers, actors, designers, and composers costs big bucks, as their stamp on the game as well as their name, will help sell the game. Sometimes they aren't even hired to work on the production itself but to "consult" by adding story, design, and imagery recommendations early on, which allows marketing and PR the leverage of name recognition. It's an unfortunate truth that the money for this comes out of the production budget, when it is really marketing- and PR-focused, but with a big budget it's affordable and only adds value to your game.

While outsourcing is typically a cost-saving measure, there are some areas where it's actually more expensive, specifically in those cases where you're seeking specialty work outside the realm of the developer's capabilities. The most common of these is outsourcing the cinematics to an animation studio. Visually rich cinematics can be used for far more than just giving the game an epic quality and feel; they can be used as a way of promoting and marketing the game.

FIGURE
5.2

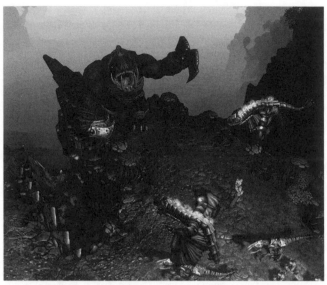

You never know what challenges you might face if you don't plan.
Image Courtesy of: "Battle Forge" EA.

The same problems arise with big budgets as would with any high-cost investment: overinflated expectations for success. The publisher has more riding on a costly game and is going to put more focus and micromanagement into each aspect. Upper management tends to also be more involved and have a greater say in the direction and content of the game, basing it more on marketing analyses than on innovation and creative ideas. The other major problem with a big budget is that everyone has their hands out for a piece of the action, causing quite a bit of wasteful spending and unnecessary resources.

The biggest woe for a producer is the pressure for the game to be a hit, as success has many executives, but failure has the producer standing alone, taking the full brunt of the blame. Big budgets equal high risk, and a bomb could hurt a publisher beyond repair, so they put all of the expectations to make it a success on the back of the producer, because after all, that is the person who oversees the product.

Small Budgets

When dealing with the challenges that come with a small budget, it may feel like you never seem to have enough to get what you need, but there can be benefits from this. Projects with small budgets allow for more creative challenges and freedoms to find alternate solutions, resulting in better gameplay. Less upper management involvement gives the team breathing room to innovate and experiment.

The drawbacks of a small budget are pretty obvious, from understaffed resources to an increase in work and hours. A small budget forces team members to share tools and resources, which affect the schedule and forces feature and content cuts.

While publishers allow more freedoms for lower-budgeted games, they also tend to lend less support, so you're not as likely to get a resource, or tool that you need, because it's not worth the cost to the publisher.

Aside from the resource challenges, you also need to be concerned with reputation. Even if all your games are big financial successes, if you're making low-cost titles you might be perceived as a "budget" developer and/or publisher, which can cost you everything from shelf space at the retailer to missing out on bigger, more ambitious games and licenses in the future.

Long vs. Short Schedules

Nothing could be better on a production cycle than having a nice long schedule. After all, the longer the schedule the more time there is to focus on individual tasks and the plan and scope of your project, and there are less intense crunch modes so the team can better invest its time on polish and bug fixing.

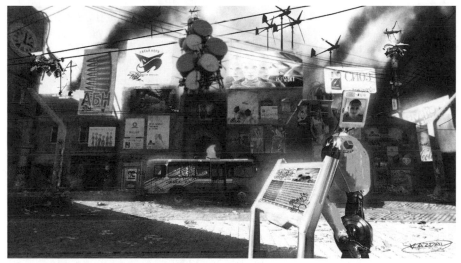

FIGURE
5.3

Planning in the concept stage helps minimize having to spend a lot of money later. Image Courtesy of: "Tango Down" Zombie Studios.

A full production cycle is what every producer strives for, but too much time can be almost as bad as too little. The longer your development cycle, the more costs the game incurs; if this goes on for too long it can make it impossible to recoup those costs of the production, no matter how many units are sold.

The other problems with a game that has an overly lengthy production cycle is that it can miss out on its market as trends in the industry constantly shift, plus it sends a message to the industry that your game may be troubled or is being mishandled.

We'd like to tell you some of the benefits of a short production schedule, but there simply aren't any, aside from leveraging a film release or event date. As far as

content and quality go, too short a production schedule often leads to a bad experience for the player.

Of course this is relative to the platform you are developing for and sometimes even the genre. A disc-based title for the PlayStation 3 and/or Xbox 360 typically take longer than developing for a Wii, handheld, or downloadable game as the technologies don't have to be as advanced and the game can be much smaller in scope. Because these games don't have the expectations and needs of a large-scale game, they tend to have the shortest production cycles.

Licensed vs. Original IPs

Between movies, cartoons, and sports franchises, in general there are more games released each year based on licensed intellectual properties than original concepts. The benefit of working on a licensed game is that it already has a built-in audience. The setback is that it hinders creativity, ideas, concepts, and gameplay because you have to worry about keeping in alignment with the "brand" over what is good for the game. Licensed games require more outside influence from third parties and stakeholders who all want input in the creative and development process, how the game is designed, and how their "property" is interpreted. Many of these stakeholders have little experience developing a game and little knowledge of how it is made, but remain insistent on providing input for the design and gameplay.

Because there are so many license holders who have limited experience with games, a third type of producer is integrated into the process to uphold the stakeholder's interest. This is the licensing producer who will be working alongside the publishing producer in reviewing the content and plans for the game.

Sequels and Expansion Packs and Downloadable Content

When making a first-time original game, the goal isn't just to make a great experience for the player, but to establish that original concept as the origin of a franchise. Publishers invest in original ideas if they feel that those ideas have the potential to be popular enough to spawn sequels. Many publishers are actually willing to lose money on the first title in a series with the hopes it will spawn sequels. Iterations in a game franchise tend to have a lower production cost by expanding on what's already been created. Once an asset, animation, model, and feature have been built, the bulk of the costs are done, so these assets are nearly all going to be reused in the follow-ups, allowing the team to focus on improving, expanding on, and innovating what already exists, with the precedent of the look, feel, and tone already established. A single successful game can spawn expansion packs, downloadable content, and sequels, plus it can evolve into a licensable brand that expand into other forms of media such as movies, television, books, comics, toys, and more.

CHAPTER SIX

Producing Skills

A quality producer must be master of many skills. Although some are more essential than others, a competitive industry producer has the knowledge to be in control of everything at task. While the most important skill is project management, it cannot be your only input into the game, or you're likely to fail. Those who consider themselves project managers over producers cannot control a single-unified vision and do not share a passion for the product. This will be reflected in your team's respect for you and inevitably the game itself.

Managing a Game

FIGURE
6.1

The three key balances of a game. A change to just one will affect all the rest.

As game development becomes increasingly larger and more expensive, the producer's job goes beyond simply budgeting, scheduling, and managing the production, but to maximize all aspects of budget vs. quality vs. manpower to ensure that the game looks grander and bigger budgeted than it actually is.

If you manage the balance of time, quality, and money properly, each sprocket component of the project will move the chain of the game along smoothly. If one of those aspects is mismanaged, or handled in the wrong order, the sprocket will miss its groove, causing the chain to pop off and derail your game.

Time affects every aspect of a production. It doesn't matter how strong a team is or how big the budget, if a game is not allotted a reasonable production schedule, then no amount of work, or money, can save it. While time is the biggest factor in a game's success, once you've committed to a specific schedule it is paramount that you stick to it no matter what. A slip in time can cause a chain reaction that causes ship dates to be missed. This causes a domino effect jeopardizing all the plans from marketing, PR, and sales, plus deals that have been made based on the production schedule and forecast. A change in street date also messes with retailers' plans for the season, forcing them to drop orders and commitments to the game; shelf space is lost and the entire ordeal severely damages the reputation of the publisher and developer.

The same goes for quality; if your team isn't trained in the latest technology or isn't working at its maximum levels, you're burning both time and money that cannot be replaced. A lack of ability to show competent work right upfront can cause your team to lose the game; the entire project can get the axe from the publisher. The business of games is more competitive than ever, and no production can risk being behind the curve.

The Key Skills of a Producer (Hard Skills)

Project Management

This is a general skill that many of the subsequent items are a part of. There are numerous schools of project management styles for game development, but at its core is how organized the producer is, the importance of structure, a proper schedule, pipeline, and multitasking—lots and lots of multitasking.

Technical skills

If you don't have the basic technical knowledge down, it doesn't matter what amazing super skills you have in any one specialty. If you need help using outlook, how to set up and use an FTP site, what a game engine is, or the fundamentals of game production, then you won't be working as a producer for very long. If a character artist doesn't know how to use Maya, then they're not going to get a job in games, and neither will you without the basic technical skills. As a producer, these are the tools of your trade.

Budgeting

Budgeting is a skill that comes from time and experience. Associate producers should be as involved as possible in the budgeting of the game, learning from those in senior positions. The budget of a game is often in direct correlation to

FIGURE
6.2

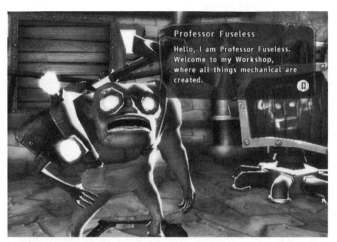

It's always good to be tech savvy.
Image Courtesy of: "Monster Labs" WBIE.

the team size. After the costs of expenses such as the engine licenses, full-motion video, tools, and software, the remaining budget is based on man-months. Man-months are a set dollar amount that reflect each individual member on the dev team: the lower the budget, the smaller the team; the bigger the budget, the larger the team. This is how a budget affects time and quality. A budget too low causes essential roles to be cut, causing the developer to take longer to produce the same results they would have produced with a full staff and creating a negative impact on the schedule.

Scheduling

Both the schedule and budget are best generated in tandem as they have a direct effect on one another. Fewer team members are needed during concepting and pre-production than in full production, so you'll need to know when you can start ramping up the staff and when you'll be able to transition them off and (hopefully) onto another project. As the producer you must factor in cinematics, audio, voice-over sessions, scripting, localization, demos, and QA. Then there are the submissions to license, stakeholders, internal and external management, the Entertainment Software Rating Board (ESRB), plus international rating boards, and of course first parties who license the right to release a game on their system as long as they approve all content. Also plan for resubmissions to all of these parties, as games are rarely approved during their first go-around. Finally there is manufacturing the product itself. This is all reflected in a master schedule that's broken down into smaller schedules for each discipline to focus specifically on their tasks.

Processes Management

The producer must generate not only the budget and schedule, but also put the pipeline in place for maximum efficiencies. While some subscribe to the Scrum methodologies of each production piece working in tandem, others prefer the waterfall approach, having everything planed out in exact detail before rolling into production. While none of these processes is perfect, the knowledgeable producer will know what modifications to make when molding the processes, schedules, and pipelines.

Asset Management

In addition to knowing what all the team members are handling at all times, you also need to know where each asset is and in what stage of completion. As a producer there are no excuses for mishandling, or misplacing an asset for the game. The asset organization is as critical as that of the production pipeline. Assets can range from any object created for the game to references such as images and scripts. If assets are not handled correctly, work can be duplicated or overlooked; if an asset is lost, or incomplete it can cause delays in the workflow. If your schedule slips, it better not be for something as silly as losing track of your assets.

FIGURE
6.3

3-D models are created by artists using modeling software packages.
Image Courtesy of: "Tango Down" Zombie Studios.

Presentation

It's the job of the producer to get what's needed for the project, so being able to craft quality presentations for internal and external uses is essential, while also being able to verbally present them energetically and concisely to an individual, or a group. Although many producers survive without having the ability to verbally present ideas and instructions in a clear voice, this always helps to instill confidence in your abilities to lead and manage. Strong presentation skills don't always equate to a quality, organized producer, but a wishy-washy presenter never instills confidence.

Written and Verbal Communications

Being able to communicate clearly and effectively with confidence and strength, so that there is no room for misinterpretation, will get you where you need to go in both the project and your career. Well-spoken, strong communication is what displays to others that the game is in good order and in the right hands. A producer with bad communication skills can give the illusion that a well-run project is in chaos, and often actually turns the project into just that by not clearly informing, or updating the team and partners.

Ben Hoyt, Sr. Producer, Paramount Pictures Games

"Communication is critical for an effective producer. Not only must a good producer be effective in communicating with a wide variety of different personality types (from artists to programmers to marketing people) but they must also be comfortable communicating internally, to the team, as well as externally to the press, the public, and the rest of their company. They must be eloquent, both verbally and in writing, and they must be comfortable dealing with everyone from testers to executives and, at times, celebrity talent. Perhaps even more importantly, a good producer isn't just an effective communicator themselves, but they are also able to help ensure that the people around them are communicating effectively. They identify when people are being left out of the loop, when misunderstandings or confrontations are beginning to arise, and when additional means of communication are required. They must act quickly and proactively to resolve these issues before they detract from the project."

E-mail and Memos

While strong verbal skills help grease the wheels, you need to be able to compose clear, direct e-mails and memos. The point of each e-mail should always be at the very top, with brief paragraphs and distinct action items. So often important information is missed because the reader skims through, or glazes over longwinded, poorly written documents filled with technical jargon with the point buried somewhere in the middle. If writing an evaluation or recommendation, put your conclusion at the top, and then go into the details on how you came to that verdict. Don't you think this is important?

Here are examples of how poorly written e-mail and memos can create problems.

When working on a multimillion-dollar production, we almost passed on a developer under consideration after receiving our tech director's review and evaluation of the dev team's abilities. The first several pages of the doc were a detailed

53

report with only a few paragraphs at the end dedicated to their strengths. When we informed the tech director that we would be passing on the developers because their weaknesses outweighed their strengths, he asked "Why? They're really good! Didn't you read my evaluation?"

The way his report was structured made the dev team appear poor to most readers, but it actually just took him fewer words to tout all of the extremely strong qualities, and his recommendation was buried in the middle of the report instead of called out separately.

For all future evaluations we asked the tech director to place his final recommendation at the very top of the report, followed by bullet-pointed statements on how he came to that conclusion.

Soft Skills (Or, What You Should Know, but Can Learn on the Curve)

Although all of these skills and responsibilities can seem a bit overwhelming, a well-organized producer can maintain a proper balance and ensure all needs are being met. While these abilities are important to have in order to properly handle your duties, there are some things that only surface from the experience of having gone through the process yourself. Because of this, the most in-demand producer is one who has worked on an entire game cycle, from concept to launch.

Examples of these learned skills include . . .

Hiring/Recruiting/Personnel

Although a producer does not do the hiring themselves, you will be meeting with and interviewing candidates for your team. You must know how to identify the right skills, qualities, and demeanor, not only for the position, but the dynamic of your team.

Politics

With budgets of games growing into the tens of millions, the most dangerous hole to fall into is to allow your game to be made by committee instead of a unified voice. An effective producer will be able to handle and upward manage those executives and partners who've never played a video game yet still want to have an influence in design, or don't understand why a game in early development doesn't look the same as a finished product.

Managing Partners

Although one company might be producing a game and another publishing, there are still numerous outside partners who hold a stake in the game, from intellectual property owners to game engine developers. Even vendors that provide multiplayer servers often require approvals over the game code. It is the producer's task to not only manage these relationships, but their expectations as well.

Outside the Team

There are so many factors in developing a game that not all of the duties can be contained by just the development team, so external vendors, contractors, and outsourcers have become a requirement.

Vendors

Most often you'll be dealing with outside vendors for game engines and middleware. While some developers have their own internally made game engine, most do not, so a license for a third-party engine needs to be secured. On top of this, additional aspects such as physics, dynamic lighting, online multiplayer, facial expressions, and motion capture all require unique middleware licenses, which you will be in charge of reviewing, selecting, and maintaining relationships for tech support. All of this requires the producer to be knowledgeable of the options, the latest technologies, and costs for budgeting, as well as juggling all of the needs, requirements, and agreements for each.

Outsourcing

Not only can outsourcing be a cost-cutting measure, but it also can strengthen areas where your team might be a little light. As the producer you'll need to work with the art and tech directors to ensure your outsourcing options are up to par, plus manage the outsourcing team and the assets delivered.

Contractors

Writers, sound/music specialists, voice talent, artists, and consultants all have deliverables, agreements, needs, and requirements that must be managed and executed by the producer. Not only do you need to ensure that your team stays on task, but you need to ensure that the contractors do as well. It is important to maintain regular communication and updates with contractors, often setting up weekly conference calls to keep everyone on the same page and invested in the work.

Other Producers and Teams

Although managing a game is complex at one developer, it can be even more so when split among multiple teams. Like outsourcing, companies that own more than one development house may split the work across multiple groups. This can create confusion and cause work to be overlooked and even duplicated, so it is essential that the producer be as detailed, specific, and organized as possible, with communication constantly flowing between all parties.

CHAPTER SEVEN

Tools of the Trade

Software Solutions and Recommendations

Because you're working in a technology-based environment, you'd best get to know the tech and tools that are part of your job. While some of these are common among project management and general office administration, others are specifically unique to the computer and games industries.

Microsoft Office

As with any office environment, Microsoft Office is just as important to a development house and publisher as it is to an accounting firm. There is no better e-mail client to help you stay organized than Outlook, you'll be writing reports in Word, creating presentations in PowerPoint, and just face it, like it or not there is no escape from Excel. Executives just love those spreadsheets. Don't get us wrong, Office isn't the be-all, end-all. The lack of compatibility with earlier versions make it a real pain when you're sharing documents across multiple offices and companies, and far too often Outlook is used as a business and personal organizer instead of how it was intended, which is why so many professionals are less organized now than they were just a few years ago. Regardless, Office has the most universally used software for general office needs, presentations, and spreadsheets.

Wiki

Since its inception in 2001, the Wikipedia.org website has been one of the largest forms of information exchange and it's all based on a technology that anyone can utilize for free. Wikipedia.org itself uses a simple language to generate pages that can be created, added to, and updated by anyone with access. This same tech can be taken, adapted, and used as a secure forum for open communication on your project. The Wiki software can be housed online or on a community server so that everyone associated with the game can contribute to or view it. The software allows

you to control the permissions those individuals can have access to, and can be protected and secured so that no outside eyes can sneak a peek.

Before the Wiki came along, teams would share information via an online or local Web forum, but the simple, cleaner, and more efficient Wiki can be used for daily or weekly reports, updates to information, timelines, guidelines, story, characters, and design. The one area it lacks is image sharing—for that it's best to include links to images or an FTP site, speaking of which…

File Transfer Systems

It's hard to conceive of a publisher, or developer surviving without one. The File Transfer Protocol (FTP site) is the most common way to transfer files and information to those outside of your network. You'll need the FTP site for sharing game documents and images, assets, and larger files. It is also commonly used for submitting milestones and transmitting game builds, however there are more efficient (but also more costly) ways to share builds that many publishers are starting to pick up on called Accelerated File Transfer (AFT) processes.

Instead of treating large files like just one item, the AFT deals with each individual byte by extracting and transmitting only the difference between new and old versions instead of transmitting whole data. This way, if there is an interruption in the transfer or some of the data is corrupted, the AFT can pick up where it left off without affecting the already downloaded content and can reach out and grab only the data gaps that are missing or being replaced. Anyone who's worked late into the night waiting for a huge build to upload or download via an FTP site, only to have to start from scratch if the computer so much as freezes, can appreciate what an AFT has to offer. The biggest benefit to using an AFT is updating game builds. If a new build is being delivered, instead of downloading the full code, the AFT can be set to only pull the new and updated information. This allows the updated build to be downloaded in a fraction of the time it would normally take.

The two most popular AFT systems are the free open source, Rsync, which requires the user to have their own server setup, and the commercial, RTPatch, which is costly but provides a secure server and tech support.

Microsoft Project

MS Project is a good way to keep track of the workflow and one of the better alternatives to Excel. MS Project assigns the resources for each task by team member and is effective in scheduling and structuring the order of tasks based on how they relate to one another both globally and by assignment. In addition to structuring the tasks based on what asset is dependent on other tasks, MS Project can generate a critical path analysis, outlining the most important tasks that can affect the overall schedule.

MS Project is designed to make things easier, especially for those not as spread-sheet-minded, and can be more efficient than using a software tool like Excel, which is designed for accounting, not project management. As Project is specifically designed for large projects with multiple entities, it can be adapted to suit whatever style of organization you choose, as long as you stick with it and stay on task.

In addition to this program, there is now an online solution for MS Project that includes a server which allows all team members to access and update the project and reports remotely.

Version Control Systems (a.k.a. Revision Control)

Allows multiple users to work on the same code at the same time, without mucking the entire thing up. Before Version Control came along, only one person could access and work on code at a time when housed on a server, causing most simultaneous work to be done locally, then the pieces painfully converged together.

Version Control also provides history and changes to any digital files to help find the latest and greatest iteration, or revert to a previous version, which helps track down the source of a bug or error in the code, adjust it, then jump back to the most up-to-date version so that none of the work has to be sacrificed.

The most widely used version control systems are the free open source CVS, Alien Brain, and MS Source Safe.

Photoshop

As a producer you'll find yourself often creating visuals for presentations, pitches, and Game Design Docs. To generate the highest quality in your visual presentation, Photoshop is a necessity. It can even be used for editing and touching up screenshots and concept art.

First-Party Software/Hardware Tools

Gathering and understanding first-party software needed for the production process should be delegated to your tech director and the tech group, but everyone on the team should have training on how to use its primary functions. The first-party software does everything from allowing you to load and play builds on a test kit to taking screenshots and allowing the game software to be form-fitted to the first-party hardware. First-party development software includes a set of software libraries and tools to control every part of the console's hardware, generate game builds, and verify builds for first-party submissions. When the latest Software Development Kit is being used, you should make sure the firmware on the test kits have been updated in order for the build to be compatible between the dev and test kits.

Disc Burners and Software

Throughout the production process you'll be burning disc after disc of builds for the game, so many so that publishers often have DVD Burning towers that will make multiple copies of the same disc. Builds of the games will often be delivered as ISOs, and if not, you'll need the software to convert them.

Autodesk Maya

Nearly all computer-generated 3-D rendered images for film, television, and video games are created using Maya software. This is a mandatory tool for your artists. As the producer you'll need access to a Maya reader that allows you to view the Maya files without actually generating or making adjustments to them. To view a Maya file you'll need an extremely powerful computer, with the artwork structured so that you are able to properly visualize what you are seeing. It's a must to have a basic understanding of Maya, including how it works and how it puts the image together.

3-D Graphics and Modeling Packages

A mandatory tool for any artist or animator tasked with generating movable 3-D models. The dimensional model is built, rigged and prepped for the surface

FIGURE
7.1

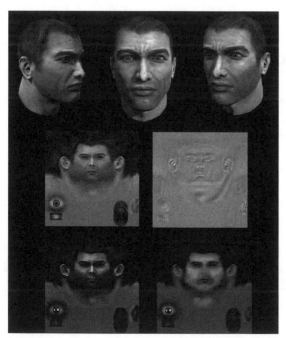

The textures of a model can look quite odd before it is all put together.
Image Courtesy of: "Tango Down" Zombie Studios.

textures (skins) of the image adding a texture map that defines how the texture will be placed. The textures themselves are created in graphic software such as Photoshop. These software packages can also be used by implementing scripting systems and plug-ins for level design, FX synchronizing, character behavior defining, and game previewing.

Unless you're familiar with how the modeling works, the textures of a model can look quite odd because they are a fully flattened image of the entire circumference of the model. The head of a person looks like their face was removed and placed on a flat sheet of paper. This texture then wraps around the model based on what was set with the texture maps and given more realistic of a look via bump and relief mapping.

Bugs: Bug-Tracking Systems

A single game in development typically has thousands of bugs that are found throughout the process, and some may still ship with several hundred unfixed bugs within them. This alone shows the importance of QA and their primary tool, the bug-tracking system. These open-source systems allow QA and other team members to log, prioritize, delegate and track bugs, plus output reports on the progress. As bugs are fixed, the tracking system is constantly getting updated since fixing one bug could cause more to pop up. Basically any part of the code that's changed even in the slightest could create more bugs, so it is important for your tech group to structure the flow of the code in as structured a format as possible so they can see how changing one part will affect another.

There are literally hundreds of bug-tracking systems and software out there, nearly all of which are Web-based. Some are free while others offer paid services which include secure servers and other productivity bells and whistles. Work with your tech director and QA leads on the best tracking system for your project. When outsourcing the QA, it's always best to use whichever system they currently have implemented within their QA team. If you or your tech director thinks the outsourced QA company is using a poor tracking software, this should be seen as reflection of the quality of work you're likely to get from that outsourcer, and should be taken into consideration when determining if they are the right company to go with.

The Process in a Nutshell

CHAPTER EIGHT

The History of Game Development

The balance of power in games has transitioned over the years. While back in the day the tail wagged the dog, where a development team had more of a say and influence in the game, now as video games have become far more corporate the dog wags the tail with nearly every decision being based on the publisher's P&L and marketing spreadsheets. This has caused a strain on the developer/publisher relationship as the two still require one another to survive. The developer needs the publisher to pay the bills, and the publisher needs the developer to create the actual game. The result is a tug-of-war ranging from creativity to process.

Video games were born out of the early days of memory-based computing as simple tech demos created by one or two programmers in college computer labs as a fun and easy way to communicate a computer's capabilities to those not-so-tech-savvy individuals. When computers became more accessible to the public, techies began programming their own games, developing the design, graphics, levels, narrative, and software on their own; even companies such as Atari started out with a programmer taking on the duties of producer, artist, designer, writer, and tech director all in one.

As games evolved into more ambitious endeavors, with more detailed artwork, intricate narrative structures, and elaborate level design, the programmer started to primarily focus on the complex programming, as graphic artists were added as well as designers and project managers. The need for a project manager understanding the design, tech, and art grew as teams began to expand from three or four individuals into teams expanding into the double digits. As the team grew, so did the position of the project manager who began to have more influence in the production, and eventually evolved into the producer.

Case Study: The History of Game Development Through the Evolution of Sierra

The industry giant that eventually become known as Sierra Entertainment started in 1979 as the husband-and-wife team of Ken and Roberta Williams working out of their home with nothing more than an idea and an Apple II microcomputer. The rise of Sierra is the perfect example of how video game development grew from meager beginnings into multibillion-dollar corporations.

Ken worked at IBM as a programmer and brought home a copy of the text-based game Colossal Game, which was the first commercially available computer adventure game. After playing through the game Roberta became inspired for a game concept mixing the rich narrative of a text-adventure game with graphics. She then went to work at their kitchen table and hand-wrote the design, story, and text for this new type of game. The documents she created would later become known as the Game Design Doc. Ken took her design and created a software program (later known as the game engine) on their home computer that was capable of mixing the text and graphics together so that the graphics changed depending on what the user typed in. This was an incredible task, as nothing like it existed previously, so each step was based on all original coding created by Ken.

The end result of this incredible and groundbreaking task became *Mystery House*, the world's first graphical adventure game. It took three months to produce and they sold it via mail-order ads taken out in the back of computer magazines. An instant hit, the demand for the game got to the point that the two rented out an office space, hired on Ken's brother, John Williamson, as an additional programmer, and began working on additional games, each designed by Roberta and illustrated and programmed by Ken and John.

As their business grew so did the technology and complexities of the game. While Mystery House used still images to go along with the text, Ken and Roberta began developing games that would allow the player to move the characters and interact with the environments via the keyboard arrow keys. By the time they completed the new game engine, the Adventure Game Interpreter, for Kings Quest, their most ambitious game of the time, the couple started adding more and more staff members for programming, art, music and more. Soon entire teams were tasked with developing games, most of which were based on Roberta's designs.

(Continued)

Computers and game technology began to evolve at a rapid pace, and development grew from a handful of members to large teams, with numerous programmers, artists, and engineers all working together on the same projects. Soon more designers were added as demand for more games became more than just Roberta could handle alone. Then, to not only ensure that the workflow was managed properly, but to ensure a unified vision that encompassed the philosophies and style of Sierra (then called Sierra-Online), producers were assigned to each production team, taking a portion of the roles that Ken and Roberta once held when they were making games on their own.

By the time the company was sold off, the staff was in the thousands with several hundred projects under its belt. Today Sierra is owned by Activision Blizzard, Inc., which employs thousands of game makers, all working in large teams to develop both Next-Gen console and online MMO games. Teams range in size, but at both the development and publishing ends, each team works with producers to manage the development and vision of the games.

The vision and evolution of Sierra's growth from a couple building a game on their kitchen table and home computer is a direct reflection of how the entire video game industry has grown.

CHAPTER NINE

Game Project Lifecycle Overview

As a game producer it is important to understand each facet involved in conceiving, creating, and releasing a game. This means not only knowing your jobs, but the exact duties of everyone involved from the individual development team members to the marketing and PR staff. From the beginning you need to know the basics of how games are made and the development cycles they go through.

Consider the game development cycle as a living being. It's conceived at the concept stage where the ideas for the game are born, then it goes through pre-pubescence at pre-production where it is given the tools it needs to flourish into adulthood, then the teen and adult years all smashed together in production, until it reaches maturity and goes gold, after which it enters its golden years in post-production as its assets are archived and a post-mortem is performed (literally).

Concept Phase

This is the stage where you figure out what your game will be.

Think: What is it you want to do with this game? What do you want it to achieve? What is necessary to engage its audience? At this stage of conception, there will be a lot of very opinionated ideas thrown around that the producer needs to manage, piece together, and use their own creative vision alongside the creative director to form into a solid concept for the game. It is also at this stage that the producer will structure the groundwork to establish the budget and schedule for the full production.

The producer and creative director should have an idea of the direction they want to take, but must never forget that the concept stage is just as much a team effort as production. Everyone—from president to programmer to property stakeholders—everyone involved will want to give their two cents, and should get

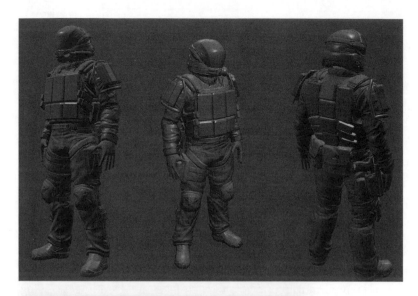

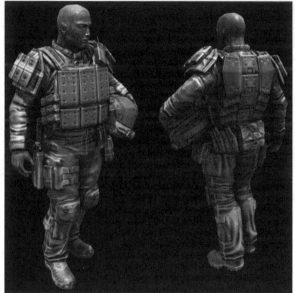

Art renditions help set the tone and mood for the direction of the game.
Image Courtesy of: "Bionic Commando" Capcom.

the chance in one way or another. Enabling team members to have creative input in a game will not only give the team a personal investment to see it succeed; this will also satisfy higher-ups who want to be part of the process and satiate the stakeholders that have put their stamp on the project.

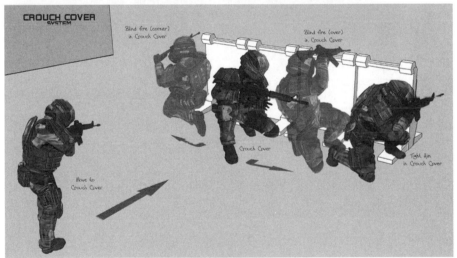

Concepts are good resources when planning your game.
Image Courtesy of: "Tango Down" Zombie Studios.

Before you can begin a brainstorming session, you should determine what the essence statement or "Core X" of the game will be. This is the single sentence that summarizes the game, encompassing the overall end goal and what will make it unique amongst the competition. Once you have the essence of the game you can launch the team ideas in a brainstorming session.

71

The brainstorming session is the most efficient and enjoyable way for the team to communicate their ideas, however these can easily break down without the proper organization and foundation set by the producer. The meetings need to be highly structured with the topics and information constantly flowing, with all of the ideas documented for later use. Once all of the ideas are narrowed down and collected, it's up to the producer, creative lead, and tech director to mold them into a high concept for the game. This concept gives anyone reading it an overview of the game's goals, innovations, features, timeline, technology, and initial design ideas.

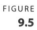

FIGURE
9.5

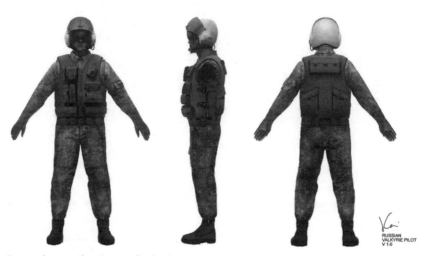

Game play mechanics are fleshed out.
Image Courtesy of: "Tango Down" Zombie Studios.

This is also the time when relationships and communication will be established for the project between the developer and publisher. Creativity is the biggest issue to sour the relationship between these two right off the bat, and it all boils down to nothing more than ego. The developer thinks they should be the full creative force behind the game, while the publisher feels that they are to be the creative leads and also hire outside resources such as a writer, or consultant. The fact is that both parties should be enabled to have a creative say. Yes the developer is creating the game, but the publisher is footing the bill and in the end it will be a reflection of their company and brand. Being pig-headed and childish about where ideas come from will only hurt the progress and the final result for everyone involved. Nothing is worse than a resistant relationship throughout the development of a game.

Pre-Production Phase

You now have an idea of what your target goals are, so now at pre-production you must devise a plan and strategy for how you're going to get there.

Pre-production works in stages based on creativity, needs, staffing, logistics, and technology, the outcome of which will be a sampling of the game itself. At the very beginning of pre-production you will need to have completed your staffing and your schedule. Because these two elements are based on the budget, the time and resources you've now established will help provide you with guidance about the scale of the game.

From the staffing and schedule you roll into the blueprints for your game, the Game Design Doc (GDD), Art Design Doc (ADD), Tech Design Doc (TDD), and sound design docs. These will serve as your game on paper. From this you should be able to know what will be produced in terms of look, style, features, sounds, and design without having yet programmed a single pixel. The GDD should be considered a living doc that will be tweaked and adjusted throughout the pre-production stage.

Once the design docs have been established, the producer will go back in to refine the schedule, now knowing what features the game is going to strive for and how those goals can be achieved, plus the work involved to get the plan running. By the end of pre-pro you should have your master schedule and your initial milestone schedule planned out.

Once you have all of your designs, staffing, and schedule complete you should begin building your production team and getting them working on the next stage of pre-pro, the proof-of-concept, which is basically a sampling of the game.

Building out the game sample is like a mini-production cycle within the pre-pro stage. You'll be creating a proof-of-concept doc which will consist of a mini-level design, what key feature you want to display, how it will look, and the steps you'll be taking to get there. Basically everything you would need to create a 10-minute sample of what you want the final product to be.

From the proof-of-concept your art leads, animators, and creative director will start building out a target render. This is an animated sample of what your game looks like, how the character will look and move, plus how they will interact with the environment. You'll also want to show the controls and how they will effect what is going on on-screen.

Once your target render is completed and approved you'll spin it into a vertical slice (a.k.a prototype), a stage that gets its name from literally being a "vertical slice" sampling from the game in look, scope, gameplay, and the direction you intend to take the game. These are 100% playable, and run on the target hardware. The outcome of the vertical slice is a mini-level of the game that proves the concept of the game is achievable and provides a sense of how engaging the end product will be. This is also how you'll be able to determine which features need to be tweaked. Going through this process is just as much a learning experience for the team as it is for partners and stakeholders.

For the producer it is extremely important to manage expectations from members outside of the team. Marketing and PR heads, executives, partners, and license holders often expect the vertical slice to look and feel like the finished game, but it should be considered a rough draft, the video game equivalent of a pencil test.

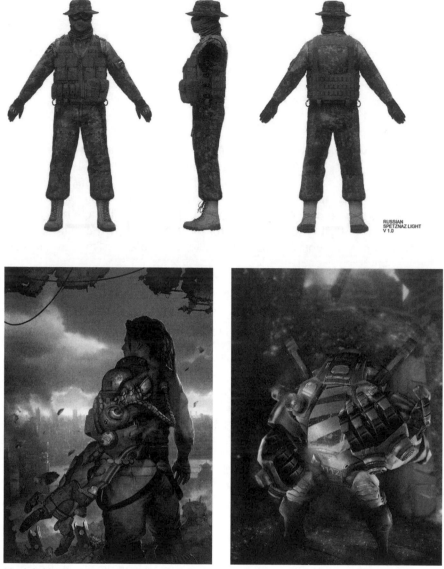

Models like these get developed during pre-pro.
Image Courtesy of: "Tango Down" Zombie Studios.

Production Phase

This is where the team is actually building the game, executing all of the designs
and work that has been established in concept and pre-production. As this rolls out

directly from the vertical slice, the standard has been set and an agreement on the direction has been approved by all parties. With everyone on the same page the team can now focus on the meat of the project without concern for direction. This stage can last anywhere from several months to a few years depending on your mandated release date.

As the producer, working towards all of the schedules and managing the team to ensure they are hitting their milestone schedules will be a large part of your task. You will also keep everyone focused and aligned on meeting their goals and deadlines, and ensure that the creative vision remains unified, in addition to forecasting and troubleshooting any issues that may arise along the way.

In addition to the actual game development, during the production stage the writer will begin working with the designers and creative director on the narrative, in-game dialogue and text. Voice-over will be recorded, localization will begin, music will be composed, marketing and PR initiatives will be executed, and many other facets that go along with a successful game completion and release will be in process.

Production encompasses the majority of the development cycle; throughout this time there will be changes made to both the schedule, staffing, and game, because no project that takes this long to create ever stays the same. At times it will feel like you're making the greatest game ever, while at other moments it will seem as though you're fighting overwhelming odds to get it completed. If you make it through to the end, you're in store for the most rewarding, yet difficult task in production: Going Gold.

The Crunch: From Pre-Alpha to Release Candidate

These are five final and extremely critical stages of your game's completion that stretch out for several months. At pre-Alpha you're nearing the end of building out levels, and combining the cinematics, sound, music, and voice-over into the code. While the in-game content is not complete, it exists in pieces and should mostly be built out. This is a big clean-up time as you want as much of it done and out of the way by the time you reach the alpha stage.

By Alpha, you should now have a roughly built version of the game, although it may not be completely playable from beginning to end, it has the entire basic framework in place. Up until this time you've been able to tweak, switch out, and adjust the features and gameplay. Once you're at the point of Alpha you'll need to have all of your features set and in the code.

By Beta you should be feature-locked and have a fully playable version of the game that you can play from beginning to end. This is the build you'll have numerous versions of as you're trying to clear out all, or as many, bugs and issues as possible. By this stage you're going to be bouncing new and fixed builds back and forth

FIGURE
9.9

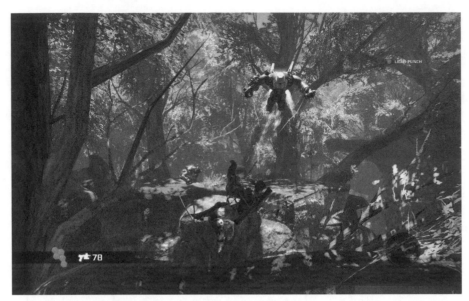

The game begins to swing into action during the QA phases.
Image Courtesy of: "Bionic Commando" Capcom.

with the QA team, and you'll need all hands on deck to scour the game for issues that could prevent it from getting approved by first parties and affect review scores. This process is called "breaking the game."

FIGURE
9.10

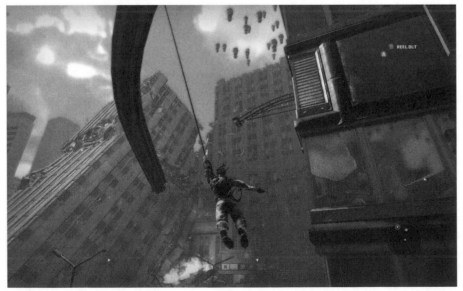

Gameplay and the look of the game get buttoned up and ready to ship.
Image Courtesy of: "Bionic Commando" Capcom.

Once you have a build that is cleaned out of the major "show stopper" bugs, you're moving on to your final big build of the game, the Gold Master Candidate (or GMC).

The GMC is the final build of the game that you are submitting to first parties such as Sony, Microsoft, and Nintendo for their approval. This has to be a perfect representation of the game, with the publishing producer putting the submission packet together. This is a very sensitive task, because something as small as a line on a form being overlooked or some development tools being left in the build could cause the game to be rejected or sent to the back of the waiting list for resubmission review.

If your GMC is approved, you must prepare the final code for manufacturing. Then to make sure it is 100% free of all dev coding and errors, you generate a Release Candidate build. If the Release Candidate is clean and approved by the first parties, it becomes the Release to Manufacture (RTM) build. The RTM is sent to first parties for manufacturing or, in the case of computer SKUs, to your manufacturer to be mass produced into the final product.

Post-production is where the project is wrapped up and archived. All assets from the developer are delivered to the publisher along with test and dev kits and any publisher-owned equipment.

For developer/publisher relationships that plan to continue on after the game is wrapped, it is preferable to create a postmortem, which is an overview of the successes and failures of the game, so that both sides can learn the causes and focus on those items for the next venture together.

CHAPTER TEN

The Development Team

One of the most important things to know as a producer is that no one person makes a game, it is a group effort made both technically and creatively by the team that you manage. To ensure that all parts work in harmony you must ensure that they all share the same vision, and that all the moving parts are on task, and on schedule. To do this you must know all aspects of the development team and the role its members play. Any console game developed requires each of these disciplines covered, and don't consider these single-person roles either; larger jobs require multiple team members. In some cases you may find teams where each member holds many cross disciplinary hats, and although this can save money, it can also affect the quality of the product and burn out your team members quickly.

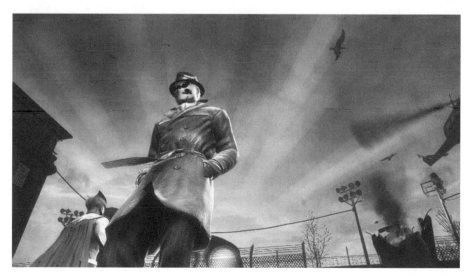

FIGURE
10.1

It takes an important cast of characters to develop games.
Image Courtesy of: "Watchmen" WBIE.

Here is an overview of the key members of your development team. Within these disciplines are numerous variations, specialties, and subordinates, each play a key role in the game's development.

Technical Director

Knowing how to manipulate, work with, and integrate every engine, platform, operating system, middleware, and pixel is the responsibility of the tech director. They are the masters of all technology involved in a game and are heavily depended on throughout the entire development process, from finding out if your concept is physically possible and planning out all of the hardware, software, tools, and middleware to figuring out the source of crash bugs, making sure that the game is ported properly, and prepping for first-party submission. A console game is lost without the technical director.

The Many Roles of a Technical Director

- Overall technical design and planning
- Devising development strategy
- Extensive knowledge of game engines and middleware
- Constructs the Programming team and initiates pipeline
- Organizes the planning of the QA, bug testing and debugging procedures along with the QA

Programmers and Engineers

Types of Programmers

Quite possibly the biggest job on the team belongs to these folks who build and manipulate the tech to put the game together and make all of its components work. Many programmers have a specialty such as physics, artificial intelligence (AI), sound, graphics, and gameplay. Even the simplest idea for a video game cannot be made without a programmer to put it all together.

Engine Programmer

As more games strive to innovate, this specialist is brought in to implement and modify game engines and middleware, pushing them far beyond their original design, expanding endless possibilities for graphics, lighting, FX, sound, AI, physics, network, and beyond.

Tool Programmer

Like the engine programmer, the tool programmer specializes not in the engine but in the in-house tools and those provided by first parties and engine/middleware manufacturers. These are used for assets conversion, level design, scripting, gameplay design, and more of the like.

Gameplay Programmer

Here we have the programmer that actually creates the different types of gameplay elements within the game, developing a gameplay logic, which includes AI and character behavior. Of all the programmers, this is the one that should work closest with the game designers.

Creative Director

The technical definition of this position is the one who oversees the creative ele ment of a game. This alone is vague enough as you already have numerous other team members handling the creative element, such as the creative director on the development side, the producers on both sides, designers, writers, and art directors, etc. On the development end, the creative director often works as lead designer and has the closest role in game development to a filmmaker, but with far more details and duties than a movie director will ever have. Basically the creative director is the director of the game. They oversee what is shown to the player, how it is shown, the look, angles, and movements of what you see and feel in the game. Basically, if it's on screen the creative director had a hand in it.

Designers

Designers do just what the title implies: They design what the game will be, structuring each level, how the gameplay will flow, what happens along the way, and the players' objectives. A good game experience hinges on the talents and abilities of the designers being able to create a fun and engaging experience.

Art Director

The look, tone, and visual quality of the game will be crafted by the art director. The AD will be initiating the environment, visual design, and primary character concepts that the art team will use as the style. The AD will establish the visual bar for the game, what unique visual qualities will make up the game's world. All

of this they will record in the Art Design Doc, not only setting the look, but devising how it will be built and created. The art director will also review each visual element; ensure it reflects the vision that was worked out alongside the creative director and/or producer.

The Mediums of an Art Director

- Establish the look of the game.
- Create a style guide for the artist to work from.
- Create the initial concept for environments, primary characters, and key materials.
- Manage the art team.
- Review visual assets and content and provide direction.

Artists

In today's Next-Gen HD world, strong artists are more important than ever. The artists create everything visual you see in the game from the environments and props to the weapons and character models, but their work doesn't just end there. The artists must also create the "bones" these are built on and rig them so the joints and movement are natural and subtle enough so that the animators have the maximum amount of flexibility and control. There are numerous types and styles of artists on this team.

Types of Game Artists

- Rigging artist: Preps the model to be built upon, creating the skeleton (or bones), adding joints for fluid movement, and once the 3-D modeling artist has created the 3-D model, the rigger connects the model polygons to the bones, plus add nodes to control the bones.
- 3-D modeling artist: Develops the 3-D model that, once skinned with textures, will become an object or a character.
- 2-D mapping artist: Creates the texture, a flat skin that when mapped to the 3-D model makes the object or character.
- Lighting artist: Deals with all lighting effects from natural, artificial, candle, and torch light.
- FX artist: This artist pushes the visuals beyond their limits. Just like an effects artist in films, this artist designs and creates all the visual special effects, including explosions, lasers, fire, and otherworldly visuals such as time riffs and black holes.
- Technical artist: Checks work to make sure there are no errors visually, or on the tech with the art pieces, fixes any glitches within the art, and makes sure it all runs with the game engine properly.

Animators

These are the folks that not only make the characters move, but control the subtle expressions in a character's face to move their mouths when they speak, show expressions in the face, and make it all look natural. Animators control most of the movement in the game, from the way the characters walk and talk to showing expressions and creating the cut-scenes and pre-scripted "gags." Even with motion capture and automated programs like Face FX, the animation still won't look natural without an animator going in to manipulate, clean things up, and smooth them out.

Audio Director and Engineer

So often the importance of audio is taken for granted, but the audio engineers who create the environmental soundscapes, VO recordings, audio effects, and implementation are as essential to make a game truly immersive as the artists, designers, and writers. Their job continually increases in challenge as home audio systems advance. Today a home system can range from mono to full-surround sound, and it's the audio engineer's job to make sure it sounds great on every set-up imaginable.

Writers

This is a duty that used to sit with the producer and/or designer, and sometimes still does, however as games gain more mass-market appeal, strong narrative and dialogue have become essential to immerse the player in the world you are creating. To do this you get the best results by hiring an outside writer, one skilled enough to pull the player in with the story presentation and believable dialogue, but with enough knowledge of game design and production to know how the narrative and structure will work together.

QA/Compliance

Although the big quality assurance push to review the game builds for bugs typically lies with the publisher, it is important for the developer to have two or three team members dedicated to testing builds on a constant basis to ensure that they are stable, and that there are no major bugs that could cause the publisher to fail a milestone. This team will also make sure that all of the first-party compliances are taken care of for submissions, and put together the gold master candidate as well as the release to manufacture builds. The QA team on the developer side will know the ins and outs of the game builds better than most anyone else on the team; they often are assigned to capture screenshots, gameplay videos, and walkthroughs of the milestone builds.

ELEVEN

The Publishing Team

As we discussed in the first chapter, the producer manages the production of the video game. On the dev side the focus is on the day-to-day elements of building the game, and on the publishing side the producer manages everything else necessary to get the game approved, promoted, and on the shelves. As with the developer, the publishing producer has monumental tasks assigned to them including scheduling, budgeting, team management, troubleshooting, being a liaison with partners and stakeholders, and of course, quality control.

The Producer

While the producer on the publishing side doesn't deal with the technical day-to-day development of the game, they do play an extremely important role in its creation and process. While the development producer oversees the dev team, the publishing producer oversees everything else involved with creating, approving, and releasing the game. This includes budgeting, scheduling, guiding narrative direction, milestone reviews and approvals, third-party submissions, and ensuring the quality of the game is at a suitable level.

While the dev producer works with the publishing producer to create and finalize a development and milestone schedule, the publishing producer must build out the schedule of all other aspects of the game, including localization, VO sessions, and stakeholder and first-party submissions. In addition, they must sync the schedules with marketing, PR, sales, and operation's initiatives.

While the budget for developing the game comes from the developer, this is only a piece of the overall game's budget. On the publishing side they need to generate the full budget which includes above-the-line costs such as actors, writers, composers, outsourcing to cinematic animation houses, recording and mixing studios for VO, music licensing, and often the licensing for the game engine and some of the more costly middleware.

The publishing producer also needs to make sure the development stays on schedule and the game maintains the quality and content levels that were agreed upon at the beginning of production. As an invested team member who has an

FIGURE
11.1

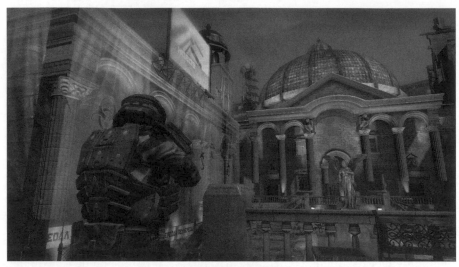

Never lose sight of your target when developing games.
Image Courtesy of "Tango Down" Zombie Studios.

outside perspective you can often better determine what needs to be tweaked, cut, or added, if the risk of the game slipping or the quality level isn't up to par. Having an outsider making mandates to the dev team can create friction, which is why the development producer needs to accept and relay to the team that the publishing producer is just as much a member of the team and has the game's best interest at heart.

Operations, a.k.a. Ops

Since the days of the Nintendo Entertainment System and the SEGA Master System, first parties have had full control over what games are released for their systems, policing not only quality and content, but mandating that they provide all test and dev kits, and manufacture the retail versions of the final games, at the publishers cost, of course. This is a very complex, political, and process-oriented undertaking, and the ops team manages it all.

The ops group covers quite a few tasks. They maintain the relationship with first parties and are the conduit for submissions and approvals. They order and secure all of the test and dev kits, and manage the manufacturing process, both domestically and internationally, plus they often are in charge of the localization team. Both the producer and ops are heavily dependent on one another; more so than any other division outside of the core team. Ops provides the producer with the first-party compliance rules and regulations, while the producer gathers detailed information, assets, and builds of the game so that the various stages can be submitted

for approval. The producer also needs to involve ops in the test and dev kit needs, the size of the game (so the proper media can be prepared and budgeted for manufacturing), scheduling when the localization process will begin, and managing the QA process, as well as what resources are necessary for each.

Tech Director

While the development tech director is an expert on the technologies that a specific company uses, fully knowing the engine in and out and how to manipulate it, the tech director on the publishing side needs to know all technology used for all games.

The publishing tech director is heavily utilized to foresee technology-driven issues down the road as well as to troubleshoot problems when they arise. They start things off before production begins by visiting each developer's studio to review the team, technology, and tools in a "due diligence" evaluation. The due diligence reports the strengths and weaknesses of a dev team, and determines if they are fully capable of performing the task necessary to get the job done at the highest quality possible. Because the tech director knows all the tools and how they are utilized, they can pinpoint where exact problems can occur.

In production the tech director reviews the tech design doc supplied by his counterpart on the developer end, as well as each game build to ensure that everything is structured and going down the right path. They also keep up to date on all of the first-party technology and SDKs to ensure that the game is being properly built and designed to run within each end user system.

As the producer you should make sure that everything that is going into the game or planned for the game is reviewed by the tech director. Even elements you might not consider tech may have a negative impact on the final code, or memory usage, so you should make sure it is all scrubbed and reviewed, making sure that the tech director's feedback and recommendations are related back to the dev team.

During crunch mode you're going to lean heavily on the tech director. He will be pulling the same late hours as you, reviewing and evaluating each build as it comes in. During crunch mode you can receive multiple builds a day as you creep closer and closer to your submission date, requiring 'round-the-clock efforts from the dev team, QA, as well as the tech director, who will be tasked with evaluating each build and often defining the cause of major bugs. In the event the dev team is unable to track down the cause of a major bug, the publishing tech director will work alongside them to figure it out and solve the problem.

Art Director

Those who don't agree that an art director isn't a crucial role to be competitive in today's Next-Gen high-def market don't have a true understanding of the visual

process both aesthetically and technically. While a producer is tasked with managing all aspects of the game, including quality, the art director's focus is the quality of the art and how it is rigged to leverage other elements that affect it such as animation.

The primary difference of an art director at a publisher is their duties are more on the focus and process of the art over actually building it. Just as the tech director they will be visiting the developer to meet the art team and review their tools and skills and providing an evaluation and final recommendation on the art team's capabilities. While this won't necessarily determine if you go with this developer to make the game or not, it will help make the decision as to what art elements will be outsourced.

FIGURE
11.2

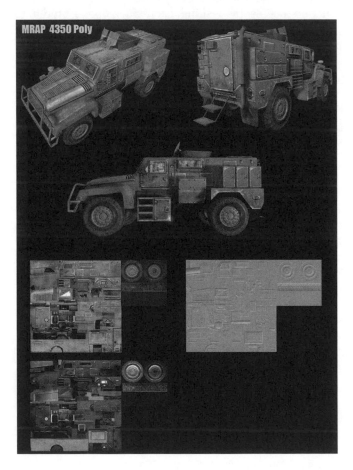

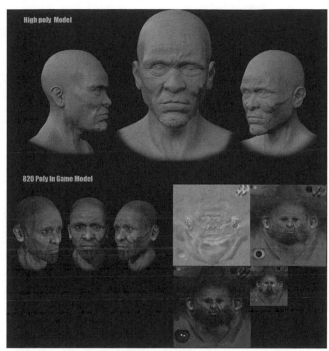

FIGURE
11.3

Sheets like these help art directors communicate their intentions.
Image Courtesy of "Tango Down" Zombie Studios.

In preproduction and production the art director will be reviewing milestones based on the visual aesthetics of the game and on how the art and animation is structured. They can troubleshoot problem areas and use the proper language to give the art team proper direction.

When milestone submissions come in the producer must immediately identify what elements the art director needs to approve. They should be primarily focused on the art design doc, but also remain looped into the game design doc. The producer provides the AD with all concept art and models, regardless of how minor the item may seem, and make copies of each build for their review.

QA Team

While the developer needs a handful of staff members to test the builds, so do the publishers, but to a much higher degree. Throughout the process it is a good idea for a publisher to have a modest staff of QA testers along with a QA lead to make sure the games are playable and don't have any issues that would prevent a first-party

approval, but when the game gets close to submission a full QA team needs to be contracted.

In some cases the full-scale QA team is an outside company contracted to review each build from top to bottom, report every single bug—major to minor—and classify them and provide detailed instructions on how to reproduce each one. In crunch mode these teams are working with the publishing and development teams around the clock until enough bugs are fixed that the game will be approved by first parties and won't get killed in the reviews.

As the producer you'll be simultaneously reviewing each bug within the report with your dev counterpart, clearing out unnecessary fixes, classifying the priority, and delegating tasks. The producer should also be testing the build, making sure they are seeing the same issues and adding their own bug findings to the report.

Creative Director

Just like creativity itself, on the publishing side, this is one of the more abstract positions. Every publisher that has a creative director has a different interpretation for the role. The position that was originally conceived to make sure the overall creative goals of a publisher are executed, with every game falling into alignment, has spun into everything from a design consultant to negotiating all of the deals with VO talent, writers, and "Hollywood consultants."

When working with a creative director on the publishing side, make sure you have a clear understanding of what their duties are at the company. Don't overburden them with materials they don't typically handle. Keep them in the loop on what is important for their needs and how they can benefit the overall product.

CHAPTER TWELVE

Publishers Selecting Developers

The idea and pitch for a video game can come from either the publisher seeking a developer to create a specific game, or the developer pitching their core idea in hopes to sell the property they wish to develop, or to sell themselves, and show the capabilities of the team.

FIGURE
12.1

Development of concepts can often bear fruit.
Image Courtesy of: "Marble Saga" Hudson.

Projects That Start With the Publisher (The Dog Wagging the Tail)

Before a developer is even on a project, the publishing producer is tasked with evaluating original concepts and licenses to see what is "gameable" about them,

91

defining what the publisher should be looking for in the game, providing input and direction on the proper development studios to approach, or discuss the potential game with, then reviewing those teams' pitches for the game. They also work with business dev, sales, marketing, and PR to define where the game fits in the publisher's slate, how it complements the other projects on the slate, what needs to be secured for the property, and what the budgetary and time constraints are.

From there the publisher takes that information and works with the tech and art directors to select a developer that compliments those needs. This is a wading process that could start with numerous dev teams, narrowing down the list based on the specific needs of the project as well as quality vs. costs.

Finding the Developer

Once a vision is decided upon, along with a ballpark figure and list of must-have features, the publisher now seeks out a developer. In cases of publishing companies that own developers, the decision needs to be made, do they go with the internally owned team, or would the game be best suited for an external independent developer?

The producer takes charge of evaluating developers through a due diligence process along with the tech and art director. While the producer evaluates the gameplay skills and vision of the team, the tech director reviews their tools and technologies to make sure these are up to current Next-Gen standards and have a proper flow in place. The art director critiques the artists' team, their tools and pipeline to craft an image, determining if they are the right choice, or if the art would be better off outsourced.

Other equations include: How often has the team shipped on time? What have their past review scores been? Time and reviews scores set the tone for how favorable the developer is. Missing once, or twice, might be acceptable, but you can track how they've done based on their past releases. If the developer is a newbie, you can base their past experience on the past work of the executives and leads. Typically, high-praised talent will set out to start a developer of their very own, and the team is expected to represent what that talent is known for.

Have them submit a pitch. Although it might not be what you finally go with, if they are the team selected, their pitch is used to see how much in alignment their vision is with yours.

All of the findings will be presented in a due diligence report where every member gives their recommendation. If the tech, art, budget, and bandwidth all look good, it now boils down to the producer making a final decision. This is based on how compatible and likeminded the developer is, if they're willing to collaborate (no one likes a developer with an overinflated ego), their track record, speaking with other producers who have worked with them, and most importantly, their passion for the project.

FIGURE
12.2

Experience counts.
Image Courtesy of: "Marble Saga" Hudson.

Projects That Start With the Publisher (The Tail Wagging the Dog)

In most cases, at a developer there is a special pet project they are internally developing as a core goal for the company, even if it is a project they never end up making past a demo. Most meetings between developers and publishers have the developer showing off an example of the work they've done, so instead of showing them something from an existing game, why not combine the pitches and present your work and your game idea all in one prototype? Not only does the developer get the concept of their idea out there, but they can also show the team's capabilities and passions, which can be used for other projects.

Even if the project itself doesn't sell, the developer could get other work from the publisher based on the strength of the presentation and team; other times the game is secured, but merged with the publisher's property, so the game may stay the same, but the core concept and characters might change. Of course there are those special moments when the developer finds a publisher who shares the same vision and they take on the project.

Scheduling and Structure

CHAPTER THIRTEEN

Scheduling and Structure

Scheduling a project can be one of the most daunting and complicated tasks for just about any producer. Although you'll have some say in the length of the project, the ship date will most likely be dictated by sales, biz dev, or a key date that coincides with an event. Once a release date has been determined, the producer must plan out dates by which each and every element of the game needs to be completed in order to ship on time. If a task is incorrectly scheduled, this error can create a backup that will affect the entire production pipeline. The animator cannot synch the lip movements in cut-scenes if the VO hasn't been recorded, or the character model not yet rigged. The sound engineer cannot implement the audio cues or even know what audio will be needed unless the design level has been established. The schedule you create needs to be flexible enough to allow padding for the big jobs and to move things around if there is a dramatic change in the team or the focus.

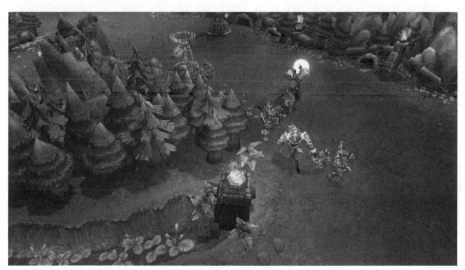

FIGURE
13.1

Scheduling ensures success.
Image Courtesy of: "League of Legends" Riot Games.

The Producer's Role in Scheduling

The producer's role is to create the development schedule, structure it to fit within the production pipeline, and have it jive with the schedules on the publishing end such as those belonging to operations, marketing, PR, and sales. Throughout the entire production cycle the producer must maintain the schedule, tweak it when necessary, rearrange workflow to ensure things remain on time, and adjust the allocation of assets in case of an unanticipated change.

Although allowing enough time and adjusting the schedule for proper game development is the primary goal, the producer can absolutely not disregard the importance of the other departments' and teams' schedules. A slight delay can easily spin out of control, causing a domino effect that can severely delay the release. For example, if a VO recording is scheduled late or delayed it can damage everything from localization to first-party submissions, which will cause the game to miss its ship date. As a result it can cause retailers to pull their orders, cancel promotion, and damage their relationship with the publisher and the reputation of the developer. Retailers base their orders on a constantly revolving stock and timing is key; you won't find them to be very understanding when that schedule is tampered with.

Why Schedule? Heavy Scheduling vs. No Scheduling

Both the dev and pub producer are responsible for knowing the status of each aspect of the game production at any given time, and should always be able to provide an answer when asked at the drop of a hat. That's because a good producer knows the importance of heavy scheduling.

When creating a heavy schedule, it is important to still allow the team members a bit of wiggle room and leeway in doing their jobs. An overly tight schedule that is heavily detailed can become overwhelming, while too loose of one or a general schedule won't help prioritize, or give a clear timeline for when tasks need to be completed.

Creating a schedule is a complex task that inexperienced producers and executives often dismiss as too much of a burden. Many companies that don't specialize in gaming, yet have a gaming division, often have teams dive into production without any schedule aside from asset lock, QA, and completion dates. Without a detailed schedule that assigns specific tasks and timelines for each team member, the project will break down into chaos, causing duplications in work, overlooked key items, and in the end, a broken product that was a waste of everyone's time, money, and resources.

Even the most highly organized producer can find themselves at a company that is not in favor of detailed scheduling. Don't let this become your habit as the burden of responsibility will still land on your shoulders, not on the unspoken policy of the department. Your team expects you to be on the ball and you should expect the same of your team.

Who Owns the Schedules?

It really depends on the structure of the company you are working for, but regardless, as a producer you should always consider yourself the owner of the master schedule. In reality the operations group owns the ops schedule, marketing and PR own their respective schedules, just as the tech, art, program, QA, and discipline leads should be empowered to own their respective schedules (once you've delegated these to them). But you must be on top of all of these teams to make sure you're constantly in the loop and nothing is being overlooked, no efforts are being duplicated, and that the work is structured properly across all the schedules. The responsibility falls on the shoulders of the producer if the timeline falls apart, so you need to be involved with each aspect of your team on a constant basis. Always make sure those groups are on track and have not run into any issues, while allowing enough breathing room to let them do their jobs and not feel they are being micromanaged.

Man-Month Schedule

The man-month schedule represents the production staffing plan and who is working on what and when during different phases of production. This is an important element for both the budgeting of the game and for allocating resources. Man-months are used to determine what staff is needed when the game is ramping up, when it's in full production, and when the product is finalized. It also lets the developer know who they need to hire, when resources can be shared, and when team members are transitioning off the project and can be routed to a new project.

After the cost of tech and above-the-line costs, the publisher determines what they are paying the developer based on man-months. Developers charge a specific amount per team member per month, so an equation is created based on how many team members are working on the game, multiplied by the number they are paying for each member. The amount per man, or woman, per month isn't the amount those individuals are getting paid, but instead it's a number that factors in the developer's overhead and profits needed to keep the company running.

A game does not have the exact same amount of team members for the entirety of a project. It starts off at the concepting phase, which only requires a handful of team members before phasing into pre-production, where a core group representing a mini-version of the full team will be utilized. When you hit production you should be fully staffed up until the game goes gold. Then it's time to start ramping the team members off and on to other things.

Milestones: How They Affect Everything

Although the producer should consider themselves integrated with the master schedule, the primary schedule they should keep track of is the milestone schedule, mainly because it is a representation of what is being worked on and when. If a

99

milestone submission is not completed on time or approved, the developer will not get paid.

The milestone schedule is an outline of the entire game development through the elements listed that will be delivered to the publisher and when. These regular deliverables (typically monthly) reflect the man-month work and represent what the publisher is paying for. If you've allocated level designers or character artists for that given time, then the publisher better sees a representation of the work they've done in that next delivery.

Because the milestone schedule is reflective of each stage of game production, if this schedule slips, then the game might slip, so it's up to the producer to rearrange things to keep it on track. This is why the milestone schedule should be considered a living document and never completely finalized. If a producer or executive says a milestone schedule should be locked, they don't realize what that truly means and likely haven't had much experience in working with this type of schedule. In the event you have to make changes, you must be able to foresee the issues that could cause delays ahead of schedule and notify the powers that be as early as possible to prepare for a switch-out of the delayed tasks with other work of equal weight to make up the difference and keep things on track.

Scrum, Waterfall, Agile, and Cowboy Coding

Producers inevitably will hear from others about which approaches to scheduling and project management work and which do not. Many times, through trial and error, a process gets developed at a studio that breeds success and is reputable. Process is a big component to ensuring a goal is achieved, especially if it's one that continues to work time and time again. Some producers will swear by the processes they subscribe to and will continue to use them as if they were gospel.

The Waterfall method is one of the older processes around. The basic theory is that you plan and design at the beginning and once all of the elements are in place, you can begin to implement and build what has now been fully specced out. Nothing gets implemented in code until all the plans and designs are completely finished. The reasoning is that you need a solid plan before you can develop your game. Unfortunately, this process is the least flexible and in an ever-changing environment, a game design landscape that is often slippery, this process has little chance to succeed in current game development. It has worked in the past, though, so people will continue to use it.

The Scrum and Agile methodologies are designed to complement one another, but for the sake of explanation we're going to start out discussing them separately.

The name "Scrum" is taken from a rugby term, as the whole philosophy was inspired by rugby players working as a team to get the ball down the field by kicking it back and forth to one another. The Scrum methodology takes that same approach into software, or in this case, game development. The way art, tech, design, and audio teams are already set up works perfectly for the Scrum methodology.

The process runs by having team members each work on a different, smaller, element of the project. Instead of being assigned a large project that could take months, the project is broken up into elements, with each element representing the project for that given timeline, typically lasing four weeks which is typically the time between milestone schedules.

The team is assigned their task by a Scrum master, who is typically that discipline's lead or the producer. The Scrum master manages several of these smaller teams, assigning projects to each and supervising their progress. Each member within the team is assigned a different aspect of the project and must see it through to completion. Once duties are set, the team "springs" which is the process of working in unison on a specific aspect of the project, passing amongst one another, quickly completing their task, then bouncing it to the next team member in preparation for another part of the task to be passed back. By the end, the item being developed is ready to be integrated into the game build and submitted for the milestone review.

The Scrum method was one of the methodologies used to create the Agile method, which can work hand-in-hand with Scrum. The two are basically quite similar but the Agile method removes the hierarchy of a team lead, having all members of the group working together at the same level and holding responsibilities for their assigned tasks. It also is more communication-driven and face time–driven. While Scrum has the team members communicating solely to one another and providing updates to the Scrum master, the Agile approach dedicates one team member to be responsible for the "customer services" and communicate almost daily with the client, who in this case would be the producer on the dev end or on the publisher end. You could also think of the dev producer as the customer service member of the Agile team, however these teams tend to be smaller—a series of small, very results-oriented groups rather than an entire development group.

Unlike Waterfall which takes on the entire project at once, Scrum and Agile allow team members to focus on their task and create fast, high-quality results, all being pieced together throughout the production cycle to build out the overall game.

The worst process is having no process at all. In the programming world this fly-by-your-seat methodology known as "cowboy coding" has all the team members diving into a project with each one doing what they feel their part should be, with no structure or direction other than a due date. This typically breaks down into chaos as nothing truly gets accomplished in a timely manner and there is no one globally reviewing the progress.

Elements of a Schedule

When creating a schedule you want to try and leave as little room for error as possible, which means adding as much detail as you can and not overlooking any of the elements, duties, or team member responsibilities. It is a good practice to create your schedule in a software program specifically designed for project management such as Microsoft Project. It's actually surprising how few developers actually use project

management software, so if you can't get clearance for it you'll at least need to put the schedule together using spreadsheet software such as Excel.

When putting your schedule together you must keep the following concepts in mind:

Resources: Determine the resources you have at hand, and what will be needed for the game. The scale, style, and type of game should be a reflection of what your team specializes in, the resources available, and what will be needed additionally. Even the dates this resource needs will be implemented, and when other resources are no longer necessary, should be included in the schedule.

Bandwidth: Consider whether or not you have the entire infrastructure needed for creating the game based on time, scale, and budget. Do you need more team members, or do you have too many? Will you be outsourcing? Are all the roles in the game development covered? Do the team members have the support needed to get the job done? These are all things that need to be considered in creating the schedule and determining man-months.

Dependencies and Priority: As the game is scheduled out you will be breaking each element up into a detailed series of tasks. Examine your tasks globally and determine which tasks are dependent on others. This will help prioritize your individual tasks by grouping them against one another. Seeing how the smaller tasks relate to the larger ones will give you a better understanding of structuring priority. An individual task that you might not consider a priority item can escalate if a more urgent task is dependent on its completion.

Team Tasks: Break down each responsibility and duty of every team member by what they need to get accomplished each given week and month. You should always be able to know what each team member is working on at any given time based on their tasks in the schedule. If there are any items that get shifted, it is up to the producer to adjust the tasks in the schedule so it won't affect the other team members' work.

Timelines: When scheduling out you need to allow enough reasonable time for each team member to get their job done properly, otherwise your project will quickly break down into a disaster. Discuss with your team leads how much time needs to be allowed for each discipline. If there isn't enough time, they you should look at what can be cut and adjusted. Prioritize the most important tasks to the least, and start cutting from the bottom. It's tough cutting features and levels that you and the team are excited about, but shipping on time is paramount.

Troubleshooting

With time and experience a producer can foresee issues coming as early as the scheduling stage. This is why the most effective producers are ones who've cut their teeth on other production cycles as associate producer and production coordinator, seeing firsthand common problems that could have been prevented. Everything from a short staff, holidays, trade shows, publisher slate changes, hardware resources, vacations, and

even pregnancies can kill a project months before the GMC is due. It's the producer's duty to make sure these are foreseen and accommodated in a flexible schedule.

Producers should take advantage of the senior producer and executive producer's experience by having them review, provide feedback on, and approve all schedule changes and provide regular updates that include what stage of the schedule the project is in and any changes that may occur, along with the reason why things may have shifted.

Other Teams' Needs and Schedules

When dealing with team disciplines and tasks, ask yourself, "Does each team member have the tools and resources they need to stay on task and on schedule?" This can include not only hardware/software and tools, but also training, updates, and support. If you come up short on any of this, it's up to you to find out what it takes to get these needs, and how long you can last without these resources before it will affect the schedule.

Many projects have shared resources, but a team member being split across multiple projects can easily have their attention shifted to the project with the most needs. Because developers have a crunch about every time a milestone delivery is due, you must confer with the producer on the other project (if it's not you) and ensure that the schedules of both projects don't have overlapping milestone deliveries, or resource needs. Tech directors can't fix crash bugs on two projects at once and audio engineers can't attend two VO sessions simultaneously.

Hardware

Oh, the pain of hardware. While nearly all developers have all of the core tools, equipment, and servers to build a game, there are two major pieces of hardware that the developer typically gets from the publisher: test and dev kits. These kits are one of the most difficult pieces of hardware to get in the world of gaming, mainly as they are only available through first parties (Sony, Nintendo, and Microsoft). Although developers can purchase kits with a developer license in place, those are costly, so publishers typically foot the bill and loan them to the developer during the production cycle, expecting their return during post-production.

The issue for publishers is that test and dev kits are extraordinarily expensive and are limited in supply because they are in higher demand than first parties can manufacture. A single project could require numerous test and dev kits, so publishers must share their supplies across all projects.

DLC, Expansion Packs, and Sequels

While building the main game, all of these things must be taken into consideration and scheduled. You're going to be building the expansion packs and downloadable

content during the same time you're making the main game, and prepping/planning for how an asset can be utilized for a sequel as you are building it, so you must have as much information as possible at the beginning of the process as to what will be needed in addition to simply just a game.

Marketing, PR, and Sales Needs

One of the eternal conflicts in any gaming corporation exists between marketing, PR, and production. The thing to keep in mind when it comes to groups such as these is that you need to understand their position and situation. No one has an easy job when it comes to video games; often the marketing, PR, and sales teams don't fully understand the pressures of production, and few PD folks understand the politics and hurdles involved with marketing, PR, and sales work. The best way to maintain a good working relationship with marketing and PR is to make the work as easy for them as possible. Let them know that in order to help with their needs, you first need them to generate a schedule as to when they will need assets such as screenshots, gameplay footage, and demos, and make sure they plot out when demos, trade show materials, and other needs will arise. This might feel like pulling teeth, especially when the marketing team, who doesn't work as far ahead of schedule as you do, might resist creating a schedule such as this. Many marketing, PR, and sales folk are extremely resistant to committing to a schedule because they feel they are now trapped in an obligation before they even know what that year holds for them.

Marketing and PR for a game typically starts 9 months before launch, but long before then you should have your schedule padded to accommodate any need that marketing, PR, and sales may have. As a producer you should know that something will be expected for E3. Look at the other tradeshows your company or publisher typically participates in. Do they often have downloadable demos via Xbox Live Arcade and PlayStation Networks, or in back with other games or magazines? A demo pulls a team off its focus, but is a necessary evil that the production team must deal with.

Also, screenshots can pull focus off as they are typically a time-consuming and mind-numbing endeavor that may take two bodies off the game development just to deal with screens.

On the publishing side, no matter what the resistance, the producer should be involved in screenshot selection and game footage. In an ideal situation the producer should actually be playing the game during the footage capture session to ensure they are seeing all of the gameplay and none of the bugs, and get just the right shots. Even though marketing and PR may give you some resistance in being part of this selection, it is important that you push back because you will be held responsible for negative public reactions to the game screens/footage, not the folks that selected them.

Because this is extremely time-consuming, you should know when these assets are typically needed in a game production cycle and pad portions to accommodate a delivery. This is why getting schedules of asset needs from marketing, PR and sales is key, however you should expect their needs to be far more than what they

ask and schedule for, as some opportunities cannot be predicted. It's always better to have more assets to promote your game than less.

Screenshots and PR/Marketing Materials

One of the larger political landmines in your professional relationships can easily be trying to manage your schedule with marketing, PR, and sales. While in an ideal situation you're working for over a year before the game's release, the work of the PR, marketing, and sales teams doesn't begin until much deeper into the cycle, so they aren't even thinking about their schedule until long after yours has been set. That being said, you need to know what their needs are and plan accordingly before they are ready to commit to anything.

The best plan of attack for this is to overcompensate. Once you start production you should include screenshots from each and every build as part of the milestone deliverable. While this used to be a huge pain, pulling multiple team members off of their work to takes screens, the Next-Gen development kits of today have made it much easier.

Also, get to know what marketing, PR, and sales have to deal with in a given year. How many trade shows do they do, and where do they land in your schedule? Accommodate time to build out a demo or sample level to show to press, the public, and potential retailers. Do they like to release playable or downloadable demos? How far out do they plan on releasing trailers and gameplay footage? Plan for magazine covers and special art and character models for press use. Eventually a website will also come into play. All of these things need game assets.

Do not just hand your game builds over to marketing and PR to record gameplay footage by themselves or via a third party. The producer should be the one playing the game as footage is recorded; otherwise they will capture bugs and unfinished portions of the game, and they will have no idea if what they are seeing looks right or not.

Example: The writers of this book were working on a game, and the publisher hired an outside company to capture gameplay footage without notifying the producers. When we finally saw the footage, which had already been used for sales sizzle videos, none of the character models had pupils and all the mirrors were bright green and glowing. We hit the roof when we found this out and insisted on going over to the third-party contractor's studio and record the footage ourselves with our own test kits. When we arrived we found they were using a makeshift illegal test kit they built themselves and were playing the game off of discs, when the builds were designed to play only off the hard drive. All the work they were paid for had to be redone from scratch.

Here are some examples of what to expect.

PR/Marketing:

- Trade shows (E3: The Electronic Entertainment Expo, Comic-Con, Penny Arcade)
- Press
- Interviews

FIGURE
13.2

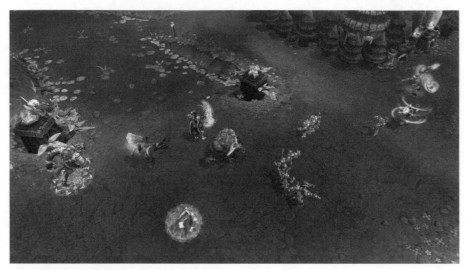

Great games make for fantastic screenshots.
Image Courtesy of: "League of Legends" Riot Games.

- Blogs
- Lots of screenshots
- Press release
- Overviews of the games, including special features
- Gameplay footage
- Websites

Sales:

- Sales tours: Visiting major retailers to promote the slate of upcoming products
- GameStop's Manager's Day
- Demoing to international sublicensors
- Exclusive bonus content

Holidays and Vacation

During and after a production cycle, team members will inevitably need a break. Talk to your team members early on about when they plan to take time off so you'll be able to accommodate for the missing team members. Your planning should not only include vacations and national holidays, but weddings and babies being born, and the shut-down of the industry between Christmas and New Year's.

CHAPTER FOURTEEN

Development Plan Management (Scheduling to Production)

This section is about how to create an initial high-level schedule for the entire project, and how to detail out the plan to get to production.

FIGURE
14.1

Aim high when developing a plan and schedule.
Image Courtesy of: "Watchmen" WBIE.

Tasking the Project

As mentioned before, no two projects are alike, so don't try to simply reuse the same list of tasks from other games, try to duplicate the task lists used by other producers, or think you can figure it out alone. While there are tasks standard to most video games, these can differ from the slight to the dramatic based on the title. You need to examine what is exactly necessary for the individual project you're working on and discuss with your team leads what is needed for its creations. Start off by splitting the project up into general goals, such as character art, environments, level numbers, etc., then break those down into the pieces that make up those goals, then dissect those down into every element that make up those pieces. On your schedule these are the tasks, on your project they are the pieces that make the whole.

Putting all of the tasks that make up the game together on paper helps give you a global look at the project so that you can find holes, you can leverage, you can look for unnecessary duplication, and you can determine whether your scope is within the realm of your time and budget. The tasks listed should be clear and easily recognizable, with simple directions everyone can understand. Don't leave it up to the team members to try and interpret the meaning of a vague task or unclear list elements.

FIGURE
14.2

Don't leave things open to interpretation. Be clear and concise.
Image Courtesy of: "Watchmen" WBIE.

Once you have your tasks down, you should discuss with the leads how long each item should take to complete. This not only helps in determining the schedule, but also if there is anything on the project that cannot be completed in the dev time. You must, however, be careful with the answers you get from the team leads as they tend to lowball how long each task will take. Mainly because they are determining it on how long it "should" take, not considering the roadblocks that come up along the way. As the producer you need to estimate and pad for this. It's always best practice to add about 15 percent to each timeline estimation a lead provides.

After the tasks and timelines are all together, list them in order of importance and dependencies. From here you might have to start whittling them down from pie-in-the-sky ideas to what is realistically necessary for the game to be completed on time and on budget, while maintaining a quality standard.

Implement tracking and communication software such as SharePoint and Wikis can help you monitor tasks, track changes, and keep you up to date—they are good at keeping histories of changes automatically.

Delegating Tasks

When assigning tasks it's time to regroup with your team leads once again and work with them to determine how each element should be delegated. You want the most responsible and experienced members assigned to the more prominent items; save the lesser ones for the junior members.

After the big tasks have been assigned, let the team know what's left. While too many of these undelegated remainders may seem undesirable, a member who is working his way up the ladder may jump at the opportunity. Any minor task that's left gets delegated to where it fits best, with the team member that can best handle the load and complete the job.

Monitoring Tasks and Tracking Changes

Set up an infrastructure for task monitoring. Always have weekly meetings throughout the entire project, and stay in constant communication with your team leads. Spontaneous meetings can come up and often do when barricades prevent a task from moving forward.

Each team lead should be providing weekly reports via whatever communication software you've selected, and a shared task list should be incorporated so that at any given time you can check it to see what has been completed and what still needs to be done. This can help you identify an upcoming problem if a task is getting skipped or delayed.

Task Management Software

There are numerous types of software that can be used to track all aspects of a project. Finding the one that fits with your team's personal style is key. Updating information in the program shouldn't be a burden, but as quick and simple as possible. Unfortunately, you'll most often find Excel used as the primary project management software, with everything having to be constantly updated, adjusted, and searched for—not to mention that one wrong code can spoil the entire spreadsheet.

While Excel is a great accounting tool and nice for creating a contact sheet or financial report for accountants, it's a terribly cumbersome and unreliable solution

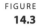

FIGURE
14.3

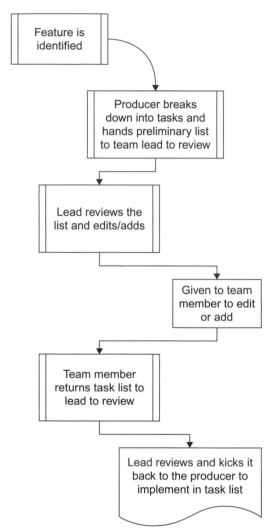

Process of how tasks are created/assigned from a feature.

for project management. The most popular project management software solutions today are Microsoft Project, Mindview, and MacProject. This business software was designed specifically for the types of items you're working on, from creating task lists and tracking the entire project to generating daily reports at the beginning and end of each day. Even if you're not currently working as a producer, if you aspire to be one, you should learn these software tools in and out. It's invaluable knowledge to have.

FIFTEEN

Budget Management

While creating a dev budget sounds like a daunting task, it's actually quite simple if you think of it as a mathematical equation. The tough part is staying on budget, because no mathematical formula can predict the unexpected changes that will affect your game's costs.

FIGURE
15.1

Project Start	5/1/09
Concept Period End	7/31/09
Pre-Production End	12/31/09
Alpha	9/30/10
Beta	12/31/10
Release to Master	4/30/11

Total Months to Gold	24

Currency	$ (USD)

Actual Milestone Payments to Developer per Project Phase (including all sku's)	
Concept	1,399,174
Pre-Production	2,258,503
Production	5,686,464
Post-Production	3,224,919
Post-Gold	53,814
Total Project Cost	12,622,875 $ (USD) Not Including "Other Costs" Listed "Provided by Publisher"

		Cost Calculations Per Sku Per Phase			
Platform	Team Size	Phase	Months	Man Months	$ (USD)
PS3/X360	12.2	Concept	3	37	456,250
	35.1	Pre-production	5	176	2,062,125
	54.6	Production	9	491	5,523,750
	29.6	Post-Production	7	208	2,438,125
	1.0	Post-Gold	1	1	12,500
				911.5	10,492,750
PC	.	Concept		.	.
	.	Pre-production		.	.
	1.3	Production		12	135,000
	1.6	Post-Production		12	135,125
	.	Post-Gold		.	.
				23.5	270,125
Other Costs		Concept			.
		Pre-production			267,500
		Production			360,000
		Post-Production			157,500
		Post-Gold			
					785,000
Outsourcing		Concept			.
		Pre-production			107,500
		Production			967,500
		Post-Production			.
		Post-Gold			.
					1,075,000

Example of a development budget.
Image: Project Cost Analysis File © 2009 Digital Development Management, Inc.

Creating a Project Budget: Man-Months and the P&L

FIGURE
15.2

Person-Month Rates	Concept	12,500
Listed by Period	Pre-Production	11,750
	Production	11,250
	Post-Production	11,750
	Post-Gold	12,500
Milestone Spacing	Monthly	

The cost of the man-months can be consistent from beginning to end or fluctuate based on the stage of development.
Image: Project Cost Analysis File © 2009 Digital Development Management, Inc.

This is where that math equation comes into play. Specifically for the game development, in addition to below-the-line costs, publishers pay developers based on man-months. Each team member is equal to a specific cost each month, so for every month a team member is working, the publisher is charged a flat amount per individual head.

To make this equation you don't simply count the maximum team members by how many months the project takes from beginning to end, as that number of dev staff on the project will fluctuate through the various stages. Based on the scope, schedule, and ambition of the game you'll be able to work with the team leads to determine out how many individuals will be needed at each stage of the project. During the concepting stage you'll only need a few members, most likely the producer, creative director, tech director, and art director. At pre-production you'll need more staff to build out a smaller version of the full team to create what will become a playable prototype of the game; the additional staff includes artists, programmers, designers, and sound engineers. Once you roll into production you should have your maximum staff and full team. Then at post-production you'll be working with a skeleton team on software updates, archiving, and postmortems.

FIGURE
15.3

The number of team members grows from the core at concept, ramp-up at pre-pro, full staff at production, and ramping down at post.
Image: Project Cost Analysis File © 2009 Digital Development Management, Inc.

Aside from man-month costs, the game's budget is factored by above- and below-the-line costs. Below-the-line costs consist of dev tools, middleware and engines, audio tools, motion capture, and outsourcing. The man-months and below-the-line costs will eventually go into the developer's contract to prevent any changes. If that number ever does have to change, it will require a lot of justification and an addendum to the contract.

The above-the-line costs consist of items not needed to actually build the game, but all the extra bells and whistles such as music, voice-over talent, recording and mixing studios, writers for both story and dialogue, consultants, and other contractors that the publisher will need for business purposes. Most often the publisher takes care of these matters and provides the resulting assets to the developer for implementation into the game.

One item that moves between above- and below-the-line costs are the cinematics. Some dev teams are extremely talented and focused at creating cinematics, while others have more of a focus on the gameplay side and don't have the resources or the bandwidth to create out-of-engine animations.

FIGURE 15.4

Other Costs				
Middleware:	**Notes:**			
Animation Middleware		115,000	115,000	
Audio Middleware		20,000	20,000	
UI Middleware		45,000	45,000	
Video Playback Middleware		15,000	15,000	
Additional Costs:	**Details:**			
Development Kits	See Bottom of Staffing Plan		Provided by Publisher	
Localization Integration	5 Languages		Included	
Script Writer			Provided by Publisher	
Cinematics			Provided by Publisher	
Motion capture		155,000	155,000	
Music		85,000	85,000	
Sound Effects		40,000	40,000	
Voice Over Talent			Provided by Publisher	
Voice Over Studio			Provided by Publisher	
TOTAL – Other Costs			475,000	$ (USD)

Outsourcing				
Location	**Item / Details**		**Total**	
Studio Name	Character Art		450,000	
Studio Name	Environment Art		375,000	
Studio Name	Vehicle Art		250,000	
Studio Name			-	
Studio Name			-	
TOTAL – Outsourcing			1,075,000	$ (USD)

The below-the-line costs are included in the dev budget. The above-the-line costs are paid out of a separate budget allotment.
Image: Project Cost Analysis File © 2009 Digital Development Management, Inc.

Don't mistake cinematics for cut scenes. Cut scenes are done in-engine using game assets and should be created by the developer. Cinematics are animated pieces done out of engine, often with higher-res models and art. If the developer does this in-house, it becomes part of the below-the-line costs, but if the publisher has it outsourced to an animation studio, then it is no longer part of the core development and becomes an above-the-line expense.

Once this is all together, the publisher takes the sum and combines it with marketing and PR costs, and then compares the total against a P&L.

The P&L

The budget of a game always has to be justified, and although we'd like it to be based on quality, in reality it's all based on the profit and loss (P&L). The P&L is basically the number of units a game would have to sell to break even and then make a profit. If the P&L is too high for the publisher to make what they deem a reasonable amount of return, then the budget of the game needs to be reduced. This is why you want to foresee where you can cut corners while you're planning out the schedule so you know in advance where you might have some wiggle room.

Example: If the game "Robot with a Gun Part III" has to sell 900,000 units at $60 a pop to make a profit, but sales predictions based on the genre, style, and built-in audience show the game selling closer to 500,000 units, then the publisher can't justify paying more than they think they'll ever get back. The result is that the overall budget for the game needs to be reduced. This is why you want to foresee where you can cut corners while planning out the man-months and schedule.

The only exception to the P&L rule is when the publisher is trying to establish a new franchise that has potential for long-term growth with sequels and/or licensing out the IP. These situations are the few times a publisher is willing to make a gamble that could result in financial loss, in hopes that the franchise takes off resulting in larger profits in the long term.

Where to Cut Corners

Managing the Budget

As the producer you can orchestrate the most incredible, award-winning game ever released; making huge profits and gaining many accolades for the publisher and developer, but if you go even slightly over budget, that's all anyone is going to remember, no matter how much money is accrued in the long run. So it's important to manage your budget closely. In the event that your budget needs to be reduced due to the P&L or unforeseen disasters, here are some ways it can be trimmed which—if approached properly—will have minimal impact on quality.

Headcount

It's always better to plan for a little more than what you need, this way if your budget clears the P&L then your game will be that much better, but if it doesn't, you have some room to work with. Always plan for a few extra heads in QA, art,

FIGURE
15.5

Key Milestones:			Project Start			Concept Period End					Pre-Production End		
Project Phase:			Concept	Concept	Concept	Pre-Pro	Pre-Pro	Pre-Pro	Pre-Pro	Pre-Pro	Production	Production	Production
Month Number:			1.0	2.0	3.0	4.0	5.0	6.0	7.0	8.0	9.0	10.0	11.0
Title	Function	Platform	1-May-09	1-Jun-09	1-Jul-09	1-Aug-09	1-Sep-09	1-Oct-09	1-Nov-09	1-Dec-09	1-Jan-10	1-Feb-10	1-Mar-10
PROJECT MANAGEMENT													
Executive Producer	Project Manager	PS3/X360	0.5	0.5	0.5	0.5	0.5	0.5	0.5	0.5	0.5	0.5	0.5
Producer	Project Manager	PS3/X360	0.5	0.5	0.5	1.0	1.0	1.0	1.0	1.0	1.0	1.0	1.0
Assoc Producer	Project Manager	PS3/X360	-	-	-	1.0	1.0	1.0	1.0	1.0	1.0	1.0	1.0
Total	Production		1.0	1.0	1.0	2.5	2.5	2.5	2.5	2.5	2.5	2.5	2.5
DESIGN													
Creative Director	Design lead	PS3/X360	0.5	0.5	0.5	1.0	1.0	1.0	1.0	1.0	1.0	1.0	1.0
Design Lead	Design lead	PS3/X360	1.0	1.0	1.0	1.0	1.0	1.0	1.0	1.0	1.0	1.0	1.0
Game Designer	Game designer	PS3/X360	1.0	1.0	1.0	2.0	2.0	2.0	2.0	2.0	2.0	2.0	2.0
Level Designer	Level designer	PS3/X360	-	-	1.0	1.0	1.0	2.0	2.0	2.0	4.0	4.0	4.0
Total	Design		2.5	2.5	3.5	5.0	5.0	6.0	6.0	6.0	8.0	8.0	8.0
ENGINEERING													
Technology Director	Technical lead	PS3/X360	0.5	0.5	0.5	0.5	0.5	0.5	0.5	0.5	0.5	0.5	0.5
Lead Engineer	Technical lead	PS3/X360	0.5	0.5	0.5	1.0	1.0	1.0	1.0	1.0	1.0	1.0	1.0
Lead Gameplay Engineer	Technical lead	PS3/X360	0.5	0.5	0.5	1.0	1.0	1.0	1.0	1.0	1.0	1.0	1.0
Rendering Engineer	Rendering engineer	PS3/X360	-	-	-	1.0	2.0	2.0	2.0	2.0	2.0	2.0	2.0
Physics Engineer	Physics engineer	PS3/X360	-	-	-	1.0	1.0	1.0	1.0	1.0	1.0	1.0	1.0
Networking Engineer	Networking engineer	PS3/X360	-	-	-	-	-	-	1.0	1.0	2.0	2.0	2.0
Gameplay Engineer	Gameplay engineer	PS3/X360	-	-	-	1.0	2.0	2.0	2.0	2.0	4.0	4.0	4.0
AI Engineer	AI engineer	PS3/X360	-	-	-	-	1.0	2.0	2.0	2.0	2.0	2.0	2.0
Engineer	Platform engineer	PS3/X360	-	-	-	-	-	-	-	-	-	-	2.0
Engineer	Platform engineer	PC	-	-	-	-	-	-	-	-	1.0	1.0	1.0
Tools Engineer	Tools engineer	PS3/X360	-	-	-	1.0	1.0	1.0	2.0	2.0	2.0	2.0	2.0

Example of staffing plan.
Image: Project Cost Analysis File © 2009 Digital Development Management, Inc.

and programming as extra heads in these disciplines are always needed, but can be trimmed down if necessary to still get the job done.

You should know your game well enough to determine where you need to heavily staff and where you can pull back. If your game depends heavily on animation, you don't want to cut there, but if you're less dependent on having a wide variety of character models, you may not need as many modelers or character artists. If multiple projects at the dev studio are in production at the same time, you can sometimes share team members that aren't always needed on a daily basis across the projects, so that number of QA members per month can change from 2 to 1.5 or if a single team member only needs to dedicate half their time to the project in a given month it can drop from 1 to 0.5. Also determine when you're going to absolutely need a specific dependency over when they're less needed. It would be great if you could have an audio engineer from pre-production to post, but they aren't as necessary until mid-production.

Outsourcing

Another area that can be a cost-saving measure is outsourcing. While most developers have a full team at all times, having those team members focus on time-consuming, menial tasks at the full man-month price can be a waste of time and money. Often it's better to have them focus their talents on the bigger items for the game and outsource the smaller duties. This especially rings true for art. Having the art team building various tables and chairs that most players won't pay attention to is wasted resources. There are low-cost, quality companies that specialize in these areas.

Often these outsourcing companies are overseas and can do decent work at a fraction of the cost, but you have to be careful not to over outsource. For a game to maintain a cohesive quality and style, it needs a full team sharing in the day-to-day

evolution of the project. Outsourcing too much of the project and "Frankensteining" it together loses the vision and soul of the game, which shows in the final product.

Managing the outsourcing is the responsibility of the team lead and development producer. Just like any team member, the outsourcing company needs to be managed to make sure the level of quality and style match the rest of the game and that they deliver on schedule. The team leads will set the tone for the outsourcer and manage the quality of work, while the producer keeps the outsourcer on track.

A good example of how this works is when artwork is outsourced. The art director will provide a style guide, plus examples of the look and feel. The tech director will also provide detailed information on how the art needs to be prepared in order to be compatible with the tech being used. At each stage of the art's development, the art director will provide direction and make sure that the team is creating work that can seamlessly be dropped into the environment with the player never noticing the visual difference between the in-house work and the outsourced elements. This is also reflected in the outsourcing company you choose. Both the team leads and producer should be involved in selecting the outsourcing company and exercise the same due diligence that they themselves go through when being evaluated by the publisher.

Quality Check

These adjustments can dramatically reduce the budget, but also drag down the quality with it. The developer and publisher need to come to an agreement on what quality level they're aiming for, based on budget vs. scope vs. P&L and how the quality level will affect perception and sales. Yes, the publisher is footing the bill, but the developer has to be mindful of their reputation, so it needs to be agreed upon at the get-go. If you're not willing to lower that level of quality but still need to reduce the budget, it's time to reexamine the scope, length, and feature set of the game and see what can be reined in, or just plain cut.

Reusing and recycling assets is another way of leveraging limitations without reducing the quality, or scope. Character models can be redressed and reused; a pre-built environment can be reskinned. Even animation can be reworked for more than one use. Just like outsourcing, you can't overdo this, or it will become noticeable to the player and mark the game as both cheap and cheesy, something you want to avoid when asking consumers to shell out $60+ for a game.

Ethics

When it comes to money, on both the development and publishing side, ethics can sometimes go out the window. These aren't the most common of instances, but if your career lasts long enough, you'll eventually see some of these unscrupulous tactics in action.

On the development side, there are some that would agree to make a game at ridiculously low costs, which would cause a corporate exec who doesn't know any better to jump at the offer, but down the road when the publisher is pregnant with the project, the developer pulls the old bait and switch, claiming that a key feature or the promises they committed to can't be done without an increase in budget. Yes, the developer is risking losing the project, but they know that once you're a certain distance into a new project, it can be more expensive to switch developers than to just increase the budget. Another tactic on the development end is to charge full man-months for the team members, only to split those team members among other projects, or worse, have it all outsourced. This is why the due diligence visit is so important, and the producer should visit the development house as often as possible.

Now don't think that there aren't questionable publishers out there too. Developers are often dependent on the publisher approving the milestones and making their payments on time. This dependency has the developer as a sort of investor in the company as the developer's future is tied into that publisher's success. However, unlike a partner that invests money in the organization, they don't have the right to look over the publisher's books to make sure they are spending the money in an ethical manner before committing to a project. When a publisher goes out of business it often causes repercussions that have an industry-wide effect, causing numerous developers to go down with them because they are so dependent on the publisher's payments to keep the lights on.

Some tactics publishers turn to when they're broke is to not approve a completed, high-quality milestone deliverable so that they can avoid having to pay for it, or delay the approval or payment of the milestone for as long as possible. For the producer on the publishing end, this can be a difficult moral decision as you'll be the one asked to reject the milestone.

The best way to handle this situation is to approve what you feel is acceptable and leave it to the higher-ups who are telling you to reject the submission to do it themselves. Then go deliver your resume to a publisher who knows these tactics aren't worth using.

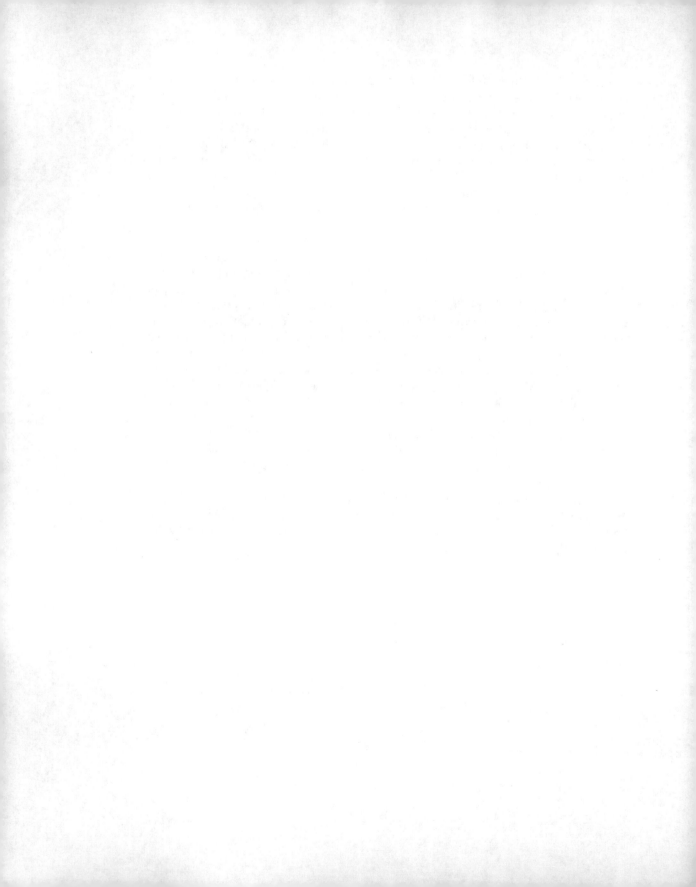

The Milestone Schedule

Don't mistake your master schedule for your milestone schedule. The milestone schedule is just one segment of the overall schedule, but it is the most important to production, listing out and defining the work that is being accomplished as physical deliverables. Each deliverable, typically due once a month, represents the work that each team member has made in direct relation to the man-month budget.

The milestone schedule calls out each point in the dev cycle that signifies accomplishments and progression. This helps everyone understand where they are in the dev cycle as well as the major deliverables that need to be provided to the publisher to show how the game is progressing. Although the milestone schedule may change and shift over the game's progress, it is put against the developer's contractual agreement with the publisher, where both parties agree payments will be made based on a level of work and quality delivered.

Creating a Milestone Schedule

As mentioned before, each line item in a milestone schedule should be a direct reflection of the development work completed based on the man-month schedule. If the man-month calls out three character modelers, there should be deliverables that reflect the work that has been done by those three artists, all representative of a month's worth of their labor.

The milestone schedule is a living document that will grow and change along with your game's development, so you can't be as beholden to the initial pass of the milestone schedule outside of key deliverables on which the ship date depends.

First you'll need to list out and define every deliverable that is needed and necessary to complete the project at each stage from concept to post-production. This will be modified as the dev cycle progresses, but you need to get it down on paper first. Then, based on your staffing, you'll need to place each deliverable in the schedule and the appropriate timeline based on when you'll be ramping team members onto

the project and off the project. You'll also need to call out the format, such as digital files, art, concepts, animation, and code, so that the publisher will know what to expect and in what format.

Once you've listed out the deliverables, organize them by priority, dependency, and the man-month budget. Place these in a spreadsheet broken down into regular deliverables. The timeline of each milestone delivery needs to be decided upon between the dev and pub producers. Typically the deliverables are in direct relation to the developer's payroll schedule. Most often this is in 4-week cycles, and in some cases 5 weeks, but having a regular monthly schedule is helpful because everyone will know when to plan for, and expect, a milestone delivery.

The milestone schedule will go back and forth between the publisher and producer as it gets fine-tuned. The pub producer will be comparing it against the non-production team's schedules to make sure demos, screenshots, localization implementations, ESRB submissions, and other outside dependencies are required. These deliverables might not have to do with actually building the core game, but they all rely on the game being at a certain point of completion and have deliverables associated with them that should be listed as part of the respective milestone.

After the tweaking is completed, you'll have a finished schedule that is a complete breakdown of all the elements for your game and when each item is due in to the publisher.

Managing the Milestone Schedule

The milestone schedule will provide the goals for the dev team and direct what they need to do for that specific month. Don't ever wait until the milestone deliverable is due before checking to see if all the tasks have been completed. Throughout the month you should make sure that each task and deliverable is progressing.

With the exception of key milestone dates that would affect shipping the game on time, don't be too much of a slave to the schedule. If built correctly it should allow for flexibility and changes, as changes are bound to surface. It's very important for both the dev and pub producer to understand this as well as their higher-ups, because it can be damaging to all parties if a milestone schedule is considered locked; important tasks and elements may have to be neglected while unnecessary items get too much focus in an effort to meet a deadline that hasn't evolved with the project.

Circumstances causing a delay or change in the milestone schedule will always arise at some point in production; this is why it's referred to as a "living document." For the developer it is of the upmost importance to notify the publisher immediately upon learning that a change may be necessary. Waiting until the milestone is due to let them know of a change, sends the message that you are not living up to your obligations and the result could be a rejected milestone. On the flip side, if the publisher decides they want to make a dramatic change or addition to the game, they must notify the developer immediately so it can be planned for. Far too often when

both the dev and publisher are pregnant with a project in a tight timeline, some executive will come up with a brilliant idea to generate more cash flow by having an expansion pack, downloadable content, or bonus features exclusive to a major retailer, which now has to be built in tandem to the game. These types of added content are typically planned out at the beginning of the project and built during full production, so if added content needs to be tacked on late in the project, the developer needs to know as early as possible to budget and schedule for it, otherwise it can compromise the final game.

Preparing a Milestone for Submission and Review

Preparation for delivering a milestone to a publisher is almost as important as the content itself. If a publisher can't make heads or tails of what you are delivering, if there is no walkthrough of the build, if the build doesn't run properly, or even if it is missing a breakdown explaining what assets are included in the delivery and how they relate to the game, the submission risks getting rejected as incomplete.

When preparing the milestone you need to place it in as logical and organized a format as possible. Regardless of whether it is delivered digitally or physically on disc, the milestone deliverable should be in a master folder calling out the milestone number and date of delivery. Within that master folder should be subfolders broken down by discipline (art, animation, design, code, and tech) along with a milestone outline document providing an overview of each item in the deliverable and how each relates to the overall project and is reflective of the man-months.

In addition to being organized, presentation is key. Each month, you want to wow the publisher with what they are seeing. And the publishing producer wants the deliverables to wow each of the team members who are expected to sign-off on the milestone. Don't expect every executive that is required for approval to be as game-savvy as you are; make sure each doc is clear and will be easy for any layman to understand. Lack of knowledge about game development is an unfortunate reality in the business world of games.

Your overview should be clear and easy to read with bullet points and screen grabs relating to each item. Any game build deliverable must, without exception, come with a detailed walkthrough. You don't want delays in approvals because your publishing counterpart doesn't have a guide to quickly review the build. You're not sending it to them so they can play a game, you're sending it to them so they can review the content.

When dealing with files, make sure that they are sent in a format the publisher can properly view. Don't send Maya files unless they are specifically requested, as few pub producers will have this costly software. Instead, send the images as Jpegs or QuickTime turnarounds. In the submission the developer should call out the firmware they are using for the build. Firmware is updated regularly and you need to make sure all parties involved are using the same update, or else the publisher will have problems running the build, or it might show up on screen with messed-up graphics.

Items to Expect in a Milestone Deliverable

Here are some examples of typical milestone deliverables:

- The Game Design Doc: Your game on paper.

- Art Design Doc: An overview of the look and style of the art, and how it will be created and implemented.

- Tech Design Doc: Outlining the entire tech, code, and how the game falls into the specs of the console. Updated regularly.

- Code: The game build can range from white boxing, feature testing, on through playable levels and the finished game.

- Memory Map: A breakdown of how the memory is being allocated, to keep the build in check for remaining playable on retail consoles. Fitting game code into memory can be a stumbling block.

- Walkthrough of the game builds.

- Sound Design Docs: Explaining how audio will be implemented into the game.

- Art: Includes anything from concept art, animations, character, environment, and object models.

- The Previous Milestone: Speak to all the changes that were made based on the feedback provided with the previous milestone, and if they were not completed, provide an explanation as to why.

- The Next Milestone: This is where you should call out any expected changes in the next month's milestone deliverables based on what you've learned from the past month's milestone. Ideally this should be discussed before including as a deliverable.

What Shouldn't Be Included as a Milestone Deliverable

Often the development team wants to include their ideas and concepts for marketing and PR, as well as story, script, and music. While you should be able to freely send these to the publisher, they should never be included as a part of the milestone submission. These are not part of the developer's requirements and shouldn't represent what the publisher is paying for. These types of items can be rejected and delay payments, so it's best to send your recommendations separate from the milestone submission, and don't put any man-month cost against them unless it was previously agreed upon to do so.

SEVENTEEN

Pipelines

The pipeline is a process where an asset or element of the game moves from concept to completion and then into the game build through a series of steps where multiple team members each contribute a portion to the overall asset. This is by no means a new concept, it comes from Ford Motor Company's assembly line techniques dating back to 1908. While the pipeline does still hold some similarities to Ford's system for building the Model T, it has since evolved and been adapted to work within many different schools of software development techniques. While all of these different development styles can vary dramatically, they are all variations on the theme of a pipeline.

Game development consists of a series if interconnecting pipelines. Each discipline can have numerous sub-pipelines within it and as each element is completed it branches off onto another pipeline, eventually working its way into the final code. The clearest example of how a pipeline works is through the evolution of a character model. The example that follows is very basic; there are numerous techniques, styles, and approaches to a pipeline, this only being one. These pipelines are also never clear lines, having the asset back-and-forth at various stages, with work in progress moving onto the other pipelines so as to not cause delays in the other disciplines' work.

An Example of a Pipeline: The Character Model

A primary character model in a game is rarely made by one single artist from start to finish. Here is a simplified example showing the evolution of a character model as it goes through the artists' pipeline (Figures 17.1–17.8).

FIGURE
17.1

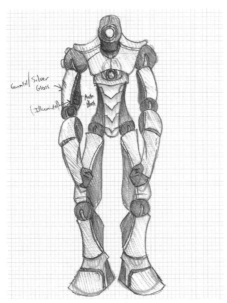

A concept artist creates a 2-D image of the character.
Image by Matthew Krause.

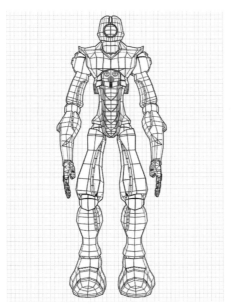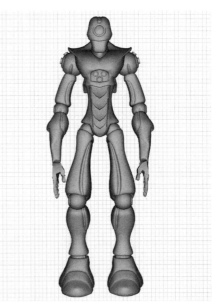

A 3-D model artist creates the 3-D model based on the concept.
Image by Matthew Krause.

FIGURE
17.4

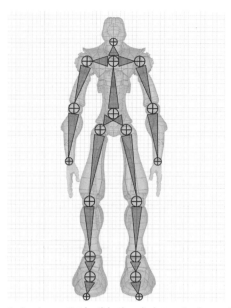

A rigging artist builds the skeleton (or bones) of the model.
Image by Matthew Krause.

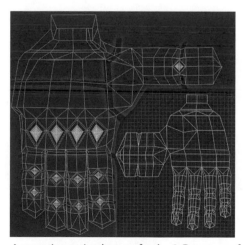
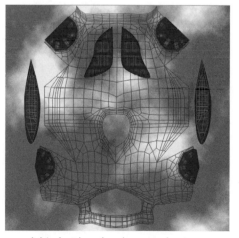

 A mapping artist then crafts the 2-D textures for the model (robot hand and upper chest textures).
Image by Matthew Krause.

FIGURE
17.7

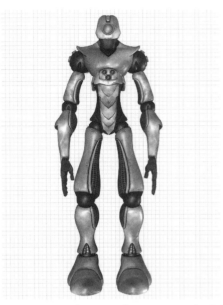

A mapping artist maps the texture to the 3-D model.
Image by Matthew Krause.

FIGURE
17.8

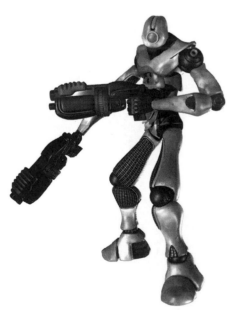

A final model is provided to an animator who adds motion to the character.
Image by Matthew Krause.

Pods and Cross-Disciplinary Teams

Recently the concept of cross-disciplinary "pods" have gathered steam and are beginning to become common-place in the development community. The basic idea behind this working philosophy is that you have smaller groups working towards a common goal that includes members of different disciplines, like a mini-team focusing on one small portion of the project. So, one pod could have a designer, programmer, and artist attached; each pod working on a different aspect of the game in order to be combined with the greater whole. The producer manages how the various pods work with one another to leverage the outcome of their work and keep them steered in a productive direction.

Creating a Pipeline

While the individual branches of the pipeline are planned out by the team leads, the master pipeline that connects all of these branches across the disciplines is strategized and maintained by the producer.

First you should have a strong understanding of what each group within your team needs in order to complete its task. If the group is dependent on an asset from another team, these two pipelines should connect, with each pod branching off to the next group that is dependent on their work, eventually connecting each and every discipline that shares dependencies; record all of these steps in a flowchart, then examine how these pipelines can best flow.

Your biggest enemy is having a backup in the pipeline that can prevent the asset from moving to the next stage, or next branch of the pipeline. You need to identify these areas and either take preventative measures or troubleshoot when problems arise. If one team member has completed their tasks on the asset, the next team member should be ready to pick it up and keep the asset moving. If you have team members splitting their responsibilities between duties, then make sure the schedule for their tasks jives with your pipeline.

SECTION FOUR

Managing Your Project, Your Team, Your Time, and Yourself

Being an Organized Producer

To be an organized producer means being an organized individual. If you can't keep your own work moving and structured, how are you going to do it for an entire project?

An organized producer should always know what stage each aspect of the project is in at any given time, know if there are any delays, and be able to regurgitate any information needed about the game at a moment's notice.

The first step in being organized is to be able to take inventory of the projects, tasks and prioritize them by importance and time. Keep everything in one place, don't have it scattered across numerous locations, spreadsheets, and files. Keep your notes and files completely organized.

FIGURE
18.1

Staying organized can sometimes seem like a constant battle.
Image Courtesy of: "Batman Arkham Asylum" WBIE.

One of the most important, yet difficult, duties of a producer is to know how to delegate. Producers tend to want to tackle everything themselves and in trying to do so end up not getting anything accomplished, causing problems for the team that you are supposed to be leading. Have confidence in the people you work with. There should be an ebb and flow with your team members and subordinates in working style. Explain clearly what you need from them; while this can feel more time-consuming and confusing than just doing it yourself, once you've communicated to your delegate what your expectations are, they will have the information they need and you won't have to go through it again.

How to Be Organized

Create a daily calendar of tasks and meetings. Instead of having to take the time each morning to figure out what you need to do that day, you should already have predetermined this before you've gone to bed the night before. You're going to depend on your calendar and daily tasks lists all day, every day. In the morning it will tell you what you need to take care of that day and at night it will let you know what you'll be handling tomorrow. As you finish each task, cross it out. What still needs to be done should be carried on to the next day. Be realistic and flexible when putting your calendar and tasks together; things come up and change every day no matter how diligent you are in planning them out. Add a "cushion" to your schedule as often as possible.

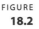
FIGURE
18.2

It's okay to keep watch over your team, but also have confidence in them to be independent. Image Courtesy of "Batman Arkham Asylum" WBIE.

We can't begin to stress how important it is to take notes, often, if not all the time. A producer should always have a notebook with them. Create one (or more) specifically for the project and put everything in it. Take notes when you're in meetings, on calls, or even just discussing the project with colleagues. Unless you have a photographic memory, don't count on remembering every single thing you need to know. You're going to be using these notes as your memory bank. Think of them as a low-tech backup system.

Tools of Organization

Don't depend on your Outlook calendar or that Blackberry to keep you organized, and don't even get me started on that iPhone. If your tools for being organized are spread across Outlook, cell phones, e-mails, Excel spreadsheets, and electronic gadgets, you're never going to be organized bouncing back and forth across different aps, programs, and hardware.

An organized person has everything in one place, be it project management software and/or a physical organizer. There are physical and digital tools that will help keep you organized, but don't use these as a crutch. They are simply tools an organized person uses to be organized, but if you use them halfheartedly or improperly, they are as worthless as not having them at all.

Don't Procrastinate

Never put off or delay a task unless you absolutely can't take care of it at that moment. Procrastination in game development equals death. If you don't want to deal with it now, you're still not going to want to deal with it later. Never utter the words "I don't have time to get organized" as this only comes from the most disorganized and inexperienced individuals.

The biggest death sentence you can give a game is jumping in with both feet, hoping the organization and pipelines will work themselves out as the project moves. This is a waste of time, resources, and money, and has been the destruction of many teams. Taking the time to be organized in your tasks means doing them correctly and leveraging your time for maximum efficiency.

Take a Class in Organization and Time Management

If you've never taken a class in organization and time management, you should make arrangements for one. Typically these are one-day seminars that will help you improve your skills and provide extremely valuable tips in being efficient with your tasks and time. Many companies specializing in organization and time management are able to come in and give a lesson to the entire team at once. If you can convince

your higher-ups to foot the bill, it will return their investment tenfold. Every team member using the same time management and organizational system offers the best structure and the best results.

Communication

Communicate and update team members and leads as to the progress of the game, tasks, and features on a regular basis. This ensures things get done and creates a failsafe to allow all tasks to reach completion.

Be sure team members are always informed with as much transparency as possible. Lack of communication leads to a breakdown of credibility and morale, plus this can result in major structural issues with the game. You should always be clear, concise, and communicative with your team and other departments you are working with. This sounds like a scary idea, but in the long run it will only be beneficial.

Don't hold back important information, even if it's scary news. Your team needs to feel like they are part of something bigger, part of the force behind the game; preventing them from access to the knowledge that affects them and their work robs the team members of being invested in the game. The team can't work blind. They need to know how the items they are working on fit into the bigger project.

Realizing communication is good, there is such a thing as too much information. A good producer knows what is important and necessary to relay and what is not. Keep things pertinent. Avoid bogging teams and other departments down with unnecessary information that doesn't really relate to them or bringing up scenarios that may or may not happen; this can raise concerns that are unfounded and generate more work than is necessary.

Communicating Outside of the Team and Back Again

Communication flow doesn't just sit internally with the team. Producers on both the development and publishing side need to effectively interact with one another. This can be a delicate and difficult undertaking. Some are too tough on each other, which causes friction and makes the project difficult for everyone involved; others can be too casual and easygoing with one another, an attitude that can cause massive delays and a decline in quality of work. Discussions between the dev and pub producer should be professional and as friendly as possible, while remaining on task. Sometimes it will mean championing one another or defending the team, other times it will mean having to get firm if there is a lack of results. Remember, you're in the same boat take responsibility for the project's successes and failures.

Publishers should keep the developer informed on what is happening with the departments on the publishing side that have a direct effect on the game. When will PR roll out? When are screenshots needed? What assets from the game will be utilized? What are the results from focus testing? Even something that sounds as simple

as recording gameplay footage to use in trailers and promo reels should involve the developer, as they know how to show the very best features and hide the shortcomings. Being on the development side with no information coming in from the publisher on what is being done outside of development is like sending your work into a black hole.

When a pub producer supplies feedback to the developer they shouldn't hold back on what they feel needs improvement. Instead they should communicate it professionally, otherwise it drives the other party to go on the defensive rather than taking it as constructive criticism. Also, call out what parts of their work you are happy with. It's always easier to focus on the negative than the positive, but not letting the developer know what's right about their work will not help them continue in the right direction.

For the publishing producer, communication to other departments is one of your bigger duties. Marketing, PR, sales, legal, and all the executive staff, stakeholders, licensors, and developers constantly need updates as to progress, challenges, and successes. It's how you convey the information and manage these relationships that are key in turning negatives into positives. Make them feel as though they are part of the team and you're more likely to get what you need from them, and will have a lessened blow if things start to go awry. It's okay to let the executives and other departments know if you foresee a problem with the game down the road, or if something unexpected occurs, but you need to come with strong and rational solutions when you present these scenarios, not just a list of problems. This keeps their faith in you that the game is in the right hands, even when they have to get involved in solving the problem.

Managing Information Flow

Here are the tools and best practices for disseminating information to your team, management, other departments, and stakeholders.

Weekly Meetings—Maintain regularly scheduled meetings with the team, your producing counterpart, and outside groups and stakeholders involved in the game, but keep these meetings separate, and become the conduit for information between all the parties. Meetings should include not only information on where you are in the project, but the reactions to that work, what other groups are doing that affect the game, what is coming up that needs to be on everyone's radar, and in general, keeping open discussions flowing.

Weekly Reports—A summary of where things are in production, list of achievements, what still needs to be done, and where the project stands at both the developer and producer.

Memos and E-mails—When key information arises that needs to be sent out urgently, or needs special attention without getting overlooked or lost in a weekly report, e-mail announcements and memos are key.

One-on-Ones—As often as possible you should meet with your team leads to see how things are progressing and provide a two-way exchange of information. Always have weekly one-on-ones scheduled. You should be flexible enough to discuss items with them at any time, but of course be smart in how you handle this.

Wikis—Although we have mentioned it before, Wikis are invaluable and flexible information and communication tools that always work as long as you take the time to read and update them. Wikis are only as relevant as the people who utilize them.

Open-Door Policy—Every team member should feel comfortable enough to approach you with any issues, question, or idea at any time. Never turn a blind eye to a team member, no matter how junior they are, as their input could save a project. Even an inexperienced voice could come up with a solution that never occurred to anyone else.

For example, during a troubled crunch mode on a project where the developer could not properly port a console title due to conflicts in the tech, the team and publisher had run out of both solutions and time. A production coordinator on the publishing side suggested that they start calling their colleagues at other developers to see if any of them had come across the same issues. This problem which had gone on for over a week was fixed literally overnight by a developer sharing the information. Had no one listened to that coordinator, the game would have missed its ship date and who knows how much longer the problem would have lasted.

NINETEEN

Reviews and Approvals

It is inevitable that throughout each stage of game development all of the work has to be reviewed and approved, from the publisher reviewing the developer's tech to each game asset needing approval from the team leads, dev producer, publishing team, and stakeholders.

Why do you need reviews and approvals? They are an important communication to the state of the project, and allow all invested parties to confirm the consistency and quality in the development progress and provide direction through feedback.

Reviews and approvals, not only between developers and publishers, but internally on both sides through the chain of command, serve as a key communication channel. If all parties have approved a character model, they are communicating an agreement not only on that specific model, but also on a general look and feel for the character.

These approvals also specify the adjustments that need to be made for the project to move forward, and provide official clearance. Even critical feedback that feels like it will delay the project should include how the issue can be fixed or adjusted. Although no one wants to receive negative feedback, it does happen and can sometimes make the game that much better by what you do to rectify it.

When giving critical feedback, you can never go in with just a list of the problems; you have to come to the table with reasons behind the problems and solutions. Never say, "This art is bad, I don't like it, please fix it." If you feel a piece of art has room for improvement, you should explain what the artist needs to do to adjust it.

Approval Pipeline

Just like the developer has a production pipeline, there also needs to be an approval pipeline on both the dev and pub sides, managed by their respective producers. Once the asset is created by a team member, and the team lead signs off on it, it

is handed over to the dev producer. If the dev producer provides his approval, the asset is included in the milestone submission and passed on to the pub producer. At this point it is up to pub producer to review the milestone, add their comments, and usher the asset though the approval process, managing all feedback and sign-offs. These reviews and approvals are made by key team members and stakeholders in

FIGURE
19.1

Example of a typical approval pipeline.

a specific pecking order to review each game-related item and the overall work and progress of the game. The reason you must go in a specific order is that many of these team members are dealing with multiple games, and their primary focus is not reviewing, yet it is an important part of their job. Don't waste their time on an item that will need to be resubmitted. If the item under review is not at the appropriate quality or stage for this party to review, you need to have it fixed or at a ready state before continuing it down the pipeline.

While all parties to review the item are important, folks at the top such as CEOs typically don't need to review it unless the item is for a high dollar amount. Most publishers give each level in the pecking order a max dollar amount their approval holds, which defines how far down the pipeline of reviews a submission needs to go.

Approval Forms

No matter what process you use to review items with stakeholders, digital or otherwise, a format that the reviewing party can use to input their feedback and provide a sign-off is critical.

While in some extreme circumstances you can accept an approval via e-mail, you'll have few problems with a stake holder going back on their approval or feedback if they've physically signed it. Some companies are advanced enough to now have digital signatures for approvals, so a physical form is no longer needed, but believe it or not, the majority of video game publishers are still using pen and paper for this process.

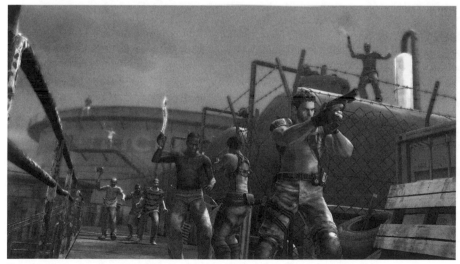

FIGURE
19.2

Step by step a producer continues along in their mission to get approvals.
Image Courtesy of: "Resident Evil 5" Capcom.

The approval form should list the stakeholders in order of the pipeline, and each have a section for their notes and signature, along with checkboxes for approved, not approved, approved with comments, or incomplete. Work that has been approved or approved with comments can move forward without having to resubmitted unless there is a specific request to do so. Not approved or incomplete submissions should be corrected as soon as possible based on the feedback given. You should also discuss the feedback to ensure there are no work arounds.

Managing Feedback

When the feedback from all parties is received by the publishing producer they must review all comments and sort out what is important and what is not pertinent. In cases of the latter, the pub producer should go back to the party that made the comment and discuss with them why they feel it is unnecessary or counterproductive to include. You know the game better than they do; non–production team members won't always have the knowledge and memory of the project details that you do, and can often make erroneous and contradictory comments.

FIGURE
19.3

Sometimes you need to be quick to meet approval deadlines.
Image Courtesy of: "Resident Evil 5" Capcom.

Once you have all your mandatory comments together, organize them by discipline and importance. Call out what is mandatory, what is a wish list item, what need to be resubmitted, and what can move forward, with or without changes. When providing feedback it is extremely important to be clear and concise with no room for misinterpretation of what is approved and not approved, and what changes must be made to move forward.

FIGURE
19.4

Beware all those who fail their submission. No room for failure.
Image Courtesy of: "Resident Evil 5" Capcom.

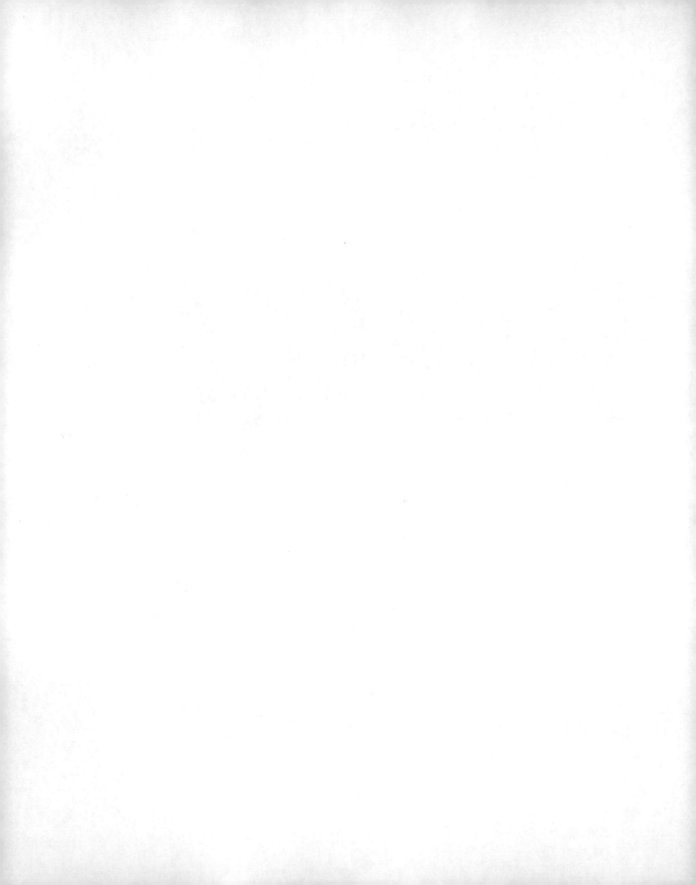

TWENTY

Meetings

The most tried and true form of communication and information flow for video game production, or any business for that matter, is the meeting; but to leverage a meeting to its fullest potential, it needs to be structured, organized, and managed before, during, and after, with someone running the meeting, otherwise it's bound to break down into conversations or a complaint session.

Running Meetings: Short and Sweet

Few folks enjoy attending a meeting, they seem to be constantly popping up, pulling you away from work that needs to get done and often lasting too long, but like them or not, they are a reality of working in the gaming world and extremely important. They provide everyone, including you, the proper and most up-to-date information, keep everyone in the loop, and discuss challenges as well as successes with the group so team members can learn from each other and develop a camaraderie. The benefits of meetings are endless, and when they are structured properly, meetings are much more of a benefit than a hindrance.

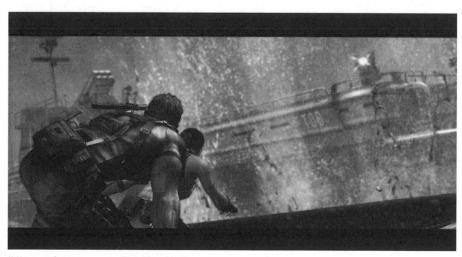

FIGURE
20.1

"We need to stop meeting like this!"
Image Courtesy of: "Resident Evil 5" Capcom.

Planning Meetings

The first step to holding effective meetings that get results is to carefully plan them on large and small scales. You want to avoid unscheduled meetings popping up all the time as this pulls your team members away from their tasks and interrupts the workflow.

FIGURE
20.2

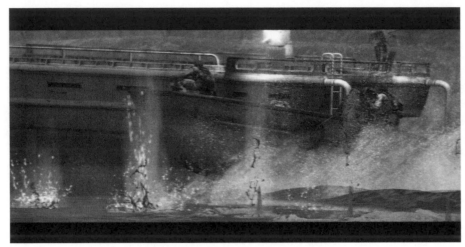

There never seems to be a good time for meetings, but they are critical for success.
Image Courtesy of: "Resident Evil 5" Capcom.

How Many and How Often

On the large scale, figure out what meetings have to occur regularly, as well as occasionally, and what one-off meetings you'll need to plan for. Schedule them as early as possible and list whose attendance is necessary and who should be optional. This is where having a standardized calendar system, such as Outlook, can be valuable as it sends invites that automatically go into the attendees' calendars, can notify you of who accepted the invite, who cannot attend, who is optional, and who has not responded yet, plus it can send updates, time change recommendations, and cancellations.

Software and Tools

Since you don't want to spread your personal organizer across multiple locations, software such as Outlook is typically quite versatile, allowing you to import it into most major project management and organization software. If you use a physical planner, the calendar program should be able to output a printable version in numerous sizes and shapes, from daily to weekly and even monthly, all of which can easily be inserted into your day planner.

Location, Location, Location

Once you've planned and juggled the schedule for the meetings, the next stage is determining who needs to attend: which team members must absolutely be there, which you would like to have, and which are optional or unnecessary. Once you've determined who needs to attend, you need to find a meeting space. The location of the meeting should always be large enough to accommodate everyone with a comfortable amount of space and seats. Nothing is more disruptive than team members having to walk over each other in a cramped space to try and find a chair or having to drag one in from another room.

Also consider what meeting spaces in your office have the equipment you need to serve the purposes of your meeting. If it requires reviewing a build and your company only has one meeting room with a monitor large enough for each attendee to view it, then your options are limited. When scheduling meetings it's best for all companies to have a master meeting schedule so spaces aren't double-booked.

The Meeting Agenda

The worst meeting organizers are the ones who show up without a list of topics to discuss, or ones who try to remember what you need to go over from memory. For every meeting you organize, you should always have a detailed agenda.

An agenda is basically a list of topics you want to cover for the meeting. This simple exercise will keep your meetings on track, prevent important information from being overlooked, and make better use of your time.

For regularly scheduled meetings, you should take the time between them to collect a list of topics you feel need to be discussed, information to disseminate, and updates. Collect these in a list, and the day before the meeting send it out to all attendees to not only prepare them for what will be discussed, but to see if there are any topics they want to add. The day of your meeting, collect all of the agenda items into a structured list organized by importance and print a copy for everyone attending the meeting. This way everyone will be able to follow all the topics under discussion and be prepared for what is coming up.

One-time meetings should also have agendas. List out the reason you're having the meeting and the topics to be discussed, and ask key meeting attendees if there is anything specific they would like included. When having meetings with visitors, it's a good idea to place everyone attending the meeting's name at the top of the agenda.

Structuring a Meeting

The beginning of a meeting should be an overview of where you are with the project. From there move into individual updates and the topics on your agenda. Always allot for an open forum of questions. This will keep all attendees up to speed on items under discussion.

Keep Your Meeting Moving

This is one of the toughest parts of running a meeting, as you have to work not only as a participant, but as a referee as well. Make sure everyone is staying on topic. Ideally discussions will continually move from one topic to the next without dwelling unnecessarily or talking in circles, yet still allowing important items to be fully covered. More important, the meeting should not break down into a social event or a complaint session. This can often mean having to speak up in a loud voice. If an issue becomes bigger than the meeting or only needs to be discussed among a few individuals, you should take that topic off the list and discuss it outside of the meeting, otherwise you're wasting the time of the team members not involved.

Notes and Reports

All meetings should have an assigned note-taker. This is typically done by a junior team member, such as a production coordinator or associate producer, however if no juniors are available, then it is up to the producer to take the notes.

After the meeting has concluded, the notes from that meeting should be typed up and distributed to all attendees as a report, recapping what was discussed. If you have a Wiki or any other organizational software that allows report sharing, the notes from the meeting should be added there as well.

Some Meeting Etiquette

As a producer you are a leader and should lead by example, so here are some etiquette tips on how you and others should behave during a meeting, especially one you are running. It is shocking how often inappropriate behavior occurs, especially when perpetrated by senior staff.

Don't check your e-mail or have your nose buried in a Blackberry when a meeting is underway. It doesn't matter how good a multitasker you are, if you're reading an e-mail you're not hearing or absorbing what is going on around you.

Don't rake a team member over the coals at a meeting. Regardless of how bad their work is or how horribly they screwed up, meetings are not held to discipline or condemn. If you feel you need to discuss an item sternly, then take it off the list, otherwise you will lose the respect of the entire team and will have a severe decrease in morale and others may feel discouraged from participating in future meetings.

Never take a call during a meeting. It's beyond rude. In an emergency situation, if you absolutely must take a call, excuse yourself from the meeting and talk outside, don't start your emergency call from within the meeting room.

Regularly Scheduled Meetings

Here is a list of important meetings you should schedule, plan, and attend to on a regular basis. These regularly scheduled meetings are key for communication and updates on the progress of the project.

Meetings should be scheduled for about an hour at first, but once you get a feel for the dynamic of these meetings, you'll be able to gauge if they need to be shorter or longer.

All-Hands Meetings—Everyone in the department should attend for global updates and to go over items that affect everyone.

Team Leads—All the team leads and the producer should meet once a week to discuss where they are with their respective disciplines, discuss next steps, obstacles, concerns, and successes.

Review Meetings—A weekly meeting with the production team is held not only to provide information, but to review the progress of work. Here you will be reviewing builds, artwork, animation, and other game elements. It is extremely important for these meetings to have an encouraging tone.

Discipline Meetings—This is one of the few meetings you need to make sure is held, without attending yourself. All of the team leads should be meeting with their groups on a weekly, if not daily basis. The team members should feel comfortable to discuss issues with their work, challenges, and problems, away from the producer's ears. Although as a producer you're there to be a problem solver, sometimes not getting involved and allowing the discipline team and their leads to handle an issue is better than handling it yourself, and problems can often be prevented or nipped in the bud before you need to get involved.

CHAPTER TWENTY ONE

Managing and Supporting Multiple Projects

Running a game is an all-consuming undertaking. Even the most organized, versatile, and responsible producer can find a single project draining their bandwidth both at work and in their personal time. As publishers struggle to try and make a profit during one of the most expensive generations of video game consoles to develop and publish for, staffs are diminishing in size, yet the scope, ambitions, and number of projects continue to grow. While producers used to have the luxury of being able to focus on one specific project at a time, today their duties are typically spread across multiple projects.

On both the dev and pub side producers are now typically dealing with a minimum of two projects simultaneously; sometimes this reaches three if some of the titles are smaller, and on the publishing side the number can be even higher, but any development house that expects a producer to work simultaneously on more than four separate titles is setting themselves and the producer up for failure. If you find yourself working on this many titles or more, it's time to update that resume, find yourself a recruiter, and get the heck out before it all blows up.

For the publishing producer, working on multiple titles is not as uncommon since your duties aren't quite so all-consuming on each individual project. A publishing producer should be able to comfortably manage three games at a time with that number fluctuating depending on the size and your level of involvement with the design and creative of each. Four should still remain the magic number of the maximum titles to manage, however at some of the less desirable publishers to work for, that number of projects can double and even triple.

Ideally, on either end, you don't want to have to focus on more than two titles at a time because it does affect the quality of both your work and home life, however this often can't be avoided and even the luckiest producer will find themselves stuck juggling multiple projects.

Juggling: How to Keep Your Balls in the Air

…and we're serious when we say "juggling". Think of each project as a ball and your time as the air. You've got to find a way to keep those projects in each pocket of your

FIGURES
21.1 AND **21.2**

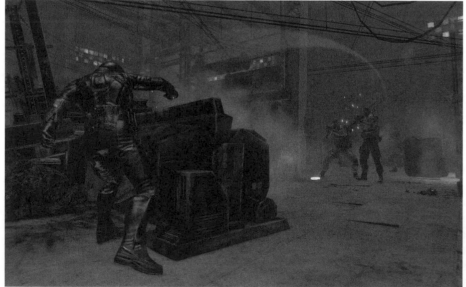

Like enemies you might face in a game, strategy is important when it comes to who you choose to fight first. You need to always keep your eye on the ball.
Image Courtesy of: "Wanted: Weapons of Fate" WBIE.

time, constantly moving in front of your eyes without dropping a ball or allowing them to slam into one another, although an occasional bounce is bound to happen.

To succeed at juggling depends heavily on scheduling. Not just in each project but in your day. Don't ever try to focus your time and mind on multiple projects and tasks simultaneously. Your day should be divided up among the titles, setting aside specific times to focus on each separately. While multitasking may be a popular buzz word, in reality trying to do multiple tasks at once means doing a poor job on everything instead of focusing on each item individually and getting the job done right. Even if you're meeting with team members and discussing multiple projects, you should split the time of the meeting up into segments, each dedicated to discussing the individual title.

Scheduling and Resource Allocation

One of the few times projects should intermix is during scheduling, especially with shared resources across multiple titles. Each project's schedule needs to interweave and flow with the others. Carefully monitor each schedule to avoid an overlap in crunch times, deliverables, first-party submissions, and GMCs. With shared resources working across multiple projects, you're going to need to structure the schedules so they don't have simultaneous demands heavily dependent on specific team members (besides yourself of course). Just keep in mind that the more titles a team member is spread across, the less time they can focus on each individual title, and the flexibility to deal with last-minute emergencies becomes nonexistent.

FIGURE
21.3

Carefully allocate your team so projects aren't battling for the same resources.
Image Courtesy of: "Wanted: Weapons of Fate" WBIE.

Resource allocation is actually quite common, especially when dealing with team members who aren't required during the full duration of the project. There will be many key members staying on board through the entirety of production, but there are quite a few who don't necessarily have to work exclusively on a single project, but ideally aren't working on all the projects at the same time. There are also times where you'll be offloading team members once their duties are complete and gear them up onto a new project.

Splitting team members across multiple projects can also be a benefit and an opportunity to leverage time if handled properly, just as many of the tech, art, and design resources can be split across each game when they share similar specs. For instance, the same artist working on a model can reskin that model to look different enough for it to be reused in another game. This isn't something you want to overdo, because multiple titles will start to look identical, but with some creativity, shared assets can appear quite different. This cuts down on the time needed to create those models as well as the costs of creating them separately for each game. This technique can also be used for animation cycles, motion capture, and some design.

CHAPTER TWENTY TWO

Staffing

Finding the right candidates for your team can be just as much of a challenge as it is a reward. These are your fellow soldiers who are down in the trenches with you during production, so not only do they need to have the right skills and experience for the job, they should also have like-minded personalities and demeanors for the overall dynamic of the team.

While most developers already have a staff and may only need to fill specific vacancies in the team, other developers mainly have a core team and that needs to be built up once a project is off the ground. For the sake of explaining how building the team works, we are going to take the scenario that you're the producer at a new developer and have to build the team from scratch.

The Producer's Role in Staffing

The producer isn't in charge of going out and finding team members, although one with enough contacts can help find some pretty good candidates, and at mid-to-large sized companies the producer won't be doing the actual hiring, but in all scenarios, the producer will be involved in the interviewing and vetting process for each candidate because they have the best knowledge base for what is needed for the project.

Start with the Core and Expand

Just like a game production, approaching things with a logical and organized process is important when staffing a project. The first wave you look for should be the team leads; this includes the tech, art, and creative directors. We've already gone into the skills that make up a good team lead, so let's focus on what you should be looking for beyond just skills.

First off is experience. For someone going into a director position, they should be a veteran of many games. It's okay to consider someone as a creative director if they were previously a lead designer on a major and successful project, but you wouldn't want to hire someone as a creative director if their last position was as a level designer. They haven't had the experience of leading a design team, setting the

FIGURE
22.1

Be careful not to choose the wrong candidate, it could hurt you in the end.
Image Courtesy of: "Terminator Salvation: The Videogame" WBIE.

tone and approach, or managing multiple aspects beyond their single role. Just like a producer has to go through a specific line of career growth, so do all of the team leads, and hiring someone who has skipped their way upward is a recipe for disaster.

When reviewing the work of a potential lead, see how similar their style, approach, and philosophies are in relation to the project. Will they need to take a different approach than what they are used to? Will the technology they are working with present a dramatic change from their past experience?

Make sure all of their skills are up-to-date with Next-Gen standards. While at the beginning of the console cycle this was difficult to come by, as we are now several years into the Next-Gen systems, most candidates should possess the experience and technical knowledge of having worked on a current title. Hiring someone who still needs to upgrade their skills is going to reflect in the quality of the final product.

Personality goes a long way and you're going to need candidates who can communicate clearly and be firm in their work without having a difficult, frustrating, or confrontational personality. Avoid hotheads no matter what their experience is. It's difficult enough making a game; having to deal with argumentative leads just causes headaches for everyone around them. The dynamic should be just as much about the teamwork as it is skills and experience of the members who make up that team. If someone's not going to work as a team player, is going to pass the buck, or wants to work in a vacuum, they won't be a positive contribution to the dynamic of the group or the product itself.

Once you've secured your leads, you should work with them to reviewing candidates for the various development positions. At this point you should meet with each candidate, but have confidence that the lead is able to select the staff that will work best for their needs and the project.

The final thing to look for in a potential candidate is honesty. This requires more than just interviewing skills, but being able to do research on someone's background and following up with references and former employers. As the games industry becomes increasingly competitive, there are those out there who will fib about their experience, past positions, and past titles. While the games and positions a candidate claims to have worked on used to be difficult to verify, as the industry has grown, it is becoming increasingly easier to look into a candidate's gameography. You will know the processes of making a game better than anyone else involved in the hiring process, so you shouldn't expect any of the executives and HR reps involved in the hiring process to know what to look for when verifying a game production background.

Example: One of the companies we worked for hired an extremely charismatic executive producer who claimed to have been the former senior producer on one of the biggest game franchises in the industry, at one of the biggest gaming companies of all time. However, when it came to working in actual production, he seemed to have no knowledge of the process, his role, or where to even get started, instead delegating all of his responsibilities to other team members who quickly became overburdened. Soon all of the projects under his leadership became troubled.

For those of us who didn't directly work with him, the truth started to surface when a candidate for a senior staff position came in for an interview, and the executive producer vehemently protested against hiring him, claiming a lack of experience on the candidate's part. As the potential candidate was a well-known and established industry veteran, the EP's reaction seemed odd. Finally some of us took it upon ourselves to look into the EP's background and discovered, not only had he never worked on that major title as he had claimed, but he had never actually worked in a producer role. Instead, the highest position he had ever held was as a QA lead. The candidate he protested so much against had previously worked with him and could easily have blown the EP's secret past.

Had one of the staff producers actually interviewed this EP instead of just corporate execs who confused confidence and charisma with experience, his lack of knowledge would have been apparent.

Andy Kipling, Producer, Zombie Studios

Building your team is the most important part of the development process. In a creative industry like game development, and especially at a small studio like Zombie, having solid people on the ground floor is critical. We need to ensure that the personalities of our team work well together and that people are effective communicators. We want people who are not afraid to ask questions or seek out information. Self-motivated team players and problem solvers are the types of individuals we strive to find.

Conducting Interviews

On both sides of the desk, conducting an interview is an art form. There are plenty of do's and don'ts. Many of these should be reviewed with your human resources representative before the interview is conducted, if your company is large enough to have one. It's generally a good practice to review the candidate's resume and experience, then write your questions down before the interview is to take place.

FIGURE
22.2

Don't find yourself in sticky situations. Do your homework before the interview.
Image Courtesy of: "Terminator Salvation: The Videogame" WBIE

When conducting an interview, always be polite and treat the candidate as you would want to be treated, even if you think that he or she won't be chosen. Keep the questions on topic, clear, and concise to get the information you're looking for, but remain casual enough so you can determine the candidate's nature and personality.

Cutting the Fat

One of the hardest jobs of a producer is letting a team member go, regardless of whether they were working out or not. It's not fun or easy, but it's often necessary due to budget cuts, a game coming to completion (when there is no subsequent project to route the team member to), or the fact that someone is simply not pulling their weight or their skills aren't up to par with the project.

It's rare that a producer below the executive level will have to actually handle letting a team member go, however it does happen and if you've been in the business long enough, you've probably been on both ends of the layoff process. The producer's role in the process of team cuts comes down to making recommendations. As the producer, you know the staff the best and where to cut the fat, or who is not working out.

In the event of a budget cut, start with the least necessary positions, ones that are nice to have but are not integral to the overall project. Also look at areas where work might be streamlined, doubled-up, or outsourced. If cutting a problem team member, first identify a replacement candidate before actually letting the hammer fall. Cutting an essential role without a replacement can jeopardize a project more than having someone there who isn't pulling their weight.

Hiring Outside the Team

Sometimes you have to look outside of the development staff to fill gaps in the teams for specialties or as a cost-saving measure.

There are numerous options when it comes to hiring an outsourcing house, so you should review the work for these third-party companies with your team leads and perform a due diligence trip to your final candidates to make sure they are up to snuff.

FIGURE
22.3

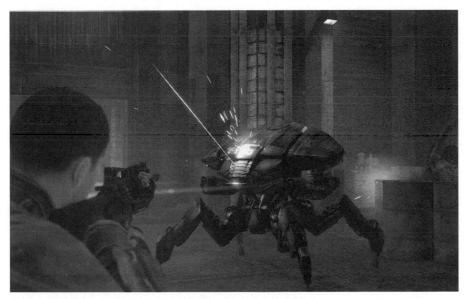

Find outside sources that have precise aim in their specialty.
Image Courtesy of: "Terminator Salvation: The Videogame" WBIE.

When hiring contractors such as writers and composers, it's important to secure individuals with game experience. While it's fun and exciting to work with a big-time Hollywood feature film writer, these are typically not the best candidates for the position and mostly end up doing only a fraction of the writing, or simply consulting on the game.

Writing and composing for games is a much more complicated process than it is for film. A game writer typically needs to create ten times the amount of content than a feature film screenwriter does, and the game writer needs to work in various formats. A screenplay format is nice when showing it to executives that don't know how to read a game script, but outside of cinematics these don't do the game much good. The writer needs to input their narrative and dialogue down into level breakdown docs and fill out thousands of dialogue lines and variations to those lines in a complex Excel spreadsheet.

Composers for games need to get used to working without the benefit of composing to a rough cut, as the game is going to be crafted in tandem to the composition. They also need to be okay with delivering their pieces in stems that the sound designers and audio engineers can manipulate to create the maximum impact.

Where to Find Candidates

When looking for potential candidates, there are numerous avenues, especially today when employment is more competitive than ever. Here are the most common places to seek your new team member.

Gaming Job Sites—The best way to find experienced candidates is through video game professional websites such as Gamasutra.com and Creativeheads.net. In addition to these sites allowing you to post a job opening, you can review potential candidates who have posted their resume and experience on the sites.

Social Networking Sites—Believe it or not, social and professional networking sites are some of the fastest growing recruiting tools out there. Today gaming professionals are listing their job titles and experiences on sites such as LinkedIn.com and Facebook.com, making them easy to find and approach.

Recruiters—While contracting a recruiting service to seek out candidates can be costly, it is a major time-saving measure, especially for smaller-staffed companies that don't have the time to look for candidates full-time. When working with a recruiter, be extremely specific about your needs. Let them know the type of candidate you're willing to accept and the types you want to avoid. The recruiter's purpose is to save you time in finding a good candidate. If they hand you a bunch of candidates that don't have the experience for the position, they are now wasting the time you hired them to save.

GDC—The annual Game Developer's Conference (GDConf.com) is ripe for the picking as it is filled with industry professionals, many of whom are looking for their

next job. This is such a major recruiting opportunity that some companies are set up there just to meet potential candidates.

Referrals and Word of Mouth—Working in the industry, you're surrounded by fellow professionals. If you're looking to fill a position, let everyone know, and you'll soon be flooded with potentials that are recommended to you by friends and former co-workers. This is the best way to seek out potentials because you're getting a recommendation right off the bat from others whose opinions you trust.

CHAPTER TWENTY THREE

Technology: What Every Producer Should Know

The tech is everything on which the game is built. Just as you'll be working closely with your creative director on the creative side, you'll be working with the tech director on all technical aspects of the game. You will depend heavily on them to know what is possible and what is not with the technology at hand, manipulate and innovate with the game engine, plus implement and build out the game integration, making sure it all runs properly.

Every element, aspect, art, and code for the game has to be implemented by the tech team, so it is critical to loop the tech director into all matters from concepting to production. It's also important to provide a clear direction as to how each of the elements are being created to ensure they can be plugged directly into the code, functioning properly and not having a negative impact on any other aspect of the game.

Your tech director knows if your ideas, concepts, and designs are actually possible with the technology and tools available, has the knowledge to push the tech to go beyond its apparent limitations so that you can innovate, and can identify what is impossible to do with the tech, schedule, and budget of the project.

As the tech director has a huge responsibility, it is your job to manage and prioritize what is being shown to them, where their focus is being directed and what their goals are for the project. They should be primarily focused on knowing and working in the tech. They are typically highly organized individuals, but as the producer you will need to prioritize their tasks so things can be taken care of in the proper order

as they come in. Because the tech director is constantly busy and in demand, the producer should serve as the gatekeeper to anything game-related coming in that is not tech-oriented, otherwise they can be overwhelmed by a free-for-all of team members coming to them with their tech needs and issues.

When issues with the game tech, builds, and submissions arise, your tech director is your first line of defense in tackling the problem and devising a resolution, including making sure the game is the correct size for the console system's memory and disk size limitations. If a game continually crashes, it's up to your tech director to find out why and how it can be fixed.

How Game Builds Are Created

Program source code is built by the programmers mixed with the engine and middleware through a compiler that's provided by first parties; the compiler outputs it all into an executable code that can be launched from the respective platform. When dealing with scripting, there is a scripting interpretation system that converts the scripted files into the source code format, which can then be compiled together with the other codes.

The game assets such as art and audio files aren't actually integrated with the game code itself, instead they are transformed into files that the engine can pull and read from. These asset files are taken by the programmer and converted into the game engine–specific format through data exporters; these convert the assets and save each as a separate engine-specific file. Those files are then placed on disk with the game. When the game build launches it finds the various files and loads them into the game memory, which opens up the universe of the game, such as art, sound, and effects.

Every developer has their own system for generating builds. What you want to avoid is a system that requires manual asset conversion or entire code replacement, even when making an update. Instead have a system that generates a build automatically and only replaces updated portions of the build.

The Game Engine

Everything in a game revolves around the engine. It is the nucleus of all the tech; the only thing limiting the team is their knowledge of how to leverage and manipulate it.

A game engine is like the operating system for the game. Just as your PC runs off of Windows, and Windows runs off of DOS, your game engine needs to run off of the first party's platform.

The engine needs to be modular, allowing for other middleware to run within it, as all in-game actions are built using different toolsets. Ideally the engine you're working with is compatible with all first-party SDKs; otherwise you're limited to only releasing the game for one specific console system.

While some developers use their own self-made engine (proprietary), others use engines licensed from other companies. These both have their advantages and disadvantages. A team who created their own proprietary engine can manipulate it, build on it, and change it to cater to the specific needs of the game; however, the proprietary engine can also be a weakness because it is typically designed to work best with a very specific style of game, limiting the dev studio to the genre and style that works best with their engine.

The licensed engine is much more flexible and considered a turn-key solution. When you license an engine you have all the knowledge and tools provided to you, tech support from the engine licensors, and a network of other developers all working with the same engine and sharing how they have manipulated and innovated it. The drawback is that you have less control. You're at the will of the licensor as to how fast the technology evolves and gets up to speed with new innovations, changes in the industry, and Next-Gen console systems.

John Williamson, President, Zombie Studios

There are a great many factors involved in choosing a game engine. Every engineer worth his or her salt will tell you they want to write their own engine. So don't be surprised when they do that. When I first broke into games as a producer, most publishers wanted you to write your own engine. But now that the stakes/budgets are so much higher, they are looking to mitigate risks and a licensed game engine is one of the easiest ways to do just that. As the publisher is paying for the game engine, either directly or indirectly, cost is usually the #1 factor in considering a game engine. It should be tech-set and feature-list driven, but the reality is cost drives everything. If you have a very, very specific game mechanic, that only one game engine can give you, you may be able to move this to #2. But if the engine is too expensive, you will be asked to make a redesign. The second factor is often how fast the team can take the existing engine and get a prototype, the first playable, vertical slice of the project. Every publisher wants the game done 24 hours after the contract is signed. And providing the publisher with early and often playable code is the best way to get you and your team the trust and thereby freedom and room to make your game.

A Little About Licensed vs. Proprietary Engines

Many of the game engines out there started out being built for specific games. For, instance the Quake *engine* was built specifically for the *game* Quake. It was so well received and flexible that it began to get licensed out to other developers to build their games on.

163

Game engines have become such big business that many developers are now working towards building their own engines, not intended for a specific game, but to license out for other developers to use. The successful ones of these are versatile and flexible enough to work in a myriad of different styles and genres, often partnering up with third-party middleware providers for maximum compatibility.

Middleware

Most actions and reactions in a game are created using middleware. These are add-on engines that add features and ability to create a living world from within the game engine environment. Referred to as middleware solutions, they are typically made by separate companies outside of the engine manufacture, but come in a pre-compiled library, some with the original source code. This allows the middleware code and game engine code to be compatible and compiled together to create the game code.

The most common middleware solutions include:

Physics—This engine simulates collision; objects being able to touch, hit, or physically interact with one another. In extreme cases where your team is lacking in animation, physics can be leaned upon to simulate some movements and animations. Most recently physics is being used to create natural movement of flexible objects such as clothes, and articulated body control for moveable characters or objects with moving parts.

Lighting—This creates the light sources and controls how shadows fall. It can also be used to show the changes in time of day, alter its look for indoor vs. outdoor lighting, alter the light color, and adjust various qualities and intensities of light.

Animation—What brings the characters to life; everything from movement and facial expressions to pre-rendered cut-scenes and scripted moments in the game are created using animation. The process for games is not unlike that of CGI animated films; however there are a series of middleware tools that need to be implemented into the engine to enable all the facets for the animators' work to run within the game.

Motion Capture—While animation is a large part of bringing our character to life, motion capture allows them to feel like their movements are natural. After a motion capture session has been recorded, the model is placed in it to match the mo-cap movements. The motion-capture engine implements the work done in mo-cap and allows it to work within the game engine.

Audio Engines—There are numerous types of audio engines; some specialize in VO implementation, others in music and sound effects. Sound engines can use different encoding methods, such as Dolby surround sound and Digital Theater Systems (DTS).

Video—Video engines such as Bink run embedded videos within your game engine such as cinematics, logos, and bonus content, both within and outside of the game.

Online and Multiplayer—Being able to go online, connecting players via a server and making sure nothing crashes or lags and that both players are seeing the actions, requires an online, multiplayer engine.

Artificial Intelligence (AI)—Characters that are non-playable, including enemies, typically have some level of AI implemented within them. Unless their scenes are scripted, these characters must have a natural behavior, some pre-designated others in reaction to how you interact with them. The AI determines where they move, how they react, what they interact with, and how they interact with you. A good AI engine is almost unnoticeable, where a bad one has the AI character constantly getting in the players' way or running into corners or walls for no reason.

Occlusion—This gives materials in the game a solid state, not only conveying where an impassable object is, but ensuring that physical objects, light, and sound cannot pass through it.

User Interface (UI)—The front end of a game that allows the player to navigate from the menu to the game, accessing the different pause menus, inventory, game saves, etc.

Special Cases—While the preceding middleware solutions are fairly standard, on a case-by-case basis there is a wide variety of middleware, each designed for a specific feature, such as hyper detail in trees and plants to cloth physics that give clothing and capes a smooth and natural movement, even realistic water can require a special middleware add-on. These should be selected based on needs and budget.

Console Systems

As is the case with personal-use computers (Macs and PCs), there are multiple console platforms, each having their own systems, hardware, software, and methodologies. As most games are cross-platform, you should be using tech that is compatible with or can at least be manipulated to work with the various platforms. In addition to the core tech, there are numerous systems that can change across console brands such as disk size, memory, visual definition and resolution, polygon count, online portals, and interfaces.

Requirements and Compliance or TRC/TCR/LotCheck

The Technical Requirement Checklist (Sony), Technical Certification Requirements (Microsoft), and LotCheck (Nintendo) refer to the various guidelines that first parties require the game code to adhere to when submitting the Gold Master Candidate

for approval. The first parties provide these to the ops group, which hands them off to the producer and dev team. On both the publishing and development sides, the producer should review every requirement with their respective tech directors and devise their own checklist of items to review when preparing a GMC submission. Having a game rejected because a first-party requirement was not followed is unacceptable and a waste of valuable time, and there are hundreds of minor errors that can be made during this process, even minor ones can slip by while the team is focused on the larger items, especially when the team is burned out from crunch mode. The more eyes that can review and test the GMC before it is submitted the better. When submitting the game you should know and have documented every single bug and issue in the build and should be confident that they are all minor and none violate the first-party requirements.

CHAPTER TWENTY FOUR

External Management (Publisher)

As the publishing producer, you are tasked with not only managing a development team who might see you as an outsider, but you also have to manage your seniors at the publisher. This can often mean you're called upon to make some tough choices, some that won't be too popular with the dev team, others that won't be popular with your very own management. If you balance these aspects properly, the development will see you as part of the team and management will empower you and have confidence in the decisions and recommendations you make.

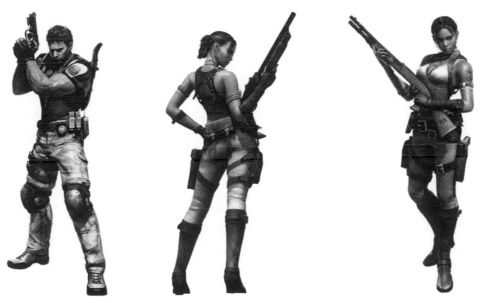

FIGURES
24.1,
24.2 AND **24.3**

Teamwork is important for a successful game, both internally and externally.
Image Courtesy of: "Resident Evil 5" Capcom.

Managing Management

Being the producer of an external team will require you to manage both upwards and downwards. By managing upwards, you're setting expectations and communicating to your management the progress of the project. There is typically a lot of money at stake and so weekly reports are the norm, clearly communicating the progress of the game at any given time.

Weekly reports should include:

- A breakdown of what has been achieved on the game in the past week and what will be focused on in the following week.

- Bullet points outlining the success and challenges the game is experiencing; this should be clear enough and concise enough so that the executive reading it can quickly assess where the project is, with some rough details.

- A broken-down assessment of some of the disciplines and how they are doing, broken down into categories like art, programming, sound, and design; this is a more detailed report explaining some of the problems with the game.

- If there are issues with the progress of the game, create a separate section about how each of those issues are being handled.

The weekly report should not just point out issues the game is having. It should highlight the positives of what's happening, the successes, achievements, and when a game has reached a key goal. If you properly convey to management what's happening with the game, it'll be much easier to set their expectations.

Presenting the Vision

On the publishing side, you are the representative of the game. Its successes and failures are your responsibility, so when presenting the work that has been accomplished, you should know everything about the game you are trying to make. After playable builds start to come in, you'll be called upon to present them to peers, executives, and other departments such as sales, marketing, and PR. Here your presenting skills will be just as important as the content you're showing. You have the power to present the vision in the most exciting and passionate way possible. Energy is contagious and this will get your audience as excited for the game as you are.

When presenting, quickly gauge who you are presenting to, what elements will generate the most excitement and the key information they need in the time allotted. Often you'll only have five minutes to present the vision of the game to an exec team, so be sure you hit the highlights early and set it up so they'll want to see more.

When doing this you'll also need to set their expectations before even showing a pixel of the game. There are many execs who haven't the foggiest idea of what a game looks like in development and may shrink at the sight of an unfinished

character model or white boxed environments, thinking that is what the final game is going to look like. Simply giving them direction at the beginning of the presentation in words they can understand, like stating they need to consider the build like a rough draft, a sketch that will be fine-tuned once the fun factor has been built, will help communicate that this game is far from looking, playing, or feeling finished.

Managing Other Departments: PR, Marketing, and Sales

While you're busy making the game itself look good, the ones who are building up the sales and success of the game sit in marketing, PR, and sales. The marketing group advertises your game, PR gets promotion for your game, and sales gets it on store shelves.

All three of these departments are just as dependent on you to do their work as you are on them. They need game assets, art, and the understanding that what they are presenting to the world is correct. They will be turning to you for screenshots, concept art, advertising and press release copy, sales sheets, sizzle reels, and much more.

Without a doubt, sales is the most powerful of all the departments as they are the ones who generate the money. It doesn't matter how good or bad your game is, it's the sales team's job to rake the cash into the business, so most of the P&L that dictate the budget and fate of your game is in their hands.

Managing sales and marketing will always be tricky and challenging. These two groups are often in a tug-of-war over who controls what aspects of the game's promotions. They both feel they should be in charge of trade shows, magazine content, special events, etc. This often puts the producer in the middle, so it's best to just give both groups the exact same information and assets, and leave it to them as to how they want to divvy it up.

One of the biggest frustrations for a producer is having no say over the direction and promotion of the game that they have created. More often than not, the press releases and released screenshots or print ads are seen by the producer the same time they are released to the rest of the world. If you want to be involved in these decisions, you're going to have to be a true politician. Work closely with these three groups, schedule regular meetings, and show as much support as possible for their initiatives. The more support you provide, the more they will be willing to open up their plans and strategies for your input. If you lock horns with them, as far too many producers do, they will go on the defensive and never share their plans, yet expect you to provide assets to them.

Look to get these items early from marketing and sales:

- Marketing plans
- Dates for deliverables: screenshots, demos, etc.
- Establish regular times to meet and discuss the progress of the game

Managing Licensors

The most important thing to remember when dealing with a licensor is that your game is representing their property and their biggest concern isn't the fate of your game, but the future of their brand and how it is perceived by the public. Educate yourself on their property, make sure you know every aspect of it when you meet with them to discuss the game. They should be so blown away by your knowledge that it will establish a comfort level; they should know that you care for their brand and want to make a game that will carry it further, not drag it down. If the licensor has more confidence in you, it will give you more flexibility as to the direction you can take the game.

Communication with this group will also be key in establishing a smooth working relationship. You should be on the same page as to the direction of the game and shooting for the same end goal. Alignment early in the process will help to make sure that the licensor will be comfortable with the decisions you make in regards to the brand. The more comfortable they are in your decision making the more they will allow exploration into some of the creative ideas you might have for the brand.

When a licensor is providing you assets, it's critical for these materials to be continually tracked and accounted for. In these days of internet leaks and bootlegging, it's not uncommon for these assets to be watermarked with the name of the producer involved, or contain a hidden tracking code embedded within the assets. It's best to house these items on a secure server and keep physical assets under lock and key. Items such as movie scripts and workprints from a licensor can be a powderkeg if leaked online, and can lead to derailing multimillion-dollar film production, cause lawsuits, and ruin careers. In many cases film studios now have the producer come to their offices to read a script without allowing notebooks or cameras, and require a representative present during the screening of a film workprint, making sure no unauthorized copies or images are created. This may sound extreme but leaks happen all the time and have driven licensors to take drastic steps.

SECTION FIVE

Concept Phase

One of the more exciting times in a game's development is the concept phase. This is when all the ideas that everyone has come up with get put on paper and the form of the game starts to take shape.

FIGURE
25.1

Concept art such as this one reflects and visualizes the high potential of a game.
Image Courtesy of: "Terminator Salvation: The Videogame" WBIE.

At concepting you will be doing just that and any idea should be given its due from the entire team. Throw them all up on a wall and examine each scheme and suggestion. Give everyone a chance to be a part of the process and never shut down ideas. Eventually you will start whittling these ideas down and working them into what will be the final concept of the game.

FIGURE
25.2

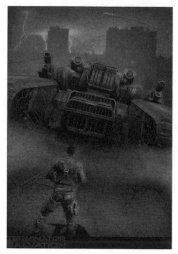

The free flow of ideas can lead to greatness.
Image Courtesy of: "Terminator Salvation: The Videogame" WBIE.

CHAPTER TWENTY FIVE

What You Hope to Achieve at Concept

While there are several creative voices in a game's production, as a producer it'll be up to you to guide and direct this newborn vision of a game. You'll be charged with running the meetings, identifying the ideas and tools that will spawn ideas for the game, working the ideas into a cohesive and single vision, and presenting them in a full-concept document, which will later serve as your mission statement for the game.

Some steps to take while creating the project vision:

- Brainstorm—Allow the flow of ideas to come from anyone and document them.
- Gather all the ideas, organize and prioritize them, then narrow them down into the ideas that are pertinent for the final game concept.
- Once you have gathered those ideas and narrowed them down, create a living document that communicates how they can be implemented in the feature set of the game. This can be a Core Game Brief, or something you might post on a Wiki for as many eyes to see.
- Gather feedback and continue to refine.

Vision Statement and Game Overview

Now that you have gathered all of these ideas and have started to refine the best ideas, you'll need to encompass all of that great information into some sort of vision statement and game overview that anyone can look at and understand. Combined, these are referred to as the high concept document.

- Vision Statement/One Liner—This is the statement that will reflect what your game is and what it hopes to achieve. Commonly referred to as a "Core X," or essence. This is the statement that all ideas are measured against. If it holds true

to the statement, then it's a safe bet that the idea will have a shot at succeeding down the road.

- The Unique Selling Points—These are usually marketing- and PR-based. Document what is special and unique about your game. As a producer, you're hopefully also a gamer and in touch with what features are popular and what players want to see in a Next-Gen game. From there you can innovate to allow your game to be unique enough to stand out, while still delivering what gamers want.

- Who Must Be Happy—It's always tough to make everyone happy, but the game's vision needs to be able to communicate effectively a game that is fun and exciting to play. If you do a good job at coming up with a clear and concise vision that has market value, you'll be that much more ahead in terms of getting what you need to make this vision a reality.

Project Design Requirements

Now that you have an initial game concept and you've documented the top goals of the game, you should work with the technical director to get a reality check as to whether these features are actually technically possible. This will also help you gauge the best technology that will be necessary to build the game out, which starts the seeds of what budget you'll be going after. At each stage of concept and pre-production, you'll want to review every feature and element you want to include in the game with the tech director.

Image Courtesy of: "Speed Racer" WBIE.

FIGURE
25.4

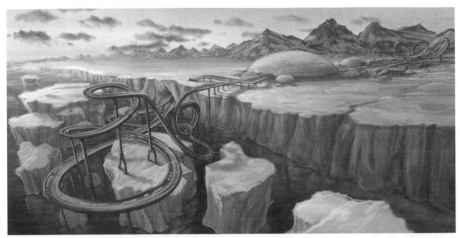

Image Courtesy of: "Speed Racer" WBIE.

FIGURE
25.5

Concepts of tracks like these can help determine what sort of technical requirements will need to get fleshed out.
Image Courtesy of: "Speed Racer" WBIE.

There will be times where you'll find that the feature isn't possible with the tech or budget available, so you'll need to work towards creative solutions to get the same results while working around the technical or cost limitations. Although you will come across situations where a feature simply can't be included, for most obstacles there will be a solution, even if you have to cheat it, and if done properly

FIGURE
25.6

Concepts of tracks like these can help determine what sort of technical requirements will need to get fleshed out.
Image Courtesy of: "Speed Racer" WBIE.

the player at the end will never know the difference. Don't ever be afraid to push the tech and creativity of your team. Great gameplay comes out of great ideas, not big budgets and advanced tech.

Design Feature Checklist

In creating a design feature checklist, you start to put down what it is you want to achieve with the particular title you're developing. This checklist becomes the recipe of your game.

Initially this should be a simple list with features that you are comfortable exploring after reviewing with the tech director, and that you think have the best shot at being successful. There will always be stumbles along the way and some features might be tough to implement, but be sure that your initial list is short, sweet, and simple enough that anyone can understand the game you're trying to build. Be sure to limit these initial feature lists to the big-ticket items that really highlight the game you're trying to make.

TWENTY SIX

The Producer's Role at the Concept Stage

At concept the producer establishes the tone, and direction, of the production. This is where processes will be established, roles will be defined, and the team dynamic will be dictated. The producer strategizes, implements, and drives all of these.

In the concepting stage, the creative director and producer are the ones at the forefront, they agree upon a direction and include the rest of the team to help fill in the blanks for the ideas that can add depth, features, and engagement to the game.

FIGURE
26.1

Early planning stages of a game can clarify what's ahead.
Image Courtesy of: "Tango Down" Zombie Studios.

Process

Here is where you'll be setting the tone of how the project will progress. A lot of ideas are being thrown around, and you need to have a process and game plan of taking these ideas, documenting and weighing them, and selecting the best of the best for the game.

Most concepting consists of meetings, documentation, and research. For the meetings you'll be setting the structure and process; even though most of these will be open forums for ideas on the direction of the game, they need to be organized and managed for maximum efficiency. Documentation will set the format on how subsequent docs will be structured and how the information will be distributed and the forum and structure of feedback. Research revolves mostly around tech and the market, including how the chosen key features can be accomplished, the best engine choices for the game, platforms, target demographics, comparable titles, and every gameplay element, genre, and style that could work best in the game.

Meetings at Concept

The producer instigates, organizes, and schedules the meetings at concept. These meetings are not only for brainstorming—they also serve to establish working relationships with all of the stakeholders, craft the design and story, and determine what the game will inevitably become.

- *Brainstorming* – These are open-forum meetings; anyone at the company involved in the product to come can attend and bounce ideas off the others. Before these meetings start, the creative director and producer have established some basics

Doing a little research can really add that extra polish.
Image Courtesy of: "Tango Down" Zombie Studios.

they want the game to achieve. Even if they already know the direction they want to go, these meetings can be a goldmine of ideas, many of which could not have been conceived simply between two team members. Write all the ideas down, no matter how outrageous; the list can be narrowed down afterward.

Once the brainstorming is complete, the creative director and producer will look through the ideas and extract the ones that are the most creative, engaging, and pertinent to the overall goals of the game. These are added to the ideas already established for the brainstorm to riff off of, the outcome of which will be a high-concept document outlining the ideas behind the game, key features, the essence statement (or Core-X), and a brief overview of what you have intended for the game.

- *Kick-Off Meeting* – Typically an internal meeting at the respective developer and/or publisher where the producer communicates the ideas for the game and what it is the team hopes to achieve. It's a time for other groups to absorb the information, discuss, and provide feedback. If done at the publishing end, this meeting will include marketing, sales, and PR teams; they will provide their insight on the marketplace, what retailers are looking for, what is tracking best with consumers, and the platforms, genres, and styles that guarantee the best success.

- *Game Summit* – The game summit is a time to bring all the stakeholders involved in the game together and present the ideas you hope to achieve. Like the kick-off meeting, it's a time to present so that everyone gets aligned in the direction the game is heading. Typically the parties that attend the game summit are the publisher, the licensor, the developer, and any other invested parties. The outcome of this meeting will determine if all parties are in agreement on the direction of the game and that the concept is (hopefully) approved to move forward.

- *Design Summit* – This is where the creative director, producers on both the dev and publishing sides, team leads, and designers all come together to discuss the overall scope and design of the game, independent of any narrative. Similar to the brainstorming session, but more focused and structured, you'll be discussing the overall vision of the game, how gameplay will be tackled, how the player will interface and interact with the world, and of course the direction to take in order to create that world.

- *Story Summit* – This typically happens later in the process, but this summit allows the writer for the game to meet with the team and the producers from both ends and discuss the design and direction of the game, and how the narrative and characters can be integrated. Far too often the writer is secured late in the project, so the story and dialogue feel crammed into a game that is already mostly built. This is what has given so many games a reputation of bad story, bad dialogue, and bad characters. Instead of bringing a writer in during the last stages of the game, have them come in early. This is how some of the best video game storytelling has been achieved. This way, design and narrative can interweave and grow together into the full game.

Peter Akemann, PhD, Treyarch Founder & President at The Workshop

"Have regular brainstorming meetings where everyone is invited to contribute to the plan for the game. These must be held early and often—when real decisions are still being made. If people feel they have a stake in the design, they'll be much more inclined to communicate about it."

Where You Are in the Schedule, Budget, and Team

Savor it now, as this is the farthest you'll ever be from your ship date. This is also the stage where the least amount of money has been spent on the game, the schedule is still being structured, and everyone is optimistic about the future of the project.

Budget: There is no specific stage of a game's development that the budget is built in. Sometimes it's put together during concept, other times pre-production, and sometimes it is built out before any stage has started. The concept stage is the least costly in the development cycle, mainly because it consists of just the core dev team and isn't as heavily dependent on tech implantation, which is mostly researched during this time.

Schedule: At the end of the concept stage, you should have built out a first pass at the milestone schedule. While you won't have a full idea of everything that will be going into the game until pre-pro, you should know when the intended ship date of the game will be and work backwards from there. Based on the ship date,

FIGURE
26.3

Concept art like this can help prove out ideas at a low cost.
Image Courtesy of: "Tango Down" Zombie Studios.

you can pull back to when you should plan for first-party submissions, establish a date for Alpha and Beta, figure when you'll need to prep for localization, when VO will need to be recorded, etc. The more you move backwards, the easier it will be to determine where you need to place key milestones until you finally have a first iteration of the milestone schedule.

TWENTY SEVEN

The Creative at the Concept Stage: The Evolution

The creative director of the game is like the director of the film, guiding the look, feel, and gameplay of the project as well as the level of design along with the lead designer. While they are always in charge of the look and flow of the game, they don't always dictate the narrative, characters, and style. There are three schools of thought as to where this part of the creative direction should come from. Many feel that the creative director should be in charge of this, just as they are with the other creative elements of the game, however for the same reason most Hollywood films have a separate director and writer, a creative director who is great at gameplay and flow might not be as great with narrative, characters, and emotions. Most creative directors come up through the ranks of the game designers, which makes them knowledgeable on what makes an amazing level structure, engaging gameplay, and how to leverage the highest visuals, but teaches them nothing about the other creative elements that a story- and character-driven game needs.

Another school of thought is that the narrative and characters should come from the producer, which is why some companies have "creative producers." These are producers who manage not only the production of the game, but narrative, visual, and some design aspects of the game as well. The creative producer doesn't always come from the design side of gaming, but they show a powerful knowledge of what has the makings for strong gameplay and fiction for the product, plus they can also manage the development of the game.

Pushing the envelope can yield great results.
Image Courtesy of: "Skate 2" EA.

Yet another direction the story and creativity can come from is the publishing producer. In some cases the publisher specifically hires a developer to build their creative vision, or craft a new sequel for the publisher's own IP, and it's the pub producer's job to make that happen. A pub producer can also have a creative producer title, under which they not only ensure the interests of the publisher's investment, but guide the creative direction.

The distinction of where these creative lines and roles begin, and end, should be firmly established early on, otherwise creative directors and producers on both the dev and publishing sides will be butting heads throughout the project. Make sure everyone is on the same page, clear on who they should turn to for what, and mature enough to not let things bruise their egos.

Brainstorming and Collaboration

Regardless of who is holding the creative reins, it is important to allow everyone to share the riches. Don't ever let anything fool you into thinking that all the ideas behind a game come from one single person. The creative and design of a game is a mishmash of numerous voices all working towards a single goal. A team who feels their ideas are being heard and utilized has a personal investment in seeing the project through to success.

FIGURE
27.3

Brainstorming can be the foundation of greatness.
Image Courtesy of: "Skate 2" EA.

At the beginning, and throughout the concept phase, you should organize brainstorming sessions. These are meetings where the team shares their ideas, all of which are narrowed down and collected by what works best for the project. You might think you have all the answers, but opening up creative input to the team generates input and feedback you might not have considered.

Brainstorming sessions should cover all aspects of the game, not just what the game is, but the subtle nuances. Tell everyone the basics of what you already know about the main concept and goals of the game. Cover the genre, playable characters

and key non-playable characters (NPCs), the world in which it exists, and the style of gameplay such as first-person shooter, RPG, adventure platformer, etc.

FIGURE
27.4

Let ideas flow and fly.
Image Courtesy of: "Skate 2" EA.

Brainstorming meetings should be scheduled and structured just as you would any other type of meeting. Break the brainstorming sections up into main topics and set a specific time limit for each topic, otherwise you could discuss the same item endlessly and never move on to the next. Keep everyone on topic and keep the discussion moving, as these types of meetings can easily wander into off-topic conversations. Most importantly, make sure notes are being taken and a record is being kept of the information.

Tips on Brainstorming

- Dedicate a specific time limit to each topic and fill that time specifically with the subject at hand.
- Write all of the ideas down on a large whiteboard so they can all be seen by everyone all at once.
- Once the time limit is up for that topic, start narrowing down the ideas on the whiteboard. The final results will evolve from this.

Brainstorming Kick Starters

- Create large character sheets and ask: Who are the characters? Why are they here? What do they look like? What are their personalities? Do they have a hobby or quirks?

- Enemies and bosses: Although it sounds cliché: What are their motivations? Why do they want to stop the protagonist?

- Create a sheet on the world: Is this our planet? Is it in outer space or in another dimension? Is there an oppressive government or is there no government at all? What is the climate like?

CHAPTER TWENTY EIGHT

Concept Risk Management

The concept stage is the most exciting, creative, and free-flowing time in your production cycle. This is where you get to really sink your teeth into pie-in-the-sky ideas, brainstorm, and plant the seed that will eventually evolve into a game. This is also the time when you get brought down to reality by taking the necessary steps to see if the concepts and ideas you and the team come up with are actually achievable in the time, budget, and tools at hand.

Look Ahead

As with all of the stages, the biggest part of risk management is looking down the road. This is the farthest you'll be from completion, so the view might be a bit hazy in the distance. As you're planning out the budget and schedule, you'll start to be able to identify red-flag issues. Is the ambition of the concept beyond what can be completed in the time allotted? Are there holes in your staffing that need to be filled? Do you have the tech and tools necessary to achieve your goals, and if not, does your budget allow for them? Working with your leads you'll understand the tech and design challenges that wait ahead. Risk management is not an easy task, but it is the very reason games have a producer, not to just be creative and maintain the vision, but to devise solutions to work around the challenges that accrue throughout a game's production.

While you want to come up with strong and innovative ideas, and you'll need to schedule and budget the entire project, the concept stage has the shortest amount of time allotted for completion. If you're lucky you might get two months to complete everything. The worst thing that can happen is that you'll conclude concepting

without having your high-concept doc, staffing plan, and initial milestone ready by the time you roll into pre-production.

Stakeholder Approvals

Not only do you need to get your concepting duties finished on time, but you also have to get the work approved by all stakeholders. Because this is the work that will set the stage for the rest of the project, it will all be highly scrutinized, so you need to allow enough time for all parties to review and provide feedback. In most cases the stakeholders will have feedback and changes they want to see made. While some of the changes will be reasonable, others will need to be discussed, but you must get the work to a place where everyone finds it acceptable and approves the vision for the project. This can become time-consuming, so start discussing the direction with them early on and integrate their input as you progress. Having time to gain approvals is one thing, but having everyone's clearance on what the game should be is essential.

Once you've gained stakeholder's approval on the concept, you can move forward without concern as they will have a difficult time backtracking if they change their minds. Some, however, have been known to backtrack and contradict their feedback, and sometimes even succeed in over riding their own approvals. To protect your project and yourself, keep a highly detailed archive of every single approval and related correspondence. Stakeholders simply aren't going to be as organized about tracking their approvals for the game as you are, so when a stakeholder denies or forgets that they approved an item or made specific feedback, you should be able to reach into your archives and quickly provide them with a copy of their original sign-off.

Looping in the Tech Director

Something that we reiterate quite a bit in this book, especially when it comes to risk management, is to review everything with your tech director, because they know better than anyone else what is possible with the technology at hand. Sometimes this means they will bring you down to reality, other times they can help innovate and come up with terrific new approaches and ways of manipulating the tech to go beyond your expectations. Without looping in your tech director, you're risking going down a path that can't be properly accomplished or should have been approached in an alternate way. By the time you discover this, you might be so far in that you'll have to waste valuable time and money backtracking or trying to fix a problem that could have be solved before you even got started.

SECTION SIX

Pre-Production

While the concepting phase is when you figure out what you're going to do, the pre-production phase is when you figure out how you're going to do it. This is also when design, tech, art, and audio plans are fleshed out into their respective design docs. The staffing will be put in place, the budgets and schedules will be finalized, and it will all result in a playable prototype that will carry you directly into production.

CHAPTER TWENTY NINE

Looking Ahead

The goal of pre-production is to turn your high-concept doc into a production plan. There is a lot to do here, and very little time to do it in. To be able to complete everything necessary before you roll into production, you need to approach pre-production in just as organized a manner as you would any specific task. The first step is to split pre-pro into three different phases: the planning phase, the design phase, and the prototyping phase. While each of these stages might have some overlap, you should separate them out in order for the team to focus on one stage at a time. Trying to juggle all three will result in three incomplete phases.

The Planning Stages

Here you and the team leads will be looking ahead and planning out the entire pre-pro and production phases. Every task, element, and strategy for the remainder of your production cycle needs to be determined right now. The outcome of this will be a fleshed-out milestone schedule, a list of the tech and tools needed for the game, a full staffing plan, and the completed budget for the game. Once everything is determined, you'll immediately start executing it, starting with staffing up the team, because you only have a short period of time to fill in any gaps in the plan. If you plan on outsourcing portions of the game, it needs to be determined here, including: deciding what work will be outsourced, finding a selection of outsourcing options, and creating a plan to secure and implement the work.

The Design Phase

This is where all aspects, approaches, and content for the game will be planned out, with the producer working with all of the disciplines to take their strategies and turn them into a cohesive plan and presentation. The creative director and designers will be working with the producer to plan out the entire design of the game, not just the location and levels, but the gameplay, features, and systems that will be implemented. It all needs to be outlined on paper before the end of pre-production

so everyone knows what is going to be included in the game—rather than still trying to figure out the design of the game when you're in production and should be building it out. That would be like starting to shoot a film without a script.

The tech director will be reviewing the work completed at high concept as well as reviewing the work-in-progress GDD and determining what technology would be best utilized for the project. Working with the producer and creative director, the tech director will provide direction and plan the tech strategy for the game, putting his findings in a doc similar to the GDD, only one that outlines the tech and engine flow designs.

The art director should be determining a visual look and feel for the game; making sure there is agreement from the producer and creative director. Once the visual bar has been set, the art director will generate an ADD, which not only serves as a style guide and visual reference for the game, but outlines how the art will progress through the art team and be implemented into the game.

Prototype Phase

The prototype phase is kind of like a mini-production cycle: You'll be planning out your game, creating a short animated piece called the proof-of-concept (or target render) and then building out a prototype (or vertical slice)—a playable mini-version of the game. These will serve as a demonstration of the game, and while it may not look exactly like what the final game will be, it represents the design, visual quality, and gameplay. This will allow the team to look back at what works and what doesn't so it can be adjusted when rolling into the production stage.

CHAPTER THIRTY

What You Hope to Achieve at Pre-Production

When you reach pre-production, both the publisher and developer should come to an agreement as to the final goals of this stage, as every developer and publisher have a slightly different interpretation of what the final results should be. While some require a proof of concept and/or a prototype, others want to roll directly into production from the planning stages. Even the definition of prototype can differ, with some considering it a visually rough build to show how gameplay and design will feel, while others expect it to look and play exactly like a level from the final game. It's bad when production, marketing, and PR have different ideas of what a prototype should be, but it's even worse if the developer's and publisher's definitions aren't in alignment.

Either way there are key pre-production goals that are universal. These are the pieces that make up your strategy that will carry you through production and to your Gold Master Candidate.

The Production Plan

This is the scaffolding from which your game will be built. It includes all the plans needed to create the game as well as the timeline and costs.

- The Game Design Doc – This is the bible of your game, a blueprint for the entire game documented on paper.
- The Milestone Schedule – If the game design doc is your bible, the milestone schedule are your commandments. This schedule breaks down the monthly deliverables that the developer provides to the producer to show the progress of the game. Most payments are set against it.

Getting great moves on paper will translate to great moves on screen.
Image Courtesy of: "Street Fighter IV" Capcom.

- The Master Schedule – This is the production milestone schedule combined with the schedule of other divisions to ensure that everything jives. It should include audio, outsourced cinematics, operations, localization, marketing, PR, sales, business development, and QA.

Finalizing the Budget and Headcount

The creation of the budget can happen at any stage up until pre-pro. When developers bring a project to a publisher, they often already have the budget and staffing planned out. When a publisher brings a project to the developer, the budget and staffing are built as part of the contract negotiations, and if the developer is owned by the publisher, this is all planned out during the concepting stage. Regardless of

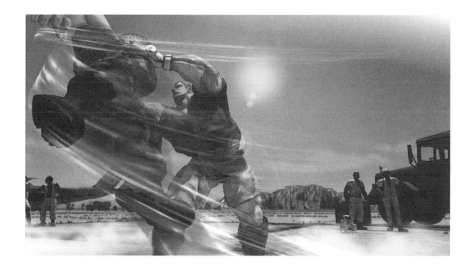

FIGURES
30.3 AND **30.4**

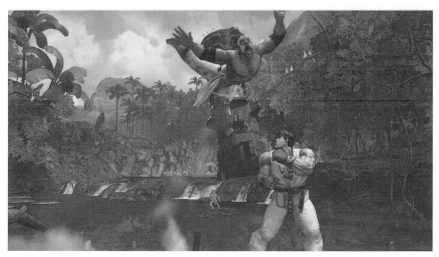

Fighting for budget and headcount is one of the toughest parts of the job.
Image Courtesy of: "Street Fighter IV" Capcom.

197

when the budget and headcount were initiated, during the pre-production stage you'll figure out what is needed for the game based on the design created at this time. This will allow you to finalize the financial and staffing plans.

Building the Team

In addition to finalizing the staffing plan, this time should be used for staffing your team. Although there will be some team members already on board at the developer, new hires are often required to fill vacancies in various disciplines, or provide additional resources. You want to take care of this now so the team will be fully staffed when you enter production, otherwise it could muck up the entire schedule.

Proof of Concept/Vertical Slice

This is where the dev team creates and tests out a sampling of the game that will mark the end of pre-production and the beginning of production. The proof of concept (also known as a target render) is typically an animated piece that shows the level of quality for the visual element, while the vertical slice, which is not necessarily at the same level as the proof of concept, gives a playable sampling of the gameplay and level structure.

THIRTY ONE

The Producer's Role at Pre-Production

Pre-production done right means predicting the future by planning it. We've already gone over creating a schedule, budget, team structure, workflow pipelines, and the GDD, but how do these relate specifically to the pre-pro stage?

The beginning of pre-production is when you plan out and implement the flow of how the game will be made, and strategize its design, characters, and narrative. This starts out by outlining what tasks every team member needs to complete in every stage of development, meaning that before you even have a game design document, you must develop all of your plans to be concrete enough to dive into production, yet have them be flexible enough to shift and change if the GDD calls for it. This doesn't mean dramatically changing your resources, but instead, being able to shift them within production so that the design can have the most advantages.

The Team

At pre-production you're working with a mini-team, a smaller representation of what the larger team will eventually be at the end of pre-pro. The essential members at this stage are the producer (but of course), the creative director, the art director, and the tech director. Although it is ideal to have at least two team members reporting to each of the leads at this stage, it can wait until later when you're working out the prototype of the game.

As you're planning out the game, an abbreviated version of the production pipeline should be put in place, in order to create a proper flow for the work being created. As the end goal of pre-pro isn't just having the game all specced out, but to create a playable demonstration, you'll need to structure the flow the same way you would in full production; only with the leads and sometimes a few team members putting the pipeline into practice. This way you can take full advantage of each discipline during the limited amount of time you have to build out the design plans for the game.

Scheduling Best Practices for Pre-Production

During pre-production you'll be building out the master schedule for the game as well as completing the milestone schedule you started at concept. The scheduling and tasks for the pre-pro stage is determined by how many months you have assigned to it while still allowing for a full production cycle. In an extremely tight production schedule your pre-pro stage can be as short as a month, which means everyone can forget about a proof of concept or prototype. If you have a full, reasonable production cycle, you can fit in all of the tasks needed to plan out the game as well and create a demonstratable version of the game.

Creating the Task Inventory

Your team is going to grow quickly at this stage, so you'll need to predict when to ramp members on and where. Right now you may be working with a small version of the staff, but as you work towards the prototype you'll be dramatically increasing that team and hopefully have your full staff by the end. To make sure everything flows and stays on task, you must plan out with the team leads all of the tasks that are necessary for the game and when they need to be completed. The basic objective that you should have is to create a path and timeline through the pre-production process of what needs to be completed, and where it needs to appear in the schedule to keep the project constantly moving.

Here are the major tasks you and the team need to tackle during the pre-production process leading up to the proof of concept and vertical slice.

- *Master Schedule* – Working with all of the non-PD groups to align other department's schedules with your own.

- *Milestone Schedule* – The tasks that make up the production stage represented by a physical deliverable.

- *Production Pipeline* – How the work will constantly flow through the various discipline in the development team.

- *Game Design Document* – Expanding the high concept doc, this cover the designs for all content in the game. It includes . . .
 - Game Design – Building out the structure of the game on paper.
 - Gameplay Features – A breakdown of the goals of the gameplay and features that will be included in the game and how the player will interact with them.
 - Character Concepts – The artists, the creative director, and the producer will determine the look and profile of the characters, plus how many characters you need vs. how many can be built in the time allotted, then adjust the needs based on the time and budget at hand.

- *Environment Concepts* – In your concepting you'll have an idea of your location. Here is where you want to plan out the look, design, and flow of your

environments. What will they look like? How will they change? How can they be leveraged by the level design, and vice versa?

- *Narrative Concepts* – Although you'll have a general idea of your story from concepting, pre-pro is where it's fleshed out into a full narrative and strategized in terms of how it will be implemented and communicated within the game.

 In some cases a writer is hired at this stage; this may or may not be the one hired for the full project. This writer takes the ideas and structures them into a clear, organized narrative. If a writer is not available at this moment, narrative concepts are typically the responsibility of the producer or creative director.

- *Sound Design Doc* – The audio for the game is just as essential as the visuals to place the player into the world you create. The audio engineer needs to devise the "sound" of the game and document it in an SDD. Not only how sound effects, voice-over, and music will be implemented, but the tone of each environment and how different audio elements will differ based on the emotion you are trying to portray.

- *Tech Design Doc* – Every single plan you have for the game needs to be run by the tech director, not only to see if it can be achieved with the resources at hand, but also so that the tech director can plan for what software and hardware is needed, and plan how to structure, build, and implement it. The tech director outlines how the tech will be handled in the TDD.

- *Art Design Doc* – While there are multiple artists all working on the project in tandem, they need a clear style and direction to build the work into. The art director will be formulating a look, style, and approach to the game, with clear instructions, examples, and formats all placed within the ADD. The art team will be dependent on the ADD until they have captured the proper style and approach.

Organize Dependencies

For each dependency to be able to create their piece of the pre-production pie, they need to be organized and structured properly. Although the producer, creative, and tech directors will be floating in and out of meetings with each dependency to go over their direction, review their work, and discuss direction, every dependency needs to be managed by its respective team lead. All visuals need to be under the art director's wing, as all design needs to be under the design lead or creative director. As you need to depend on each of these leads managing their tasks, you should work with them in outlining each of their group's duties so you can merge and prioritize it with all of the other team tasks.

Expanding in Pre-Pro

As you should now know, the pipeline is the structure and organization of how the tasks flow through the process. In pre-production you'll have a much smaller

team, so it won't be as complex as it will be in your proof of concept stage, or when you're in full-blown production. It is important to know what items should be handled in what order, otherwise you're going to have delays with team members waiting to take their part of the process. Luckily, as you're right now in planning stages, most of the individual tasks can be handled in tandem with one another.

You'll first start off by expanding the high-concept doc into a breakdown of features, a narrative, characters, and environments. This begins with the producer and creative director; the tech director and design team will add their input and ensure it is feasible.

CHAPTER THIRTY TWO

The Game Design Doc

A writer has his outline, an architect has his blueprint, a scientist has his thesis, and a video game production team has its game design document (the GDD). As we've previously mentioned, the GDD is your game on paper, but let's examine what that really means, and to do so we need to dissect the elements of a game. The essence of a typical Next-Gen console game consists of the following.

- Narrative: The story, explanation of what is going on.
- Characters: The playable characters, enemies, companions, NPCs (non-playable characters)
- Locations: Streets, buildings, the sky, forests, bodies of water, ships
- Movements: Walking, running, climbing, strafing
- Combat: Punching, kicking, grappling, struggling
- Weapons: Guns, swords, blunt objects, lasers
- Design: Layouts, maps, levels, paths for the player
- Goals: Missions, obstacles, puzzles, bonuses, things to do
- Tone: Moods, senses, emotions, sounds

What the GDD does is break down each of these elements and explains in detail how they will be handled and achieved, and goes through the journey of each. This is by no means an easy task regardless of how detailed a vision you have in your mind. A game is a fully realized artificial world and the game design explains every nook and cranny.

Now take a game that's 8 hours long across 10 levels. While the GDD outlines the scenario of the game, movement, weapons, and missions, each of these 10 levels needs to be explained exhaustively, taking us from the beginning to the end and

outlining every thing and place along the way, the different paths, who and what is encountered, found, interacted with, and the player's goals. While a screenplay averages around 90 to 120 pages, a GDD can be anywhere from 300 to over 1,000 pages, each page chock-full of information.

The GDD is rarely created by one single individual, but instead by an entire team of designers led by the creative director, with the producer overseeing the evolution and providing direction to make sure it maintains the vision, tone, and quality set by the high-concept document from which it is being built. Once the initial pass of the GDD is created, it is then the job of the producer to maintain it and keep it current and organized.

The GDD should be considered a living document that is constantly being iterated upon with portions being added and altered. Even in mid-production one idea can spawn another, which can be built to improve the game, but if the GDD is ever considered locked, then new innovations can never grow. There is a point, of course, where the creative additions must end, but through most of production, the GDD and the task of building the game should move together.

The creation of a GDD is an evolutionary process. It starts with the high-concept document, taking apart its essence statement and features. From there the basic mechanics of the game are sorted out along with the narrative—not necessarily the story details, but the scenario, including the location, time period, universe, and the main goals of the game's protagonist. From the needs of this world and characters, the feature sets will grow, melding necessity with engagement for the player. Questions should be asked: Yes, a character needs a tool for a specific goal, but how can that tool be made enjoyable for the player while adding to the experience and world of the game?

Once the basis of these elements have been created, the crafting of the design begins to gel. First, globally look at the location(s), style, structure and characteristics of what can be leveraged as the best design for the flow of the game and gameplay. As this is built out, over time each individual level is designed. These will take up the bulk of the GDD, as they include all of the features and elements from the other aspects of the doc, but they are now implemented into a full walkthrough of the intended experience.

The Various Formats of the GDD

As games are now far more detailed than ever before, the format of the GDD has begun to evolve along with it. More teams are starting to prescribe to new ways and formats of creating and contributing to the GDD. The traditional format is one large document that is edited as new information comes in and grows as the features are fleshed out and the designs are built.

More often now you'll find GDDs that are split into smaller design docs, each taking an element or level of the game. This allows a specific focus on one individual aspect. While this makes it easier to focus on and digest the individual feature or level, it also makes it harder to see the game from a global sense. This is why the producer plays such an important creative role in the GDD, not just in structuring, organizing, and putting things together, but in maintaining the same visualization of the game in all aspects.

Another format that is growing in popularity is the Wiki-style GDD. Here larger groups can all contribute to the document through a server, using the same software tools the popular Wikipedia website generated. The full GDD exists on a server for the team to edit. This form allows team members easy access and allows for edits to be made online. This is especially good for sharing information and changes, but it can also become very unwieldy unless carefully maintained and organized, which is difficult to do because everyone has access and some individuals may not be as structured as others. Wiki's are also not very image-friendly so it is difficult to include visual elements that help illustrate ideas, and work out designs.

Not Just What, but How!

The GDD includes every element of the game and what needs to be built, but what's equally important to include is how it will all be done. Think of the GDD as an algebra exam. Not only do you need to give your final answer, but you need to explain what steps you took to solve the equation in the end. It's easy to dream big in a GDD, but tech, time, and budget don't always allow for every idea. You need to be able to prove that everything you want to include can actually be achieved and by what means.

While the tech, art, and sound leads will be creating their own design documents, those outline the overall approach and flow. What the GDD needs to examine is how the individual elements and features will be crafted. As always you'll need to include your tech director in regular reviews of the GDD, as well as the other discipline leads in their respective elements. You can't expect the art director to craft a style for a game if they are unaware of the elements and design, just like you can't expect a sound engineer to create the audible tone of the world without knowing what that world is and where it will be taking the player.

Your tech director will be able to determine how each element can be tackled, and identify the tech and tools necessary to do so. The outcome of their reviews lets you know what is feasible and what needs to change, either the GDD or the tools, time, and money at hand.

The Elements of a GDD

We've looked at the essence of what makes up a game; the elements of a GDD dissect all of these but need to be maintained in a specific organized structure.

Some of the basic elements you will need:

- Description of your vision of the game: Often taken from the high-concept doc and essence statement.
 - Summary
 - Game Goals
 - Mood/Theme
- Primary features & Secondary features
 - Environments that are immersive
 - Combat Mechanics – Hand-to-hand, weapons, etc.
 - Character Interactions
- Game Mechanics
 - Character traversing systems
 - Camera Control and Movement
- Combat
 - Style and delivery
 - Targeting
 - Basic combat vs. Complex combat systems
 - Charge Ups
 - Defense
 - Combo attacks
- Player Challenges
 - Enemies – Strengths, weakness, and special attacks
 - Special events (ala God of War)
 - Design guidelines for AI and how non-player characters interact
- Environmental Designs & Interaction
 - What does the terrain look like and how should it feel
 - Interaction and danger – for example, finding lava pits, or fire
 - Scope – how large are the environments, is it an open world?
- Characters
 - Listing out the characters and defining attributes
- Locations
 - Where the player will go
- Level Design
 - Layout of the level that describes what happens to the player
 - Maps out where specific interactions and hotspots will be
 - Describes any puzzle elements that need to be solved

The GDD should include breakdowns of each of your characters in story, traits, skills and abilities.
Image Courtesy of: "Street Fighter IV" Capcom.

 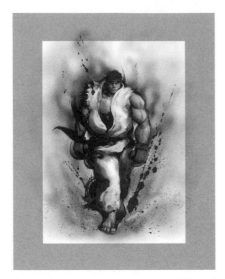

The GDD should include breakdowns of each of your characters in story, traits, skills and abilities.
Image Courtesy of: "Street Fighter IV" Capcom..

THIRTY THREE

Tech, Art, and Sound Design Docs

In addition to the game design doc, which is put together by the creative director, lead designer, and producer, there are three other essential design documents required, the tech, art, and sound design docs. These three documents are typically generated by their respective leads, and while they are sent in to the producer for review, the producer isn't necessarily always involved in their creation.

The Art Design Doc (ADD)

Just as the tech design doc structures the plans for technology, the art design doc sets the plans for the approach and creation of all the visual aspects of the game. This goes far beyond just the look, feel, and style of the art, but addresses how it will be created as well. The ADD includes a style guide showing the visual target, approach and standards for the art, concept examples, color pallets, fonts, and libraries of pre-existing art.

On top of just concept art and a style guide, there should be detailed plans on how the art assets will be created and manipulated, and the pipeline each piece will go through from concept to completion. This includes the technology and tools used to create and complete the art and animation.

As a cost-saving measure, most games have some portion of the art outsourced, mainly with minor models such as tables and chairs so that the dev artists can focus on more important assets. The outsourcing company uses guidelines set forth in the art design doc to mirror the look and feel established by the art director. The outsourcing plan will also be outlined in the ADD, providing a background on the outsourcing company, what they will be handling, and how the art will be secured, reviewed, and integrated, plus a schedule of the deliveries.

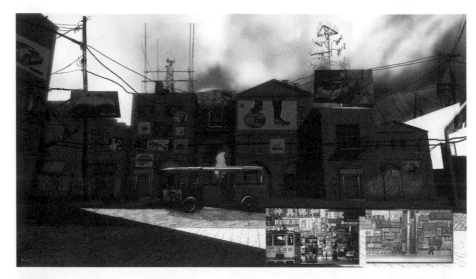

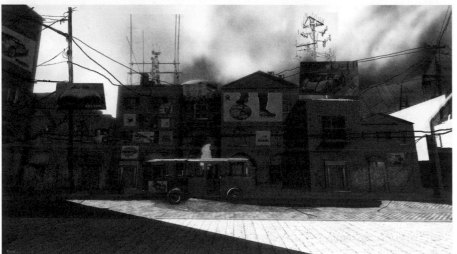

ADD's often include real life and graphical references, especially to set environmental styles and tones. Image Courtesy of: "Tango Down" Zombie Studios.

The Sound Design Doc (SDD)

The three major areas of the SDD are the voice-over, music, and sound effects. This is the strategy for the approach and style of the sounds in the game as well as how the tech side will be structured. Although the SDD doesn't include sound files per se, it does list examples, especially with music, to give the reviewer an idea of how the audio will feel, including listing composers and specific soundtracks that mirror the same genre and feel.

Each console has its own unique sound chip and memory requirements that allows for different capabilities for audio, but also has its limitations that vary across the different platforms. This is why some games sound slightly different based on what platform is being used, because the audio had to be adjusted to accommodate that console's specific sound chip and memory limitation. This used to be a bigger problem than it is today, console makers now are using better audio compression and a standardized format such as .wav files.

The Tech Design Doc (TDD)

Once the evaluation of the specs and the tech needs have been established, it's time for the tech leads to structure all of information into a TDD. This is a detailed strategy outlining on paper how the game technology will be handled and planned, and how the threads of the software will flow. It's proof on paper of how the game build can be completed.

This doc includes all aspects of game technology, including pre-built items such as the game engine, tools, scripting, and middleware, outlining how they will be integrated and communicated with one another, and converted into the game code. This is also where the memory is managed to ensure the builds will run properly on the target hardware, and that all of the game assets such as art, sound, camera, and controls will function properly together in the flow of the engine and fit within the console memory.

Localization is an area that you don't deal with until the end of production, but it needs to be planned and structured at this early stage so the game can be pre-rigged to accommodate it. Plans need to be included in the TDD about how the dialogue, on-screen text, and artwork containing text such as signs and graffiti can be switched out with translated iterations for each territory the game will be releasing in.

Tech Design Doc Table of Contents Recommendations
By Tech Directors Tae Joon Park and Randy Culley

1. **Development Environment**
 a. Considering platform
 - Screen resolution goal
 - Ex: 1080p, 720p on console
 b. Minimal and recommended system requirements for PC

2. **Engine and Tool Technologies**
 a. Engine block diagram
 b. Tool chain diagram
 c. Engine technologies
 - Threading Structure
 - Memory Management
 - Math Library
 - Rendering Architecture
 - Shader
 - Lighting and Shadowing
 - Camera Control
 - Animation
 - Physics
 - AI and Behavior Control
 - Script
 - FX
 - Sound, Music, and Video
 - UI and HUD
 - Player Input Control
 - File IO and Streaming
 - Network
 d. Tool chain
 - Level Tools
 - Asset creation tools
 - Previewing Environment

3. **Game Play Technologies**
 a. Main Player
 - How to implement main character or object behavior caused by player input?
 - Navigation system
 - Attack and defense system
 - Object interaction – grab, throw, open, close, and any other
 - Special Movement
 i. Ex: sniper mode, invincible more, stealth mode, flying mode, etc.
 - Vehicle mode, if exist
 b. Behavior Control
 - How to implement character or object behavior caused by terrain attributes?
 - Ex: Swimming, Climbing, Hanging, or Sliding
 - How to implement character or object behavior caused by collision?

(Continued)

- How to implement character or object behavior caused by attacking or damaging?
- Character view direction, lip sync, and eye movement control
c. NPC behavior
 - Animation transition diagram for each NPC
 - If there are any kind of special behavior control scheme for NPC, please explain
 - Ex: team behavior, game history – based behavior, environment recognition based behavior, path finding based behavior
d. Combat and Damage system
 - Combat Type
 - Melee combat, ranged battle, etc.
 - Damage Control
 - Weapon system
 - Melee weapon, ranged weapon, defensive device (shield), etc.
 - Targeting system
 - How to recognize player combo input and realize combo attacking movement?
 - How to avoid continuous attacking or damaging?
e. Dynamic environment game objects
 - Please explain how to implement interactive objects and their behavior
 - Ex: environment puzzle, trampoline, trap, moving platform
f. Game interactions
 - Are there game interactions that can change background geometry or game objects? How to implement?
 - Ex: destroying
 - Are there game interactions that can change position or orientation of game objects? How to implement?
 - Ex: Grabbing, throwing
 - Are there game interactions that can affect the other game interactions? How to implement?
 - Ex: Hiding behind an object, inventing new device by combining game objects
g. Camera Control
 - What kind of camera system will be used in this game? How to implement?
 - Ex: Fixed camera, following 3rd person view camera
 - How to control if there are some objects or background geometries that occlude the main character from the camera?
h. Sound/Music/Video/Cut Scene
 - How to sync with game events?
 - Streaming from disk? Or loaded into memory?

(Continued)

213

i. FX
- How to sync with game events?

j. Environment Data
- List of data items included in the level data
 - Ex: Scene description, collision data, event triggering and handling data, FX script data, camera data, initial positioning data for characters and props, special data structure for rendering acceleration, etc.
- List of data items for game characters and props
 - Ex: Collision data, FX triggering data, animation data, behavior script, etc.
- If there are specific constraints on game data, please explain why they must be applied and how to make game data satisfying them.

k. Memory map and File I/O
- Estimated memory map
- Data streaming plan

l. Game specific scripting
- Game specific enhancements
- Game specific scripting environment

m. Game progress control
- Mission and quest management
- Game progress save and load

n. Game object system
- What type of object system is being used
 - Inheritance based
 - Component based
 - Hybrid approach
- What are the major game objects supported and used by the game

o. Mini-games (if they exist)

p. Network and online features (if they exist)
- Configuration style
 - Ex: p2p, server/client
 - Inter-platform co-operability
- Cooperation features and competition features
- Do you provide downloadable contents?
- Do you have a plan to provide update patch? (Only on PC version)

q. Efficiency issues
- Please list all the techniques used to improve execution efficiency
 - Ex: LOD, culling, mip-mapping, spatial data structure, etc.
 - Please do not be restricted on rendering acceleration techniques

4. Production Issues
- Production flow diagram
- Build Control System

(Continued)

- Version Control, Asset Management, Source Control
- Localization Strategies
- Multi-Platform development, platform-to-platform porting strategies

5. **Development Schedule and Work Assignment**
 a. Schedule for each of the development activities described in section 1 and 2
 - Qualification conditions for each development activity
 - Dependencies between the development activities
 b. Technology classification
 - List of technologies required to be newly implemented
 - List of technologies that have been already implemented
 - List of licensed technologies
 c. Work assignment if there are outsourced developers or artists

6. Quality Assurance and Risk Management
 a. Risk assessment
 - Risk analysis on management, artwork creation, technical activities, etc.
 - Are there any platform-specific risks? If they exist, do they impact implementation activities on other platforms?
 - How to mitigate assessed risks?
 b. Stress test plan
 c. Quality Assurance Plan
 - Visual Quality Assurance Plan
 - System Robustness and Efficiency Assurance Plan

CHAPTER THIRTY FOUR

The Tech Side at Pre-Production

As the game is being planned out at pre-production, you should include your tech director in as many aspects as possible, partially to determine whether everything being planned is feasible given the resources of the project, but also so that the tech requirements and needs can be planned out. This is also the stage where the tech is tested to verify that the work built for the game can be integrated into the engine and executed on the target hardware. The final outcome of the tech side of pre-production should be a fully vetted tech design doc detailing the strategy of how the tech will be structured and flow, securing all of the tech needs before going into production, and a working prototype, sampling the gameplay.

Evaluating Tech Needs

As the game is brainstormed the tech director will determine what equipment and software is needed for the production stage and will be working with the producer and creative director to determine the best game engine. In the majority of cases, developers either specialize in a specific engine or use their own proprietary one, but it's not unheard of for a team to use a different engine than what they specialize in, especially if the game calls for different needs. Even the top game engines aren't flexible enough to work with every genre and style of game.

Although the primary engine is what your game will be built on, this is also the time to determine what middleware will be necessary and which middleware option compliments the engine you're working with. This is no easy task, as there are numerous middleware solutions that you may need, and they still might have to be reworked and manipulated to fit your specific goal, just as the game engine is often manipulated to fit the style and genre of the product. The more expensive engines come with many middleware solutions already integrated, but these might not be the ones that are best for your project. If that's the case, you must secure a license for a different one and have the tech team rework it for a seamless integration into the engine.

The engine and middleware aside, there are several other tech needs to build out the pieces of the game and make sure it can run on the first-party console's software development kit (SDK).

The Tech Design Docs (TDD)

Once the evaluation of the specs and the tech needs have been established, it's time for the tech director to structure all the information into a tech design doc. This is where the tech director outlines on paper how the game technology will be handled and prepped, and how the threads of the software will flow.

The TDD also includes the strategy of getting the tech from point A to point B. This establishes guidelines and limitations for each team to go by when building their respective pieces of the title, and it also sets the process for integrating. The integration itself and the approach of how the game features will be possible rests with the tech group, and with the producer working with them to ensure that communication is properly conveyed and that things are moving along the timelines dictated by the schedule.

Proving the Tech Works

During pre-production you'll be working towards completing a prototype of the game. To get to this point, throughout pre-production you must test all of the intended game mechanics, features, design, and art to ensure they can be built within the engine, and prove they can run properly on the target hardware. Something that might work perfectly on the PC dev environment might run horribly on the target hardware as it is not as powerful and cannot be manipulated as easily. To do this you and the tech director must run tests to make sure what is being built can load properly into the console memory without chugging, crashing, or creating functionality issues. This is why dev and test kits are so important to have during pre-production. You do not want to risk getting to the production stage to find that work your team has built won't run on the hardware. Some of the biggest disasters in game development have been caused by a lack of planning and testing.

Automated Build Process

Once you've tested to ensure that pieces can run on the target hardware, you'll then need to establish an automated build process. This is a setup that pulls and updates code, art assets, audio, and information from the data management software to automatically generate debugged builds with updated history and code. By the end of pre-production you'll be creating builds regularly and will need to establish this process so that the team is not delayed with trying to stop their work to cook a

build. This also helps with narrowing down bugs that pop up when combining the assets into a build.

Dev and Test Kits

The dev and test kits are two kits from first parties that allow the team to prove their concept will be playable on the target hardware. The dev kit contains powerful hardware equal to that of the computers you are developing on. The test kit is closer to the retail unit but allows in-development builds to be run off disk and the hard drive. The test kit and dev kit can connect with your computer via a user interface, sometimes called an SDK dashboard. The dev and test kits themselves are just hardware. SDK, libraries, and compliers need to be secured from first parties separately and are updated regularly.

The first party SDK includes libraries, compilers, and all the tools to convert game code into an executable. Using the SDK, executable code is generated on a development PC, burned to a DVD, or transmitted into dev, or test kit hard drives directly. After that, you can launch the game on those kits.

The library is a part of an SDK, which communicates with game code, controlling every part of the hardware in the system, but it does not rebuild the game code into an executable. This rebuild is performed by the compiler.

The compiler takes program code and an appropriate part from the library, links them, and then generates the executable code.

Dev and test kits have almost similar functionalities such as running executable codes, taking screen shots, or recording videos, but the big difference is that the dev kit can be executed with the code level debugger (also an SDK tool) running on the development PC.

The code level debugger is a tool for programmers to discover and locate program bugs. Line by line it tracks the behavior of game code, status changes of game assets, and contents of console memory at the level of game code.

THIRTY FIVE

Proof of Concepts, Target Renders, and Prototypes

There are multiple techniques for illustrating that the team's ideas are right for the game and fully achievable. Some companies use only one, or two of these strategies, while others may take advantage of all three; the proof-of-concept, target render, and prototypes. When hearing these stated together, they may sound as though they have the same meaning, and the end goals of each are indeed quite similar, plus they can work hand in hand, but they each facilitate a different process, and should be defined as such to avoid confusion.

While one, or all of these are expected requirements in some form or another, there are publishers who won't contact a developer for the full game until they prove themselves with one of these demonstrations.

Proof of Concept or Tech Demo

While this isn't a working model or a demo of the game, the proof of concept shows how a specific gameplay feature will operate. Take for instance Spiderman's web swinging. Before it is implemented into a build, or demo, it is carefully tested and focused on, separate from the rest of the game. This can be done in-engine, using flash animation or a myriad of other styles; there is no specific format mandated by the proof of concept, you just need to use it to show that the idea and approach is right for the product.

Target Renders (Tone Video)

The target render is a non-playable animated video illustrating the game's potential and gives a visual impression of the goals for the final product. It's especially good for those execs and management who aren't familiar with what a work-in-progress

game looks like. Just as it's named, this video is aimed for the "target" of the game, highlighting the possible gameplay, art, movement, and visual quality. It only needs to be a few minutes long, focusing on the main features you hope to implement in the game. Some go as far as having an animated controller on the screen, demonstrating button presses and controls in order to show the ease of play.

When managing the target render, be very careful that the team doesn't get too elaborate with it. The video is supposed to appear exactly as though it's a sampling of the final product, not a glitzy animated trailer. If it can't be done in the game, it shouldn't be done in the target render. Don't use impossible camera angles or moves, or animation that cannot be reproduced during gameplay. If a target render is signed-off on and down the road the game looks nothing like it, milestone deliveries might fail, projects canceled, and publisher–developer relationships severed. Even if the project continues, if a deceptive target render is shown publicly and the final game doesn't resemble what was previously shown, it will be skewered by both the public and press alike.

Prototypes

The prototype is an important and defining landmark in the development of the game and marks the end of pre-production. It is a sampling of all the key features, as well as the look and feel; it's also a tool to gauge whether your plans are achievable and head in the right direction for the game and the gameplay.

A producer must remain vigilant that the prototype is completed on time and to the satisfaction of management and stakeholders. Unlike the target render, which shows what the game will look like but is not interactive, the prototype should be fully playable on the target console the game is being developed for.

What is a prototype?

- It's a playable version of the game: not necessarily pretty, but fun to play.
- Designed like a mini-level showing approximately 10 minutes of gameplay.
- The art is typically rough; it should represent the goals for the style, but is not to be considered finished art.
- The music and sound effects are usually placeholders.
- Should be primarily focused on design and playability.
- Proves out the overall goals set forth at concept and pre-pro, delivering engaging gameplay, features, look, feel, and design.

What it isn't

- A demo: The prototype should not be expected by any party to be used as a press or public demo of the game. It is more of a rough draft and is far too early of a stage for exhibition.

- Perfect: It's not going to have "everything" the final game will have, just the important features you hope to highlight and prove are fun.

The prototype is significant beyond just proving that the team can achieve the goals of the game; it's an indicator of how the production will flow, the time it takes to create each asset, what the weakest points in the development process are, and where the strengths are that can be leveraged.

For gameplay it shows which features are the best and where more focus needs to be made. If a feature doesn't work or is annoying in the prototype, then it either should be cut or dramatically altered. This is also where you can learn from "happy accidents," when an unintended element ends up becoming a great feature of the game. Sometimes glitches can end up as major gameplay elements.

Be sure to clearly communicate early on that the prototype will by no means represent the final product visually or in gameplay. It is simply proving that the tech works and serves as a test run for the production to find where things need to be tweaked. Any stakeholder or management team member going into the demonstration of the prototype expecting to see something at the level of a finished retail game will be sorely disappointed. A misinterpretation such as this can derail the game's production before it even begins. Never expect any of your higher-ups outside of production to have knowledge of how games are made or developed, or what they look like at the various stages. It's part of your job as the producer to educate them on this, explaining that a prototype that has only been in development for a few months is not going to look like a game that's had a full production cycle. It might sound silly that we're having to explain this, but you'd be shocked at how often this occurs as more non-gaming executives enter the business.

Art and models in a prototype are typically basic, but should illustrate the direction and style the visuals will be going. Often times it will have "banana textures" as placeholders. These are plain pieces of geometry without any textures. They're not pretty, but they allow the person playing the prototype visual reference to walls, corridors, and other spaces, and will let the player have a visual reference to collision detection. At pre-pro you don't have a full art team or modelers working on the game, so you need just enough detail to show at least one character model performing gameplay aspects such as basic walking, running, arm lifting, and head turns.

Prototypes also allow programmers the chance to explore the tech and see where they can push the limitations of the game consoles and game engines capabilities. They can then set a plan that the game designers can use to expand upon where they want to take the game. Manipulations like this are referred to as "Pushing the Tech" and/or "Pushing the Engine".

Having an idea of where things can be pushed and cheated will allow for more creative freedom, and will establish how unique qualities can be added. The programmers and tech engineers will also determine and eliminate any technical risks and hurdles that you might experience during the production stage. As they are now working in the actual environment of the console, nasty bugs and items that may prove to be too costly, or negatively impact key features can be discovered, tested, and fixed or adjusted.

FIGURE
35.1

Characters are part of the iterative process of creating a prototype.
Image Courtesy of: "Watchmen" WBIE.

The design team leverages the prototype for testing by seeing their designs in action with other players, identifying what is confusing or frustrating, and what is fun and engaging. This will help them structure and build the full level designs and gameplay. The producer should review with those playing through the prototype what they like and dislike about the design and mechanics, providing information to the designers on all points with recommendations as to how it can be improved.

FIGURE
35.2

The iterative process yields results.
Image Courtesy of: "Watchmen" WBIE.

Like with a sketch for a painting, eventually the rough lines will be taken away and only the best pieces of the art will remain.

For the team, the creation of the prototype sets the stage and environment as to how you will all be working together, not in just the pipeline, but how communication and camaraderie will flow as you all work together towards a common goal. Once you've established a pipeline at the prototype stage you'll be able to see what works and what needs more focus. After evaluating and documenting the pipeline, you should have a clear understanding of where it needs to be balanced for the most efficient leveraging of the team and resources.

One thing to remember, in assessing the reactions to the prototype, is that what you communicate is just as important as how you communicate it. Not everyone takes constructive criticism well, so instead of saying that a design or feature is bad, poor, or stupid, say that the players found it frustrating, confusing, or unengaging. This communicates the same message without being insulting or putting anyone on the defensive. Also, come back with solutions; ask those that didn't like it how it could be better. When providing criticism, you can't just say something is negative without explaining why and providing solutions or launching pads for ideas.

Types of Game Prototypes

Depending on where you might end up producing your game, a prototype might have different functions or definitions.

- First Playable – A first playable is just that, when the game has transcended the "on-paper" phase and has become something that is actually playable that can be interacted with on-screen. It can be as simple as a flash game running on the PC, or as complex as the game running on the target platform.

- White Box Prototype – White boxing is a common term for early playable tests, allowing the team to iterate on a design in engine and typically on the target platform. Not only is this a form of prototyping, but is also an evolution of the game design. This is where a designer or programmer tests their ideas and gets to see their results quickly in order to make changes and modifications. The white boxed levels are not just used to show character action and movement, but for the level and environmental design as well, giving the designers the freedom to move around portions of the world to best suit their goals and make sure it works in-game.

- The Vertical Slice – This form of prototype is more polished and a closer representation to the final game. It's called a vertical slice because it is basically just that, a sampling of the top features, design, and gameplay, plus the look and feel of the environments and character models. The vertical slice represents a small level of the gameplay, showing character interactions with one another, their environments, and combat, as well as in-game goals and challenges.

Building the Prototype into a Demo

Today nearly all games need demos for both press and public use, but these are also major headaches for the producers and the dev teams, because they cause interruptions in the full game development. Early on you should loop in marketing and PR to establish when a demo will be needed and for what uses, so it can be planned and scheduled out with as little impact as possible.

Often when a vertical slice is a success, it is built out to become the demo. This helps save time and resources; however, you have to be careful to remove or change the features that are going to be altered and dramatically polish it up to look and run like a finished retail game.

Transitioning from Prototype to Full Production

You now have a completed prototype that proves the viability of your game, so it's time to roll that knowledge, experience, and tech over into full production. The developer should present the completed prototype to the publisher in person and walk them through it. This is good to gauge initial reactions, but be sure to allow the appropriate review time for full feedback. Once all mandated input has been collected, have a meeting with the team to discuss the successes and shortcomings of the game. Discuss what could have been done differently to avoid some of the pitfalls. How did the process of building the prototype perform? Could it have been improved? At the end of a full production cycle, this process is known as the post-mortem, and is designed so that the publisher, developer, and team can evaluate and learn from the game and how to approach their next project. Here you will be performing a mini–post mortem, like an autopsy of the game, dissecting and learning to streamline the process in full production.

THIRTY SIX

Risk Management: What Can Go Wrong at Pre-Production

This is where you'll be looking to see what in production will be affected by the decisions you make during pre-production and the steps you can take to make sure you are making the right choices.

Technology

During pre-production the technical abilities of the developer should be carefully evaluated by the publishing team, primarily by the tech director. If drawbacks and weak areas exist, they need to be identified. If there are some issues on the game engine or tool chains that can be technical obstacles or challenges, a mitigation plan to resolve these risks should be prepared, which can include recommendations for licensing a new engine or middleware, modifying the existing system, or outsourcing to a third party.

Pre-production is the stage where all the technical aspects of building the game will be determined, planned, and scheduled. While the tech director will be driving this, the producer must provide them with the tools necessary to make it all happen. In addition to acquiring the software and hardware for the game, all of the respective licenses should be in order and paid for. This responsibility can fall on the shoulders of the developer or producer, depending on how it was initially agreed upon in the contract. Some of these licenses only provide limited "seats," meaning you're allowed to have the software on a specified number of computers based on how many "seats" you paid for. Always make sure you are using legitimate and fully licensed copies of the software and tools, no matter how common they seem. Major legal issues can ruin not only your project but harm the entire company if unauthorized software use is discovered.

Knowing where to skimp and what to invest in is extremely important, not just for quality, but for the schedule and budget as well. Some game engines come with compatible middleware as part of the license, but these aren't always the best solutions for what you are trying to achieve. The producer, tech director, and creative director need to determine if a license for separate middleware is worth the extra expense or if the existing solution can be manipulated enough to get similar results.

Approvals

Because you will be determining the direction of the game throughout concepting and pre-pro, you must make sure everyone is on board and signed-off on the vision of the game with no room for misinterpretation. There are some really basic, but essential, steps to ensure this.

Once you have your essence statement, concept, game design, art, and tech design docs completed, you must have all parties agree to, and approve in writing, all of these documents. While some companies use a digital signature process, many are still in the dark ages using hand-signed approval forms. Either is fine so long as it includes not only their sign-off but specifically indicates if the submission is approved, not approved, or approved with comments, and if they are require a resubmission. In any case, make sure that all parties know that once they sign their approval, there is no going back on that decision.

Vision

As the producer you know the game better than anyone else, so it's up to you to make sure that all factions hold the same unified vision. The work generated from a team split by different interpretations will not mesh in the final product.

Part of cementing this is to keep a vision statement in a place where everyone can see it through the entirety of the project. Hang concept art up on a wall. Your work space should always be decorated with information that visually projects the goals of the game. Schedules and milestones should be either pinned up too, or on a whiteboard. If there is ever a question about where you are in the project, anyone can come by and see it.

Schedule Locked

Don't go into production with just an early draft of your schedule. The timeline of the game's production needs to be fully vetted out by the time pre-pro ends. While milestone deliverables may shift, the schedule should be built with enough flexibility that another item can be switched out in its place without having an impact on the overall timeline. Regardless of how flexible the milestone schedule is, the actual dates should not change and the overall project master schedule should be locked.

Pipelines Established

Have the production pipeline established during pre-pro right before you build out the prototype. This way you can check for bottlenecks and adjust them into smoothly flowing conduits. There might need to be some tweaks along the way to leverage efficiencies, but you should stick to a single process. Major changes in the pipeline slow everything down and should never be taken lightly, so you need to plan for contingencies that will prevent having to make any major alterations. By the end of the prototype stage, every team member should know their tasks and the tasks of everyone else involved with the process.

Be Fully Staffed

You want to have the full team ramped up by the end of pre-production. Trying to find the time to seek out, interview, and hire suitable candidates once you're in production will burn time and dollars, plus cause delays in the overall process if you end up waiting for an essential role to be filled.

Outsourcing

Make sure your outsourcing needs have been identified and an outsourcing company has been contracted. Don't wait until you're in production to see what needs cannot be handled by the development team due to bandwidth or resources. You also need to leverage outsourcing so that your team members aren't focusing on minor or insignificant assets at a time when their attention should be focused on more important goals.

The Production Phase

Once you are past the planning stages of concept and pre-pro, you're ready to put those plans into action by slicing into the meat of the production. If your concept and pre-pro were successful, the transition into the production stage should be a smooth rollover from the prototype into the full game. The actual experience of going through all of production can feel like just as much of a journey as it is a job. Developer and publisher alike, you're all in it together and the producers on both sides have the most pressure to make the game a success.

As the journey of the production stage can last up to a year or more, it allows for more hurdles and fires to endure and snuff out. The term "dying on the vine" is commonly used with this stage as politics, changes in business and the market, or just plain bad luck can kill a product at any stage of production. This is also the most costly time as both publishers and developers are burning hundreds of thousands of dollars a month and sometimes more.

Production is also the time of successes and camaraderie. While concept and pre-pro are thought of as the most creative phases for a game, it is during production when the most experimentation occurs, as the team works to manipulate the tech and innovate what is there to make the most engaging experience for the player.

CHAPTER THIRTY SEVEN

What Are Your Goals for the Production Phase

The goal of production is to build the game. While this is simple to say, it is by far the most complex and lengthy stage of the process. While you've now completed a working, playable prototype of the game, a clear line has been drawn as to what the look, feel, design, and structure of the final product will be. Based on the successes and shortcomings of the prototype, the group can decide together what adjustments need to be made during production.

The roll into production should feel almost seamless as you and the core team have already been working on a playable build of the game for the prototype, so the basic asset pipeline is now established with only the need for tweaking and additional heads as the full team is put into place. If you're missing any disciplines at this point, start aggressively recruiting to find the right person to fill that spot, because you don't want any delays due to a shortage in staff.

The pipeline will consist of artists, designers, audio engineers, and programmers all working both independently and together to integrate their pieces of the game into a final code, leading to a submission to first parties and the product hitting store shelves on its scheduled release date.

Communications and approvals will be at a high, especially during the early stages of production. Once all parties have found a comfort level as to how the team and producer are handling the game, subsequent approvals will be easier to secure without as much micromanaging.

During production the producer's job is to make sure everything moves along like a well-oiled machine. This, however, isn't always possible with the issues that erupt during the production phase, but you should prepare for it, with a flexible enough pipeline and schedule so that things can be shifted to accommodate a short-coming or unforeseen monkey wrench.

FIGURE
37.1

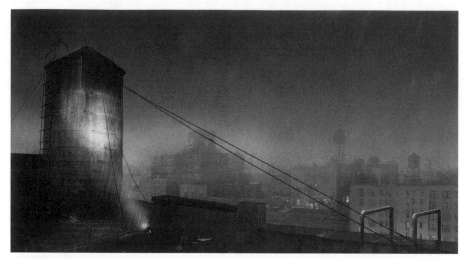

Through rain, sleet, snow or gloom of night, nothing should stop you from rolling into production on time.
Image Courtesy of: "Watchmen" WBIE.

While the global crunch mode for a project is when preparing a Gold Master Candidate for submission to first parties, the development team has a crunch mode every month when the milestone is due. Although milestone submissions are a valuable process that provide the publisher with an insight into the progress of the game and the quality of the dev team's efforts, it often feels like a burden to the dev team who have to stop the progress of their work in order to prepare all materials for that month's submission. This may seem like a pain, but it is also a reality of working in the business and should be accounted for when planning out the tasks and schedule. Milestones are what keep the lights on and the bills paid. It's okay for a publishing producer to have faith in a dev team, but it shouldn't be blind faith. Members of the dev team need to see for themselves that the work the developer is crafting is in alignment with what was agreed upon, that they are truly able to execute what was promised, that all quality bars are being hit, and that the game will be an enjoyable experience for the end user.

There is so much work in production, it sometimes seems that creativity gets lost, so challenges that come up during production aren't always a bad thing. These challenges allow the team to step back from the details of their work and examine the best ways of tackling the issue, which often turns into a creative solution benefiting the final product by making the game more fun to play.

As production moves along, the artists will create the assets and environments; the animators will bring life to what the artists have created; the sound engineers, writers, and VO talent will give it a voice, a feeling of space, and emotion; the designers will create the flow of the levels, gameplay, and actions; and the programmers and tech director will get it all to fit and run properly on the console. The Producer oversees the flow if it all, like the conductor of an orchestra, working hard to avoid any sour notes.

FIGURE
37.2

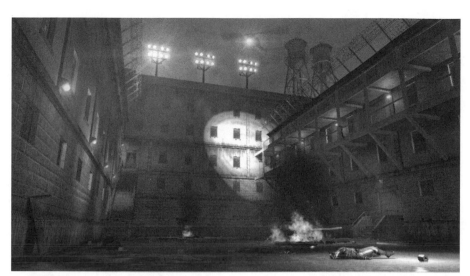

In production your game comes to life.
Image Courtesy of: "Watchmen" WBIE.

CHAPTER

THIRTY EIGHT

Builds and the Build Process

The game build is a demonstratable representation of the code that you can run off a test kit version of the target hardware. In early stages, it can be as simple as stationary images that you can rotate the camera around to see different angles, while the deeper you get into production it evolves into a build with controllable characters, white box levels, and eventually playable levels that will be built upon to become the full playthrough of the game.

The build of the game serves two purposes. First, it allows the progress of the game to be reviewed, demonstrated, and interacted with, second it also proves that the work being accomplished in development can run on the target hardware and doesn't put a drain on the console memory.

Each first party has a separate and unique way to convert the game code and assets into an executable format that will run on their specific platform. The software that reformats the code that your team creates into the binary executable code readable by the console system is called a compiler. Each first party has a website dedicated to providing support and the latest software development kit (SDK) and firmware, the latter of which is updated regularly. Typically this is all managed by the tech director.

The build also gives the publisher and stakeholders the opportunity to view the work in progress as part of your milestone submission, enabling the publishing producer, tech director, and art director to review not only the build, but its contents in action, assessing the quality of the work and making recommendations for the next milestone. Being able to see the game in action, with high-quality content, also gives executives on the publishing side confidence that the game is on track.

Builds are also used as demos, for press, and are sometimes made available to the public. These are separate from the distributed or downloadable demos. They can only be played on test kits and are never released to the public other than during in-person demonstrations.

Before you begin to deliver builds to the publisher, the format it is delivered and played in must be discussed and agreed upon. Most builds are delivered to publishers

via FTP site, but depending on the format delivered, the build can't always run off disk. Instead, it must be transferred directly to the test kit hard drive.

Formatting the build from a dev kit to run off a disk on a test kit is time-consuming, and often frustrating. A dev kit has twice the amount of memory as a test kit, so often a lot of time and resources have to go into adjusting the build to run off a test kit; having it run smoothly off of a disk takes away even more time. In some cases, the assets are just too large to fit on a burned disk.

The issue for publishers is they need to have the game played by several team members, all of whom have separate test kits that aren't always hooked up to a server onto which they can load a game build. Having a disk allows the build to be handed off to multiple parties, rather than just in the office connected to the server. This also helps if the build of the game needs to be taken on the road for demonstrations such as sales tours. The other problem on the publisher side is that not all departments and individuals are as tech-savvy as the producer and dev team.

The reason developers sometimes try to avoid disk-based builds is that they take longer to create and don't play as smoothly when running off of disks. Builds loaded from hard drives run faster, while, without enough optimization, data loading and streaming from a disk may result in severe chugging and freezes. While it's nice to have a smooth-playing build on the hard drive, the end consumer is going to need the game to play off disk, so trying to avoid disk-based submissions can only create more problems down the road if you're not able to get that memory problem fixed. Getting into the habit of submitting disk builds will only be a benefit in the long run as it forces you to deal with the streaming memory issues right up front.

Of course in some cases the decision has already been made for you, because some first-party consoles, like the Nintendo Wii, will only play full-console game builds off disk.

CHAPTER THIRTY NINE

The Quality Assurance (QA) Process

The QA team, also referred to as testers, are the team members responsible for reviewing game builds, scrubbing them for bugs, and making sure they function properly and follow the first-party requirements. QA staffers have roles to play on both the developer and publisher sides of the fence. At the developer, QA is much smaller, sometimes consisting of just two or three team members, while at a publisher the QA team can grow to the size of other departments.

So why have testing at both the developer and publishing ends? While the developer's QA setup is to verify that the games are acceptable enough for the milestone submission, and to help track down major bugs in the game, they are also utilizing the development equipment and setup for ideal situations. On the publishing side, the QA's environment is intended to mimic the setup a consumer would have, using different test kits, servers, and equipment than what was used at the developer's to test the build. While the dev and pub testers should be seeing the same thing, simply using different equipment can show issues with the compatibility of the build that would not have otherwise been spotted, and help narrow down certain issues. This testing goes through each version of the game, from different consoles to different territories, so testers not only need NTSC test kits to review builds, but PAL kits as well.

A tester's goal is to play in every combination possible to try and "break the game"; then log each bug, along with the steps to recreate it, into a bug-tracking program that generates bug reports, classifying them by degrees of urgency. A bug is a glitch, or error in the software of the game, that prevents it from being played the way it was intended. While each company has their own unique standards for labeling bugs, the following are industry standards: "A" bugs are show-stoppers that will prevent the game from being played; these include crashes, levels or art not loading, controls not responding or functioning, a model falling outside the environment (called "falling though the world"), and anything else that prevents the game

from being played. "B" bugs are serious issues that hinder the quality and playability of the game. While you might be able to play a game with a B bug, it can be a poor and frustrating experience for the player and cause serious quality issues that will prevent the game from getting approved by first parties. This could range from characters getting stuck in place, lack of control feedback, streaming issues where the environment may not load as fast as the game, slow or overwhelmed streaming causing choppy motion and gameplay, or triggers in the game not going off when passed. "C" bugs are issues that affect the quality and gameplay experience, but are lower on the priority list because they don't prevent the game from properly being played. C bugs can consist of clipping, object detection, sound effects not playing, and color errors.

These bugs are then all input into a tracking system and output to a report that often can be viewed live, as the bugs are being input into the system. Both the publisher and developer have access to this report, with the producer in charge of prioritizing the bugs by importance and assigning them to the appropriate team members for fixes. This often includes direction, feedback, and a deadline as to when it needs to be completed.

QA plays the game in every combination possible, trying to recreate every possible way the gamer at home could play or use the game in their console. This ranges from simple playthroughs to constantly repeating play, trying to play badly, just wandering around the environment, etc. First parties also have their own list of bugs they want QA to test for; these include being able to open the disk tray and removing the disk without the game crashing, disconnecting the controller or the batteries dying without the game continuing, even soak tests—which have the game and console running for extended periods of time, even days at a time, yet can still be picked up and played without skipping a beat.

The reason you want to start testing so early is that while the game is in mid-production, you want to be able to catch major issues that could snowball into larger problems if not caught early. Software programs are fickle, and one slight change to the code to fix one bug could create an entirely new set of issues. As you get closer to the end of production, around the pre-alpha stage, the publisher will dramatically increase the number of testers, sometimes contracting external teams with round-the-clock testers playing the game in a variety of different ways and scenarios, trying to find all of the issues that can occur.

Once the game has been thoroughly tested with all A bugs cleared out, and as many B and C bugs fixed as time allows, the remaining bugs are output into a final bug report as part of the first party GMC submission.

CHAPTER FORTY

Localization

Localizing a game is customizing it to ship in another country. The most common territories to receive localized versions of Next-Gen console games are England, France, Italy, Germany, and Spain, commonly referred to as EFIGS, but there are also parts of Canada that require the game text to be in both English and French. These aren't the only territories where games can be localized. Console gaming is popular in Japan, Korea, China, Russia, and the Nordic regions, but they don't commonly receive iterations of North American games. Unless you work for one of the publishing giants, or a Japanese or Korean publisher, your game isn't likely going to get a release in Asia without a sub-distribution deal. Aside from these, most other countries play their games on the PC, with many sub-distributors in place ready to license your game from the publisher.

The primary task of localization is to have the text and VO translated—including all the dialogue, on-screen text, user interface, and manuals—as well as available or switched out text within the game code. This needs to be prepped within the game's framework at the early stages of production, including rigging signs and graffiti as separate files to switch out. Typically developers are contracted just for EFIGS, with additional fees tagged on per each additional territory.

While the developer may be the one who implements the translated assets, they don't handle the actual translation or manage the process. At some larger publishers and localization companies there is a localization producer who specializes in managing the process of getting all the text and dialogue translated, getting the new localized VO recorded, and having it all prepped into a localization kit that is sent to the developer. If the publisher doesn't have a localization producer, then the publishing producer is in charge of managing the process.

When the game is shipping to separate territories it won't necessarily release on the same date, which can be really helpful when trying to juggle all the different builds to the various first parties and international rating boards, all while trying to finish the primary game, however, as of late publishers now look to ship simultaneously worldwide in order to prevent piracy of games from one region to the next. Most licensed games that are based on movies look to ship day-and-date with the film in each territory to leverage marketing initiatives.

Steps in Localization

First, no matter what side you are producing on, you need to schedule for localization. Translation of text, especially in a dialogue-heavy game, is time consuming. The words aren't just directly translated, but massaged into flowing dialogue that makes sense to the international player. On top of that, new VO needs to be recorded. All of this must be achieved for each country and juggled to stay on task and on time. On both the publishing and development sides, the producer needs to plan for this lengthy phase in the schedule. Once enough time has been established to get it completed, the game code needs to be prepped to receive and switch out localized text and audio files.

When the English dialogue for the game is recorded, the producer should be present, and perhaps the associate producer, to log any off-the-cuff changes in the dialogue that commonly occur during VO sessions with talent. Once you've recorded the final VO and have completed the in-game text, a packet needs to be put together for the company managing the translations.

This translation packet should include the following:

- A full word count of all the game-related copy and dialogue. This dictates the cost of the translation and gives everyone an idea of how long it will take to translate.

- A complete log of all the in-game text, dialogue, and manual copy placed within a spreadsheet.

- A guide to file naming conventions to make the localized files easily switched out in the game code.

- A glossary of slang phrases used in the game, along with their meaning, as these terms might not have a direct translation.

- Once the packet is completed it's sent off to a contracted translator or a translation house.

Once the dialogue script has been translated it is typically re-recorded by actors into the localized language. In some cases a region will opt to not have the VO localized and just use subtitles. Although this is cost effective and alleviates quite a bit of the work, it makes the end product look cheap and is very distracting to the player.

Once the recordings are complete, it's time for all of the sessions to be edited and voice-over files made. These and the in-gamer text files are sent to the publisher and developer for integration in a localization kit.

The localization kit includes all of the assets the developers need to switch out with the game code so it is now in a separate language. You should allow a few weeks for each territory, especially in the cases of VO where the character mouth movement and timing may need to be adjusted.

FORTY ONE

Risk Management During Production

Most things that can go wrong in game development happen during production. This is the lengthiest and most tech-driven stage with the maximum opportunities for disaster, so knowing ahead of time the common issues that arise during production will help you take preventative measures and make fail-safe plans. These might not stop every single problem from occurring, but at least they will soften the blow.

Time

We've said it before and we'll say it again: Time is your enemy in game production. There is never enough time no matter how well you plan.

Scheduling Issues

Before locking your schedule, review it with all parties, including those outside of production. Aside from your own, the schedule you need to be the most mindful of is that of the Operations Department as they will be working with you to plan first-party submissions and QA. Other departments you should be looping in are sales, marketing, and PR as they all have initiatives dependent on your title.

Unexpected Delays

While there are some areas where delays are foreseeable, there are others that come completely unexpected. Illnesses or injuries, deaths in the family, alien abductions . . . you have to plan and prepare for your team members' lives sometimes getting in the way. In the event of a delay you should design your milestone schedule with the flexibility to switch a deliverable or discipline out with another portion of the game so that the milestone deliverables are still complete and no production delays are incurred.

Date Changes

There are three common factors that could cause the release date of your game to change.

1. *Games Based on Movies*: If the film date is pushed out, no problem. It will either not affect the completion date of the game or will give you more time to get the work done. Lengthening out the production cycle does increase the budget, so this should be considered before making any changes to the schedule.

 If the release date is pulled in, then you're going to have some problems, as there is no way to truly prepare for this. A few weeks might only result in feature cuts or a rushed crunch mode for the game, but pulling it in by months could spell disaster. The publisher should take as many preventative measures for this as possible in their contract with the studio.

2. *Slate Change at Publisher*: Sometimes a project gets canceled or there is a major change in the release slate that forces the publisher to move the street date of the game. This is not a matter that should be taken lightly. The publishing producer and his seniors need to discuss this issue extensively with the executives who make the final decision and clearly communicate and document the repercussions of such an action, noting that it could negatively impact the game and determining what damage control can be achieved. This will give them the information to weigh the risks against the rewards.

3. *Dev Team Behind Schedule*: This falls on the responsibility of the producer, as they are the ones with full control over the schedule, mainly because they wrote it. Be realistic when building the schedule out, adding flexibility and padding wherever possible. Don't set your team up for failure by creating an overwhelming schedule with work impossibly stacked up.

 If you have a team member who's having a problem getting their work completed on time, sit down and work with them on pinpointing what is causing the problem or delay. It could simply be a technical matter or a personal one. If a team member is consistently behind in their work and not reaching their basic obligations even after you've worked the issue out with them, it might be time to consider outsourcing their work or finding a replacement, a tough decision but a reality of the business.

Technology

Here you'll be working with the tech director to try to foresee and troubleshoot problems that may occur down the road. An experienced tech director will have

their own strategies for preventing problems, but a less experienced one might not realize there should be concern until a problem arises.

- *Planning Tech in Order*: When building out multiplatform games, don't spec the tech out based on the capabilities of the largest, most powerful of the consoles. Start with the platform that has the most limited capabilities and build from there. This is more challenging, but will help make sure that the game will be compatible with all of your target platforms.

- *Compatibility Issues*: When using a middleware or tech outside of the engine, make sure they are all fully compatible with the engine and one another. Not all middleware works efficiently with every game engine, so research is key when selecting the proper software solutions.

- *Outdated Tech and Skills*: This will come up during a due diligence visit, but a developer who uses out-of-date tech or whose team members have not upgraded their skills with the changes in technology are red flags sending the signal that you might want to go with another team. This is their business and if they want to stay competitive they need to make sure they are up to the industry standards, which will reflect in your game. Yes there are those developers who haven't yet had the chance to release a full Next-Gen game, but they should be able to prove their worth with upgraded and up-to-date talent and tools.

- *Delays in Engine Upgrades*: Game engines are constantly being tweaked and upgraded to remain compatible with the ever-evolving console upgrades. This can create problems especially when an engine is technologically further along on one console than it is for another. Engines might also not be up to speed across all platforms. Typically they are built for a lead platform, integrated into its specific structure, and then retooled to work on the other major platforms. This means that the technology and flexibility of the other platforms will always be slightly behind the primary one.

- *Broken Builds*: Bugs and crashes are par for the course, but if the cause behind the problem can't be found or solved, you're in big trouble. If using a licensed engine, you and the tech director should get involved with the development community that shares that same engine, they can help with their shared experiences on how to fix complex issues that might arise. If using a proprietary engine, the tech director needs to reverse engineer to try and narrow down the source of the problem.

- *Memory*: Like computers, game consoles use memory. The memory requirements of the game need to be carefully managed and monitored to make sure it can properly load into the console without overburdening the system's limited memory, and to prevent memory leaks. The memory maps should be reviewed monthly and regular builds produced for the target console and prove that it runs properly.

FIGURE
41.1

Memory Allocation Table

For *put here game name* on *put here platform name*

	Size of Data Loaded into Main Memory	Size of Data Streamed from Disk
Game Executable main module additional modules, if exist render targets/frame buffers shaders streaming buffer size amount of memory reserved for system	0.00	0.00
Game Characters and Objects vertex data index buffer size animation data texture data collision data data for physics control control script	0.00	0.00
Game Effects geometry data texture data control script	0.00	0.00
Game Level Data background geometry data texture data control script scene description data for physics control data for path finding data for collision detection	0.00	0.00
Audio Data music data sound fx data	0.00	0.00
Video Data cutscene description movie data	0.00	0.00
UI Data texture data font/string data control script	0.00	0.00
Etc.	0.00	0.00
Total size of Data Loaded into Main Memory	0.00	

Complete this form for each platform
Modify this form if there are additional data items not listed here

Tech directors utilize memory map documents such as this to help organize and track memory usage.
Image Courtesy of: Designed by Tae Joon Park and Randy Culley.

Changes in Direction

When it comes to making a game, you want to stick with the same plan through the entirety of the game, but on problem projects where the gameplay and process are not moving well, dramatic changes in the game may have to be made to get the game back on track. This creates a lot of chaos and the only preventative measure you can take is to not screw up: Do the game right the first time around. Have confidence, always take pride and passion in your work, and make sure everyone is in agreement on the concept, direction, and plan.

Critical Stage Analysis

At various points in the development of the game you should stop and with the team leads, take a look at where you are with the project, identify your successes, and identify what can be improved without negatively impacting the flow. This huddle should happen at key stages in your schedule to help see if things can be tweaked or leverages made for improvement. Keep in mind that just because you can make a change, it doesn't mean you should. Changes in the pipeline, process, or duties can interrupt the flow of the production, so no decision should ever be taken lightly or rushed without the proper research.

SECTION EIGHT

Crunch Mode

Okay, vacation's over! You think you were working hard before? Well, that's nothing compared to now! This is an all-hands-on-deck phase where it's time to finish the game and scrub it clean. Any misstep now could cost the game so there will be no vacations, no visits from the in-laws, schedule that wedding for some other time, and you better hope no babies are due for these next four months—because you've just entered crunch mode.

CHAPTER
FORTY TWO

What Is the Goal at the End of Production?

Without a doubt this is the most stressful time of production for everyone involved, with the majority of the pressure on the producer. You might have been a good producer up until now, but if you drop the ball during crunch, it was all for nothing.

FIGURE
42.1

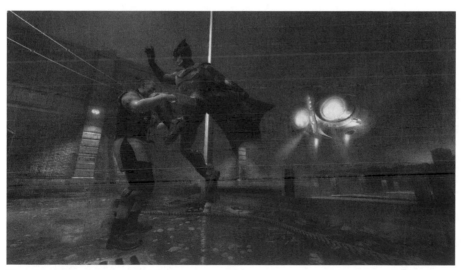

Time to gear up for the good fight.
Image Courtesy of: "Watchmen" WBIE.

The goal is simple: Hit your ship date. To do this the game must be content complete, free of all "A" bugs, localized, compliant with all ESRB and first-party guidelines, properly submitted, and approved all in time to get the game manufactured

and shipped to retail. With about four months at your disposal, this may not seem like such a big deal, but you'll find in the midst of it all, there is never enough time, so you'll have to take full advantage of the team and time you have, with everyone working at their maximum bandwidth.

The process of crunch is split into four stages: pre-alpha, alpha, beta, and Gold Master Candidate.

Pre-Alpha

This is the time to prepare for the coming storm. Everyone should be using this time to take care of the big issues and get much of their work complete. Artists need to be at the fine-tuning stages; designers should be focusing on gameplay and balance; programmers are moving efforts towards compressing the code to fit within the console memory; and audio should have all their domestic voice-overs recorded, music near completion, and the majority of sound effects and cues prepped.

This is also the time the localization kit arrives with localized VO recordings, translated on-screen text, and notes on containing any special information or instructions. By the beginning of alpha, the programmers should start implementing the localized assets for international submissions.

Alpha

This is where you want to put together in the code every aspect of the game that has been built up to this point. Now this doesn't mean your content is complete or the game is playable from beginning to end, but all the levels should be there and can run off the target hardware. This gives everyone a clear understanding of what's been done and what still needs to be taken care of. It also lets you see any glaring problems with the overall game, if something has been overlooked or misdirected. Of the final stages of the game this might be the one that has the most abstract of definitions. While the developer may consider the content enough to be considered an alpha, the publisher might not feel enough is there to accept it as such. This is why you always want to be ahead of things and define clearly what percentage of content needs to be completed by alpha. Your goal should be about 75 percent in gameplay, art, and design.

Although this is a time when you want to be entirely focused on getting the game completed, there are the international versions that need to be handled, ESRB submissions to be prepared, manuals written, and QA reviews of each build followed by bug fixing.

Beta

When you've reached beta you should be content complete. Everything that is going to be in the game is present and you're now ready to focus heavily on bug fixes and

fine tuning. If your game is shipping in other territories simultaneously, the dev team should now be integrating the localized assets delivered at pre-alpha so that international submissions can also be prepared.

On the development side the producer has their hands full with bug fixes, making sure that any tweaks or quality issues are getting taken care of, managing the integration of the localized content, and getting the most up-to-date builds to QA and to the publishing producer. You should also be reviewing the first-party compliance guidelines and checklists with the team leads to triple-check that everything is well within their guidelines. The team's primary focus is going to be on bug fixing and gameplay balance so as the producer you'll have to shoehorn in any additional issues without preventing them from getting any other necessary work completed.

If your game was planned out well, things will be intense, but still moving forward. If you're hitting roadblocks that prevent the game from being ready to submit to first parties by the end of beta, it's time to make some tough calls.

First determine what is preventing you from being code complete. Is it a bug that no one can figure out how to fix? If your tech leads are coming up blank on a bug, look to the first parties themselves for insight. If that doesn't help it's time for the team to start reaching out to the development community and see if anyone else has come across the same issue and find out how they fix it. If it's a matter of not having all of your levels or content finished in time, figure out what can get cut; sometimes it's features, other times it's entire levels. Better to have a slightly shorter game with fewer features than no game at all. No one likes to make calls such as this, especially with all the hard work that's been put into what's getting cut, but at this point you need to be more focused on shipping than making everyone happy.

This is also the time the dev producer needs to gain approval from all stakeholders, including the publisher. Make sure that all feedback from pertinent stakeholders has been taken care of or at least spoken to, as beta is no time for outside parties to start requesting major changes. The most they can do is mandate if they feel the product is acceptable to proceed to the Gold Master Candidate, after which no changes can be made.

On the publishing side, things are just as intense. The publishing producer is the one who actually prepares the submission to first parties and is held accountable if the game misses its submission date. They also need to prepare the game content portion of the ESRB submission and provide marketing with everything they need to know for the game manual. The publishing producer will be working alongside the dev producer and QA, checking for bugs, escalating the ones that would affect first-party approvals and downgrading the insignificant ones. A good publishing producer will put in the same long hours as the dev producer, assisting the process in any way they can. Even just reviewing and logging bugs is a terrific asset to the team.

Once the beta stage ends you'll all be exhausted, but the reward is a GMC that will be provided to operations along with the full submission packet and off it goes to first parties.

Oh, but it doesn't end there. This is the time you now have to prepare all of your international submissions and go through the QA process all over again, but this time with builds that aren't in English.

A Word on Zero Bugs

Don't let anyone fool you, there is no such thing as a game with zero bugs, it's really just about how many bugs first parties are willing to live with and how minor they are. Some games gain approval and are released with bugs that are hardly noticeable and rarely found in typical gameplay. Others ship with a ridiculous amount, there is no way to know or guess why or how this happens, it just does.

You should be focused primarily on the first-party requirements and clearing out all bugs that an average end-user would encounter, anything you have time to fix beyond that is cake.

GMC and Release Candidate

Although it's nice if your game gets approved during the first go-round, you should plan and schedule for at least two submissions, so if a build comes back rejected you have the time to fix the issue that caused the rejection and get back in line for review.

Once your build has been fully approved, your game has "Gone Gold"! At this point you need to provide one last, final, clean build of the game to first parties for manufacturing, something that is easier said than done, which is why it's referred to as the Release Candidate. The Release Candidate is the final build for retail with all of the development code pulled out and is a perfect reflection of the game code. Like all other candidate builds, it needs to be submitted to first parties. If approved it becomes the Release to Manufacture build.

CHAPTER FORTY THREE

Game Ratings:
The ESRB and You

The Electronic Software Ratings Board (ESRB) is an independent nonprofit organization that rates the age group, appropriateness, and content of video games, assigning an age certification (a.k.a. rating) and calls out the degree of questionable content. They also work towards educating parents and consumers about knowing what to look for when determining a game's suitability.

The ESRB was created in response to the outcry from parents to have film-like ratings for video games so that they would have an idea of what is appropriate for the age they are purchasing for. The board reviews all materials present on the game disk including bonus content, all packaging, manuals, and marketing materials. Even the lyrics to songs being used for the game and advertising are scrutinized. Every ESRB-reviewed game must prominently feature the ESRB age rating information and if the game has not yet been reviewed it must feature an RP: Rating Pending identifier. In recent years the ESRB also requires "content descriptors" that are pre-set terms to explain the type of content in the game.

The ESRB is specific to North America; each country/territory has its own unique ratings board, with separate sets of guidelines, some being much harsher than those in North America. For instance, a game rated "T" for Teens in North America might still be deemed inappropriate for minors by the OFLC ratings board in Australia, or could even get banned if they consider it bad enough.

The international ratings boards include the following:

- The Electronic Software Ratings Board: North America's game-rating and certification organization, independently operated.

- Pan European Game Information (PEGI): Game ratings board covering most of Europe. They use a different, but similar ratings system, have many of the same guidelines, and even have their own content descriptors. In some European territories the PEGI is legally enforced, while in others it is purely optional. There are also a handful of countries within Europe that have their own separate ratings systems that must be used instead of or as an alternate to PRGI.

Here are the countries that legally require PEGI certification.

- Finland: Also allows the option of using their film board's rating system, the Valtion elokuvatarkastamo (VET/SFB) as an alternate to PEGI
- Netherlands
- Norway
- Lebanon: This country is unique as it will accept both PEGI- and ESRB-certified games. The only exception is with adult-only games, as they will only accept titles certified by the ESRB with the AO rating.

Here are the territories that recognize PEGI but don't legally require it.

- Austria
- Belgium
- Bulgaria
- Cyprus
- Czech Republic
- Denmark
- Estonia
- France
- Greece
- Hungary
- Iceland
- Ireland
- Israel
- Italy
- Latvia
- Lithuania
- Luxembourg
- Malta
- Poland
- Portugal: Also has an additional media ratings board, the General Inspection of Cultural Activities (translated), also known as IGAC.
- Romania
- Russia: Doesn't use a ratings system for in country–made games, but requires all games from other countries to contain a PEGI rating.

- Slovakia

- Slovenia

- Spain

- Sweden

- Switzerland

- United Kingdom: On games that are deemed for adults only must contain the British Board of Film Classification (BBFC) rating of 18+ instead of the PEGI rating.

Germany is the only country that doesn't recognize PEGI, instead using their own ratings board, the USK.

- USK (Unterhaltungssoftware Selbstkontrolle) is the legally enforced German ratings board. Considered to be one of the toughest on violent content. USK ratings are a mandatory requirement for the game to be sold in Germany, but it can also accompany the optional PEGI rating.

Other ratings boards include

- CERO (Computer Entertainment Rating Organization) is the Japanese ratings board. The Japanese market is completely different than that of any other territory. If your game is releasing in Japan you either work for a Japanese publisher or the company that is releasing your game has a sub-distribution deal with a Japanese publisher. Because of this, the Japanese publisher will be handling the CERO certification.

- OFLC (Office of Film and Literature Classification). This is the certification board for both New Zealand and Australia for all forms of media, including video games. Like the USK they are known for their harsh guidelines.

As each territory and ratings board has its own unique requirements and deliverables, we are going to focus specifically on the ESRB, as their requirements are often the standard, with other territories requiring the same and more.

Although the ESRB is optional by legal standards, it's a mandatory requirement by all first parties and nearly all retailers. Basically the only platforms on which you can release a game without an ESRB rating are PC and Mac. This is also the case for games rated AO: Adult Oriented.

Determining rating:

The ESRB constantly updates their requirements and guidelines for submissions and ratings. Several times a year they make presentations to all of their publishing partners to update and educate them and provide examples of how decisions and determinations are made. Any producer working on the publishing side should attend these presentations.

When planning out the game, you should work with sales and marketing to determine the age rating you are targeting. The age rating affects not only your demographic, but your sales as well. There is no way to fully predict how the review committee at the ESRB will rate a game, but the ESRB is open to working with you to help make sure you're guided with the right information to develop the game into the realm of your target rating. Other ways to reach your target rating involve just using common sense. If you have a decapitation, then you're most assuredly going to get an M rating at the minimum. Blood might get you a T for Teen as long as it's not excessive. If you want an E-rated game, avoid any form of violence, or fatality at all costs.

ESRB Rating Guide

EC: Early Childhood: Games suitable for ages 3 and older. Does not contain anything violent or that could be perceived as violent or offensive.

E: Everyone: Suitable for children ages 6 and older. May contain some light cartoon violence and/or extremely mild language.

E10 + : Everyone 10 and older: Suitable for tweens and older. May contain slightly more cartoon violence and mild language than "E" rated games and/or include minimal suggestive themes.

T: Teen: Recommended for ages 13 and older. Can contain violence, suggestive themes, crude humor, minimal blood, and/or some strong language.

M: Mature: The hard "R" for video games. These games are not suited for children. Recommended for ages 17 and older. Can contain intense violence, blood, gore, sexual subject matter, and/or strong language.

AO: Adults Only: This is the "X" rating of the ESRB. No one under the age of 18. First parties do not allow any game with this rating to release on their console and most major retailers won't carry them either. Titles with this rating are typically only released for home computers.

RP: Rating Pending: The game has been submitted to the ESRB and is pending review. Only used on marketing and PR materials before the release of the game. No game can ship with this rating.

Submitting for Approval

When submitting to all territories, you're going to have to juggle all the different submissions and guidelines. Make sure all the contracts with the review boards are in place, find out what the length of time each review period entails, and pad enough time for each game to be reviewed at least twice, just in case you don't receive your target rating on the first go-round or if your submission is rejected.

Here are the items you'll need to submit to the ESRB.

- A detailed questionnaire with areas for supplemental materials such as scripts, lyrics, dialogue, images, and any visual content that can illustrate what the ESRB needs to properly review and make their determination.
- A DVD containing scenes and portions of the game playthrough that fall into the categories defined by the ESRB, but also include recordings of content that might be questionable within the gameplay, cinematics, and cut scenes. Such examples include combat, violence, alcohol, language, and gambling.

If there is any content that can't be viewed by the public, but is contained within the code it must be submitted or removed from the game. This includes unlockable content, alternate skins, etc.

How Can Your Game Get Rejected?

If it's discovered that you have questionable items that appear "hidden", or is not outlined in your submission, it will immediately be rejected with a penalty fee. If your game releases and this content is found later, the rating can be recalled and pulled from shelves. In the past there have been developers and publishers who attempted to sneak by content that they knew wouldn't be approved by the ESRB, but there are other times when the content was included purely by accident or the producer neglected to outline it on the submission doc.

For example, in a game submitted to the ESRB that contained a promotional trailer for a television show targeted at the same demographic was submitted; no one thought it would be a concern until the rejection came back from the ESRB with a hefty fine. The problem was the trailer contained an image of a partially dressed stripper dancing, which was not outlined in the submission doc. Although this would have been deemed appropriate for the target age, it was seen as an item the publisher was trying to slip by. It was a totally innocent, but costly mistake.

Resubmitting

If your game is rejected, in addition to paying a fine, you also resubmit. You can also resubmit if you don't get the rating you want. There is no penalty other than time as you end up in their que at the back of the line. When resubmitting make sure you have spoken to all of their issues, and have made the proper adjustments to the content.

FORTY FOUR

First-Party Submissions

The three big console makers in the video game industry are Microsoft (Xbox 360), Sony (PlayStation 3, PlayStation Portable), and Nintendo (Wii and DSi). Each of these major players hold one of the biggest stakes in the industry. While some games are exclusive to one specific platform, most publishers try to release multi-platform games where the same or similar version of the same title is released on all three major consoles.

This isn't an easy process; not only do each of these systems use unique technology, making it difficult to port a game code directly from one to another, but they each have a stringent and unique approval process that all games must go through to release on one of the respective platforms.

FAITH Harvester main reference Peter J 03.07.08

FIGURE
44.1

Never mess with tech.
Image Courtesy of: "Terminator Salvation: The Videogame" WBIE.

The process in gaining a final approval, called certification, is a lengthy and stressful process, but in the end all that work will only benefit your game as it ensures a quality standard and allows your product to ship for on a historic system . . . that is, if they don't reject it.

Just to clarify, first parties want to see your game approved and go on to great success. More popular games available for their systems equates to a higher demand for the console itself. The reason the submission process is so tough, with numerous requirements, is to protect the first parties brand. The industry learned a lesson from the downfall of the Atari 2600 back in 1983 when, with no way to prevent unlicensed and low-quality games from being manufactured for their system, the market became so flooded with bad games that it literally resulted in the industry crash in 1983. Not wanting to repeat this, first parties strictly police what releases for their system and closely protect their technology.

They protect their policies so much that they forbid any of the information on submission requirements to be released publicly. All license holders and their staff are legally prevented from releasing any information on the individual submission requirements; however we can provide you with some information and tips that will help you prepare once you're in the trenches.

Now, each party has different processes and guidelines. They are all going to require a minimum of two submissions; some require three. Here we will look at the different submissions and what they relate to. The review time for these stages fluctuates between 10 and 20 business days.

First Submission

This is a standard request typically provided near the end of pre-production. You'll be filling out a form (typically online) that asks basic information about your game, the target audience, age rating, and technology. They will also want to see a description of the game both in design and narrative, plus any concept and game design docs available at that time. If you have a prototype built or any playable code, it should be included in the submission as well.

This is by no means a difficult process and most of the time the feedback and questions you receive back are reasonable. Sometimes it's approved to proceed to the next stage, other times they may have some concerns they would like you to speak to before clearing the game for the next stage. Here the publishing and development producers review the comments and provide detailed and respectful feedback. Most of the comments from first parties are stated as questions or asking for specific clarification. If you're clear in your responses when resubmitting and it's obvious you're not planning on making a game that is in violation of their standards, then you'll be approved to proceed on to the next stage.

FIGURE
44.2

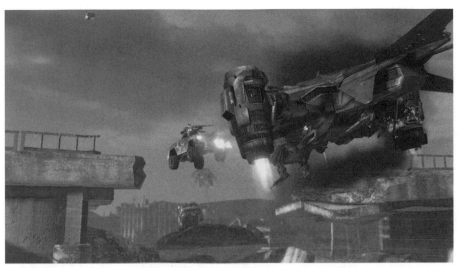

Taking the leap into your First Submission can be a bit nerve wracking.
Image Courtesy of: "Terminator Salvation: The Videogame" WBIE.

Second Submission

This stage usually falls around pre-alpha. By then a great deal of your game has been built and first parties want to see it. The code built so far as well as a walkthrough and any gameplay-related documentation is submitted. You should also include any responses outstanding from their feedback from the first submission, even if you were cleared to proceed. The response to this submission will be detailed information of what they expect to see for the final Gold Master Candidate submission.

Gold Master Candidate Certification (Third Submission)

Each first party has a different name for submitting your GMC for approval. Microsoft refers to it as Technical Certification Requirements (TCRs), Sony coins it to be the Technical Requirements Checklist (TRC), and Nintendo just calls it Lot Check.

This is the biggest submission for your game and the most daunting event in the entire production as it will make or break your game. The GMC is the final completed version of the game, free of all A bugs, and as many B and C bugs that you could clear out before submission time. If you miss your submission date, you have

FIGURE
44.3

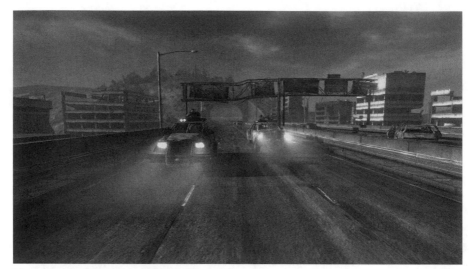

It's a race to the finish as you get closer to your GMC.
Image Courtesy of: "Terminator Salvation: The Videogame" WBIE.

FIGURE
44.4

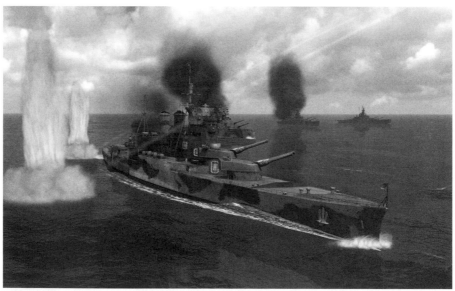

Navigating through the rough waters of certifications can be tricky.
Image Courtesy of: "Battlestations Pacific" WBIE.

to go to the back of the line. First parties are reviewing an overwhelming number of game submissions and they can't hold your space if you're not ready in time.

Operations will provide a checklist of certification requirements that the team must adhere to. It includes how to submit, the format, what they want to see cleared out of the code, what you should make sure is working (or not working) before you submit, and requested information about your submission.

After carefully going through each stage of the certification requirements, having them double-and triple-checked by a new set of eyes, the GMC build will be sent to the publishing producer, who will review it once again with the tech director to make sure it covers all the cert requirements. From there the publishing producer fills out the accompanying documentation, provides a most up-to-date bug report, a walkthrough of the game, the ESRB age rating certification, and any other bells and whistles first parties require.

This is all handed off to the operations team; they do the physical submitting.

While you're waiting for your approval, it's best to keep working on bug fixes and tweaking for the international builds.

This serves two purposes:

1. You'll have an even better game build when submitting for international territories, and

2. If your game is rejected for North American release, you're ahead of the game on generating a cleaner build.

Not all of the first parties have one central office to submit international versions of the game. Sony has their North American wing, Sony Computer Entertainment America (SCEA) and their European offices, Sony Computer Entertainment Europe (SCEE), both of which require separate submissions. Just because SCEA approves your build, SCEE could still possibly reject it, so you should strive to keep iterating on fixes until it is time to submit to internationally.

If your game is rejected you must rush to make the required fixes and return a new build to the first party as soon as possible in hopes that this new one will clear.

When you do receive approval, you've "Gone Gold" and the code for that very build is going to become your Release To Manufacture (RTM) build, the version of the code that gets provided for mass distribution. Even if the team has continued making bug fixes, go back to the version that was submitted and approved as the final RTM.

Post-Production

CHAPTER FORTY FIVE

Producer Role During Post-Production Phase

The wrapping of a film typically is followed by grand parties and celebrations, followed by premieres, jubilation, and back slapping. When most games wrap, it's a quiet time, simply business as usual. Rarely are there celebrations with the exception of perhaps some of the team members going out for a drink, but by this time everyone is exhausted, emotionally drained, and wondering what their next job will be, if they're not already working on it or on vacation.

At this point, with the exception of some small duties by the team leads, the producers stand alone, on both the development and publishing sides.

Once the RTM has been delivered, the producer on the development side will be working towards ramping team members off of the game and hopefully on to other projects. Some team members may remain if software updates are necessary or if there are plans for future downloadable content (DLC), however DLC is typically built out during production, so unless there are predictions for the game to be such a big hit that more content needs to be planned, in the end the staff will be back down to the core that you started with at concept.

The main goals of post-production are archiving and the postmortem which are manned by the producers on both sides, who will be working together to plan and organize for the archiving delivery, and prepping the dev and test kits to be returned. They will also be working together on the postmortem. If the two groups want to continue working together they will be sharing their postmortem information, discussing the successes and shortcoming of the project and how to improve them on the next one. All of this will be combined into one large doc as a learning tool. If the two groups choose to part ways, then the developer and publisher will typically have their own separate postmortems organized by their respective producer.

If no future moves with the game are planned all that is left after the archiving and postmortem is waiting for the game's release. At this point marketing and PR will be working their magic, and hopefully heavily promoting the game. They will be turning

to both the pub and dev producers to provide content and publicity, be it through blogs and podcasts or interviews and demoing the game for press and the public.

Hopefully, sales predictions are such that a sequel is planned, and if the publisher/developer relationship was successful enough, the two parties will continue working together. This way everyone can roll right on to the sequel, building out on what is already created to make a bigger, more elaborate game.

CHAPTER FORTY SIX

Archiving

Your game is finished and most likely getting ready to hit the store shelves for everyone to see and play. The team has wound down and is probably looking for the next project. The only thing left to do with the game code now is to archive it.

Archiving is best described as putting the game together in order for it to be stored in a safe place so that if you ever need to retrieve it, you have a place to draw the game from. This needs to be done with great care and efficiency in case the game source code is ever needed again. An archived game is an official version of the title that represents the culmination of what was developed and shipped.

In addition to archiving the code, you'll want to include all of the art, audio, design, and any other element or asset from each stage of development.

The archive should include:

- Last version of the game, typically the version that shipped into stores (Release To Manufacture, RTM).
- The full code of the game, referred to as the source code.
- Documentation: should include last bug report and QA certification, legal checklists that certify the game was proofed by your legal team, TCRs and TRCs, last tech report, ESRB certification, and first publisher certifications.
- Localization disks: should include localized versions of the game, each territory's build on separate discs, along with all of the elements from the localization kit.
- A detailed walkthrough of the game.
- Every documentation, contract, approval, asset, and pertinent correspondence related to the game. Basically every element and related material.

Once you have all of these items secured, you will want to make multiple copies so that if anything happens to the masters, you have something as a backup. These copies of the game get stored in a fireproof vault for safe keeping by the publisher with additional copies stored at other locations for safe keeping in case something disastrous happens to the originals (which has happened before).

During the archiving period, you will want to be sure everything else gets closed out. All test and dev kits that the developers have been using throughout production need to be returned to the publisher, as other projects are likely waiting to use them. The final payment to the developer is contingent on the delivery of the archived code and assets, and test and dev kits. This serves as the final milestone deliverable.

CHAPTER FORTY SEVEN

Postmortem

It's a curiosity that the industry has chosen the look back on a game's production as a postmortem. The term brings so many bleak and foreboding thoughts; after all, it is a term that represents death. Perhaps this is why everyone tends to dread the postmortem so much, as it is a recap and review of the game production, going over its successes and shortcomings. However, the purpose of a postmortem is to be an opportunity for everyone involved to learn from the experience and make it that much better on the next go-round, turning any negatives in the project to positives for all future productions.

Every key team member on both the developer and publisher sides will be asked to contribute to the postmortem, with the publishing producer as the one who puts it all together. Ask each team and department lead to provide at least 5 successes and 5 shortcomings from their side of the process. These should all be put together in a final postmortem document with an intro of the overall project and a final conclusion of what was learned from the entire experience.

Although it sounds simple enough to list out what went right and what didn't, this can actually be quite challenging and it will exercise your skills in fair communication. This is not the time to throw blame around or try to finger-point. Postmortems are learning tools only, so instead of stating who did something wrong that caused a problem, you need to explain what was learned from the issue and how it could have been approached differently if you were put in that exact same scenario again. Terms such as "bad" and "poor" should be avoided, instead using "room for growth" or "challenging" with an explanation of how the problem could have been avoided.

For example: When helping some fellow producers craft the postmortem on a music rhythm game, their original statements were negative, angry, and counterproductive. One such statement was…

> "Music licensing was a disaster! It happened last minute, we couldn't get the songs we wanted and it ended up costing way too much, draining our budget to get what we needed."

This is pretty much an example of how not to write up a shortcoming of a game. It comes off as angry and doesn't give any context as to the cause of the problem,

nor does it pose any solutions. The only end result from a statement like this will be anger from the other parties that worked with them to get the music, as they would rightly feel a lack of respect for the hard work that they put into it, plus it would leave management wondering why the producer didn't do a better job managing this task instead of complaining about it.

The truth is that the music in the game was terrific and far exceeded anyone's expectations due to an extraordinarily short development cycle for the game. All of the music licensing had to be done last minute by a team member with little to no experience in securing such rights; but they worked very hard and did the best job they could with the time and resources allotted to them.

Our recommendation to this postmortem issue was to look at the problem from a different angle and state how it could be prevented next time. The final statement ended up as…

> "While the music we were able to secure for the game ended up a great success, there were some challenges caused by getting the music near the end of our tight production cycle and securing the songs from several different license holders. To save both time and money we should reach out to a music licensing company during the concept stage of the game, who could work with our team in acquiring music rights early on. This would have allowed us the luxury of molding the game alongside the pre-secured music, so we wouldn't have had to work backwards to try and shoehorn it in. This also could allow us to create a cost-saving slate deal, securing all of our music from one licensing house, rather than multiple rights owners."

Several successfully crafted postmortems have been published in *Game Developer* magazine (gdmag.com) and on Gamasutra.com. These are terrific resources to see the right approach and format for a postmortem.

INDEX